Burhan Dogançay

Fifty Years of Urban Walls

THIS CATALOGUE HAS BEEN PUBLISHED ON THE OCCASION OF THE EXHIBITION **FIFTY YEARS OF URBAN WALLS: A BURHAN DOGANÇAY RETROSPECTIVE** HELD AT ISTANBUL MUSEUM OF MODERN ART

MAY 23–SEPTEMBER 23, 2012

EXHIBITION CURATOR
LEVENT ÇALIKOĞLU

PROJECT COORDINATOR
ASSISTANT CURATOR
BİRNUR TEMEL

İSTANBUL MODERN EXHIBITION MANAGEMENT

CHIEF OPERATING OFFICER
GÜNİZ ATIS AZRAK

MARKETING DIRECTOR
GÜLCEM BAYER DENİZ

REGISTRAR AND EXHIBITION MANAGER
S. GÖZEN MÜFTÜOĞLU AKSAN

ARCHITECT
ENGİN UZUNOĞLU

CATALOGUE

EDITORIAL COORDINATION
ANGELA DOGANÇAY, BİRNUR TEMEL

GRAPHIC DESIGN CONSULTANCY
BEK DESIGN AND CONSULTANCY LTD

GRAPHIC DESIGN APPLICATION
PINAR AKKURT, BEK

TRANSLATION
NAZIM DİKBAŞ

ISBN 978-3-7913-5219-0 (ENGLISH TRADE EDITION)
ISBN 978-3-7913-6414-8 (ENGLISH MUSEUM EDITION)
ISBN 978-3-7913-6415-5 (TURKISH MUSEUM EDITION)

İSTANBUL MUSEUM OF MODERN ART
Meclis-i Mebusan Caddesi,
Liman İşletmeleri Sahası,
Antrepo 4 34433 Karaköy,
Istanbul / Turkey
T (+90 212) 334 73 00
F (+90 212) 243 43 19
info@istanbulmodern.org
www.istanbulmodern.org

Prestel Verlag, Munich
A member of Verlagsgruppe Random House GmbH

Prestel Verlag
Neumarkter Strasse 28
81673 Munich
Tel. +49 (0)89 4136-0
Fax +49 (0)89 4136-2335

www.prestel.de

Prestel Publishing Ltd.
4 Bloomsbury Place
London WC1A 2QA
Tel. +44 (0)20 7323-5004
Fax +44 (0)20 7636-8004

Prestel Publishing
900 Broadway, Suite 603
New York, NY 10003
Tel. +1 (212) 995-2720
Fax +1 (212) 995-2733

www.prestel.com

Library of Congress Control Number is available;
British Library Cataloguing-in-Publication Data:
a catalogue record for this book is available from
the British Library; Deutsche Nationalbibliothek
holds a record of this publication in the Deutsche
Nationalbibliografie; detailed bibliographical data
can be found under: http://dnb.d-nb.de

Prestel books are available worldwide. Please
contact your nearest bookseller or one of the above
addresses for information concerning your local
distributor.

Editorial Direction: Anja Paquin
Copyediting: Chris Murray
Production: Andrea Cobré
Origination: Repro Ludwig, Zell am See
Printing and Binding: Passavia Druckservice, Passau

Printed in Germany

Verlagsgruppe Random House FSC-DEU-0100
The FSC-certified paper Hello Fat matt
was supplied by Papier-Union-Ehingen

BURHAN DOGANÇAY

FIFTY YEARS OF URBAN WALLS

EXHIBITION SPONSOR

OYA ECZACIBAŞI
Chair of the Board, İstanbul Modern

Foreword

İstanbul Modern is pleased to present a selection of works retracing the fifty-year artistic career of Burhan Dogançay, one of Turkey's preeminent contemporary artists. This exhibition will be the most comprehensive examination of his work to date.

Ever since the 1960s, Burhan Dogançay has traveled to countries in all four corners of the globe passionately documenting urban walls with his camera; he collects advertising bills, torn posters, graffiti, and pictures, which he then reconstructs into narratives with new connotations to create compositions open to multiple interpretations. His works advance urban history by propelling transient, random images from the past, all varied expressions of collective memory left on wall surfaces, into the future.

Drawing inspiration from urban walls, Dogançay observes, explores, and stores the content of their surfaces, accumulating a wealth of themes to create new series. The topics, materials, and techniques he uses in his compositions change and evolve with the constantly varying walls of cities around the world.

Intertwining reality and fiction, light and shadow, the artist's works contain political, social, and philosophical references to art trends, customs, and the current zeitgeist.

Urban walls are a mirror of society and a perfect means of communication for Dogançay; they provide a way to keep a finger on the pulse of what is happening around the world. So, wherever he goes, he tracks down these "walls that whisper, shout, and sing" to reinterpret and transmit the stories they tell. Dogançay reveals to the viewer the dynamism and soul of cities through images reflecting and interrogating daily life, retained on wall surfaces deteriorated by the assault of the elements.

Throughout his artistic career Burhan Dogançay has worked in a wide variety of mediums including painting, drawing, printmaking, tapestry, sculpture, and photography. The first retrospective in Turkey covering forty years of his work was organized in 2001 by the Dr. Nejat F. Eczacıbaşı Foundation at the Dolmabahçe Cultural Center. A traveling exhibition, T.I.R. Museum, was later assembled to carry a selection of the works from the show to various universities in Turkey. Now, in 2012, we are delighted to be hosting a large-scale exhibition celebrating Dogançay's half-century long artistic career, this time at İstanbul Modern, a museum the artist himself had expressed a longing for over the years.

We feel certain that this event showcasing a selection of urban walls from the last fifty years will serve as a testimony to the passage of time for younger generations and offer them a unique opportunity to better appreciate and interpret the world in which we live.

My deepest thanks go first and foremost to Burhan Dogançay, indisputably one of our finest artists, to Angela Dogançay for her meticulous and tireless assistance in the preparation phase of the exhibition, to Murat Ülker for his faith in the project, to Zuhal Şeker for her cooperation and dedication at every stage of the process, and to Oktay Duran for sharing our enthusiasm.

I would also like to extend my gratitude to all the museums, institutions, and private collections at home and abroad who contributed to the exhibition *Fifty Years of Urban Walls* by loaning us works of the artist.

Additionally, we are keen to express our gratitude to Yıldız Holding for their generous support.

Finally, I would like to thank our exhibition curator Levent Çalıkoğlu, assistant curator Birnur Temel, and the rest of our team at İstanbul Modern who contributed to the success of the exhibition.

MURAT ÜLKER
Chairman, Yıldız Holding A.Ş.

Yıldız Holding Statement

BurhanDogançay, one of the great masters of Turkish contemporary art, will be exhibiting his work in a comprehensive retrospective at the İstanbul Modern. As an art lover, I am delighted that Yıldız Holding will be sponsoring this exhibition.

I attach a particular significance to the fact that Burhan Dogançay, who succeeded in his journey from local to international artist very early in his career, and who has had his work displayed in some of the world's most prestigious museums, such as the Guggenheim and the New York Metropolitan, will be exhibiting his work in a show entitled *Fifty Years of Urban Walls* in Istanbul, which he considers his home.

The fact that Dogançay's work has been displayed at important international museums and within private collections makes it possible to follow and appreciate the universal journey of a Turkish artist.

Artistic activities leave a lasting impression by deepening a community's relationship with art. As Yıldız Holding, we take the sponsoring of projects that develop the community culturally and artistically very seriously. Without a doubt, Dogançay's retrospective exhibition *Fifty Years of Urban Walls* will provide such enrichment.

I think that getting to know Burhan Dogançay and to witness his unique artistic approach provides us with a different perspective. We are constantly learning new things from his work. Talking about the theme of his work, for example, he says: "Walls are the only places where people express themselves freely. It was like this 20,000 years ago and remains the same now." After hearing these words and observing his works, it is impossible not to pick up the habit of looking at city walls, at streets, and at people with a different perspective.

This exhibition is an intellectual festival of visual delights for those who know Burhan Dogançay, and a new beginning for those that do not know him, especially the young.

We would like to thank the collectors and museums who have participated in this major exhibition by entrusting valuable works by Burhan Dogançay to İstanbul Modern.

Acknowledgements

İstanbul Modern would like to express its gratitude to all the museums, institutions and private collectors
who have lent works to this exhibition or who have facilitated loans without which this exhibition and its catalogue
would not have been possible.

Sincere thanks should be given to the following institutions and to all the private collectors for their generous support:

Bayerische Staatsgemäldesammlungen, Pinakothek der Moderne, Munich
The British Museum, London
Casa dell'arte Collection
Dogançay Museum, Istanbul
Georgia Museum of Art, The University of Georgia, Athens, Georgia
Kennedy Museum of Art, Ohio University, Athens, Ohio
KUNSTEN Museum of Modern Art, Aalborg, Denmark
Louisiana Museum of Modern Art, Humlebæk, Denmark
Moderna Museet, Stockholm
Musée de Grenoble
Museet for Fotokunst-Brandts Klaedefabrik, Odense, Denmark
Dr. Nejat F. Eczacıbaşı Foundation Collection
The Solomon R. Guggenheim Museum, New York
Sprengel Museum, Hanover
Staatsgalerie Stuttgart
Walker Art Center, Minneapolis

Yalçın Ayaslı
Şerife and Mehmet Ali Babaoğlu
Bell Holding Collection
Burhan Dogançay
Nil and Oktay Duran
Oya and Bülent Eczacıbaşı
Ekspo Faktoring A.Ş.
Mrs. J. G. Freistadt, Vienna
Maral and Oskar Fuchs
Georg Guggenberg, Vienna
Benjamin Kaufmann, Zurich
Öner Kocabeyoğlu
Şahinöz Collection
Yıldız Holding A.Ş.

An anonymous lender, courtesy ASB Art Sale Berlin GmbH, Berlin
Two anonymous lenders, courtesy Susan L. Halper Fine Art Inc., New York

Sincere thanks are due to **Brandon Taylor** and **Richard Vine** for their insightful essays, and to **Clive Giboire** for
his notes on the artist's series—their contributions will undoubtedly add to a greater understanding of the artist's work.

Last, but not least, **Angela Dogançay** deserves special thanks for having laid the groundwork for this exhibition and
its catalogue.

Contents

LEVENT ÇALIKOĞLU

Half a Century of Urban Culture: The Recording of History and the Anatomy of Walls

Wall in New Delhi, 1995

Burhan Dogançay is one of the few artists who have kept a record of the times we live in through the use of walls, which are among the key symbols of modern and contemporary urban culture. His practice of thought and production are both shaped by examining walls that reflect the contemporary memory of socio-cultural transformations, and by becoming a stakeholder in the history of walls, which constitute a public field of expression. This energetic transformation, which from the early 1960s to the present day has constructed new fields of social, cultural, and political discourse through the medium of walls, holds a light to the complex and protean alternative history of urban life.

Dogançay has made the subject of his art the subtle interplay, the game of puss-in-the-corner, between word and image, culture and visual media, political power and social habits; and as an urban traveler he has been, for almost half a century, taking photographs of walls, and mapping their anatomy, in various cities across the world. Dogançay reminds us that on these surfaces, which are open to many different contemporary interventions ranging from posters to slogans, and messages with sexual content to serious newspaper clippings, we can discern the pulse of history. The common platform of knowledge and expression for artists, walls serve as the confessionals of established culture. They act as a political meeting point where slogans clash, an intimate surface where lovers pour out their hearts, a fresco where film posters become stratified, a complex social network loaded with all manners of symbols of violence, eroticism, and solitude. These surfaces, where unofficial powers are pitted against their dominant political counterparts with what is at times an absurd language, are also the conveyors of an uncontrollable world of communication where all manner of hierarchies are dismantled. Dogançay examines walls—the space of an infinite process that incorporates writing, scribbling, passing one's time in an irresponsible and carefree manner, struggling for the transformation of the system, manipulating reality, seducing the *other* and revealing the invisible tentacles of power—in the guise of an anthropologist; it is as an artist that he constructs new realities from them.

For an artist who believes that the complex nature of the present can find form only in a platform of freedom that is open to the public, walls serve as a public blackboard. Conveying a common memory, these blackboards establish similarities between the hardships, dreams, and desires of people living in different cities of the world. Through their surfaces—which people use unreservedly to reveal who they are, what they like, whom they curse, what makes them angry, whom they vote for, which icons they fall in love with, what they have to endure to keep on living ... in brief, all the external and internal forces in their lives—Dogançay interrogates the layers of identity that make us who we are.

Formed from a blizzard of collaging, with hundreds of images and scraps of text, Dogançay's works reveal the present power of political authority that has explicitly permeated these walls. He chooses walls to settle his accounts with his own time and to show that this present moment did not take shape suddenly and out of the blue, but continues to be fashioned from the remnants of yesterday's power structures. This is perhaps why in some of his works leaders or icons from turning points in the political history of the world are summoned into the present. Powerful ideologues of

the past are exposed by Dogançay as nostalgic souvenirs, lightened and turned into playthings by popular culture. The artist reminds us that leaders condescendingly grinning at the public from a poster from many years ago are trapped in the dusty pages of history and yet may re-emerge. In other examples, he conveys the colorful and entertaining political lives of famous statesmen who have become the superstars of the present. The composition of these works clearly displays the flavor of a photo-novel. The visual framing of the works allows them to feed off each other, and the details of a specific story reveal truths that we actually all know quite well.

In these works, Dogançay produces a language that exposes, through the use of walls, the tentacles of power that have surrounded our lives. Although the fragments of all types of information he juxtaposes tap into the same veins as narrative painting, or the inflated language of popular culture, the outcome reflects how much thought can benefit from visual culture. At the precise moment he invites us to see an exposition of reality, he simultaneously issues a calm reminder that what we see is in fact fiction dressed in artistic language.

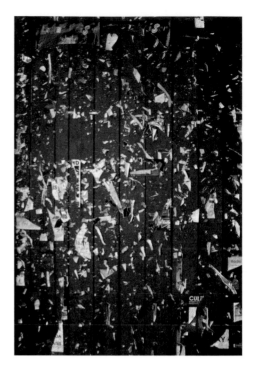

Dogançay is aware of the fact that contemporary art progresses via languages and signs. This is perhaps the golden key to the special and privileged place he has earned for himself in global art history. His canvases, constantly open to innovation and shaped by countless techniques and interventions from collage to photography, and from environmental influences to touches from nature, are nurtured by the main concern of the fundamental investigation of modern artists: *To create an image that cannot be encountered in any other experience.* Although his references are from street culture, all Dogançay's works are, in terms of artistic unity and image composition, born of the expression of his personal imagination. Although they emerge from the depths of a different type of experience, they aim only to be seen and to be themselves with the images they bear . Therefore, every work is unique, each painting a singular image. On the other hand, these works also contain fundamental contemporary themes. They constantly evoke the present and remind us that they are dealing with their own time. Rather than timelessness, it is this very moment in the present that they host— and the potential inherent in this moment to shape our world. The complex nature of today is reshaped in each work, the complex structure of the contemporary revealed.

By means of the synthesis he has developed over the last half century, Burhan Dogançay has become one of those rare artists who act as an intellectual bridge between modern and contemporary art. These works, in which recent history is called forth to the present via the images they contain and so enveloped in a nostalgic spirit, also remind the viewer how close a relationship they share with the multiple languages of the present time. These images that we know, that remain stuck in our memory and feed off the iconic moments of visual history, bear both the spirit and magic of modern times, and betray the directionless, drifting nature of the contemporary world. Dogançay constantly updates his creativity, which, with versatile styles and techniques, is born of the modern, but shaped by the energetic language of contemporary art. Burhan Dogançay narrows the present-day boundaries between street culture and art, transience and timelessness, memory and the subconscious.

Wall in Geneva, 1977

BRANDON TAYLOR

Dogançay's World

It began, BurhanDogançay tells us, when something caught his eye during a stroll down 86th Street in New York: "It was the most beautiful abstract painting I had ever seen. There were the remains of a poster, and a texture to the wall with little bits of shadows coming from within its surface. The color was mostly orange, with a little blue and green and brown. Then there were the marks made by rain and mud."[1] Taking out his sketchbook, he jotted down the details of what he had seen in those few square inches of wall. He immediately went back to the studio and started work on the conversion of the sketch he had made into a work of art, faithfully duplicating each torn poster fragment, each grimy stain, in the surface of the painting. The year was 1963. Dogançay was 34; a newcomer to New York, and at the beginning of a long artistic career, one that would take him to many corners of the globe, making further notes and photographs of the walls he sees there. In doing so, he has placed himself squarely in the mainstream of modern art: to observe the urban maelstrom and the feelings and energies of the city street. As Baudelaire said in recommending the rapid, quickly changing sensations of the street as the true subject that the artist must portray, it is "the ephemeral, the fugitive, and the contingent" that are the components of modern beauty; not the timeless features of eternal beauty, but the "relative, circumstantial element" that will point towards the morals and emotions of the age.[2]

The beginnings of Dogançay's artistic career may lie in his epiphany on 86th Street, but in a different sense he had already started to look carefully at the cities he had been in before his voyage across the Atlantic. He had spent time in Paris in the early 1950s, preparing his doctorate in economics and had returned to Turkey, only to embark on more international travel as an employee of his country's government. Dogançay's Paris was not Baudelaire's, of course; but it had shown him the power that cities have to speak their identity through the diversity of the street: Paris in the early 1950s was a city of torn posters and faded pre-war advertising, a congenial if decayed community slowly raising itself from the horrors of war-time occupation. He could have returned there at the beginning of the 1960s; but by some intuition he opted for a posting to New York instead, conscious that America was rising as a commercial and artistic power. "I am not clairvoyant," he reassures us about this decision, "but I saw that Paris had lost its advantage as the capital of the art world, and [that] New York was where it was happening."[3] Naturally, his first months in New York demanded an awkward compromise between his role as a Turkish diplomat and his increasingly frequent painting excursions into the street. Finally divesting himself of his diplomatic career, he decided to devote himself to a life in art, at a time when New York was becoming, perhaps had already become, a ferment of artistic activity, full of doubtful precedent and hesitant experiment, and yet with a rising reputation for art that was large in its ambition, grand and energetic in its scale, and commercially as well as critically active at the highest level.

1 Burhan Dogançay, cited by E. Flomenhaft, "Dogançay: A Heroic Quest," in *Dogançay: Doors and Walls*, Tenth Avenue Editions, New York 1994, p. 29.

2 Charles Baudelaire, "The Painter of Modern Life" (1863), in *The Painter of Modern Life and Other Essays*, translated and edited by Jonathan Mayne, Phaidon Press, London 1964, pp. 3, 12.

3 Burhan Dogançay, cited in Flomenhaft 1994 (as note 1), p. 28.

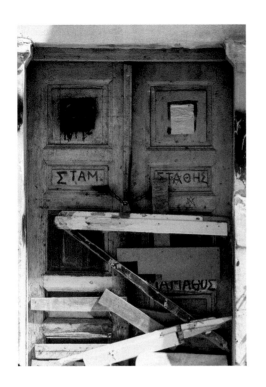

We do well to linger on that moment of arrival, and the many contexts to which the young diplomat-turned-artist was now exposed. The city's wall surfaces—one sure source of 'modernity' for Baudelaire—had for more than a decade been absorbing younger American artists who were aware of the forces unleashed by the dynamic new economy, by its sheer productiveness and ambition—both its prodigious energy and its waste. Something of the scale of the urban wall had already rubbed off on those American painters of the 1940s and 1950s, by then known as Abstract Expressionists, who had wrestled in their art with the contradictions between individual and collective action in a time of headlong social and scientific change; above all the contradiction, as it must have seemed then, between the impersonality of the urban wall and the demands imposed by a culture premised on consumption. A younger but related group, those who made up the 'Beat' sensibility of late 1950s America, had moved even closer to the attitude that would fuel Dogançay's fascination with the flyblown surfaces of the street. The Beat artists and poets had declared themselves absorbed by the neglected and the overlooked, by the random in city experience and the happenstance in personal life; and they had begun to convert those attitudes into new formal procedures in art—in painting and sculpture, poetry and the novel. It was the city of Frank O'Hara and Allen Ginsberg. Artists coming to prominence in the late 1950s such as Allan Kaprow, Jim Dine, Red Grooms, and Claes Oldenburg had already begun to experiment with non-art materials such as objects picked up on the street, with broken or degraded signs, and translate them into three-dimensional structures and environments that contained evidence of word-forms, advertising, and graffiti. Hyper-production and prosperity, twinned with the rapid obsolescence and urban waste, were encouraging a posture of wide-eyed celebration at what was almost a spectacle of poverty combined with decay. "Everything belongs to me because I am poor," Jack Kerouac had written in the spirit of the group.

Dogançay's status as a diplomat must have kept him aloof from that experimental culture. And yet a fascination for the qualities of the New York streets was quickly absorbed by the young artist from Turkey, a relative stranger to the city, no longer supported by a regular income, but with time to observe the material circumstances and conditions of his adopted home. It so happens that Dogançay just missed seeing the groundbreaking *Art of Assemblage* exhibition that had been curated by William Seitz at the Museum of Modern Art in 1961. It was a show that had reawakened a new attitude to the mixing and montaging of genres in art, to casual, even provisional assembly. Specifically it had mobilized a fascination for 'junk'; an old nautical term now widely absorbed into the youthful vernacular, and meaning material broken by over-use, but also matter whose very uselessness made it seem attractive, the more so if it was damaged as well as slightly rare. The Beat artists had already treated 'junk' as a category that now included, in Seitz's words, "Beat Zen and hot rods, mescaline experiences and faded flowers, photographic bumps and grinds, the

Door in Athens, 2004

poubelle, juke boxes, and hydrogen explosions ...[but also] the images of charred bodies that keep Hiroshima and Nagasaki before our eyes; the confrontation of democratic platitudes with the Negro's disenfranchisement." To that already expansive list Seitz added "the peeling *décollage* on abandoned billboards in the blighted neighborhoods of Chicago or Jersey City, accented by the singing colors and clean edges of emblems intended to sell cigarettes and beer ... [that] take on an intense beauty more poignant than that of the lacerated posters and graffiti that cover the old walls of Rome and Paris."[4] Quite evidently, language itself was now acting as a powerful stimulus to new art. And yet, like other artists of his generation for whom the city and its energies had become important, Dogançay needed his own method for the conversion of real city surfaces into art.

Dogançay's work from those early years is mostly in the painted medium alone, and reproduces more or less faithfully, at their correct scale, the look of urban billboards, graffiti-covered wall surfaces, as well as broken or neglected entrances such as windows and doors. And yet those works cannot quite be counted as 'Beat,' since, and contrary to superficial impressions, we find them to be un-casual in their appearance and most often very carefully composed. Technically often ingenious, they are the result of long hours of patient reconstruction; and it is Dogançay's adherence to an ethic of strenuous studio work that mainly serves to distinguish his practice from that of Americans who addressed the urban scene. The distance he has maintained from a contemporary artist like Robert Rauschenberg, for instance—himself in thrall to a 'Beat' sensibility in 1950s New York—is significant; and notwithstanding Dogançay's admiration for his work. By the time of Dogançay's arrival in New York, Rauschenberg had already mastered a *bricolage* idiom that could reabsorb material from the degraded public sphere; to begin with, broadsheet newspapers transferred whole to a pictorial surface and then obscured in layers of black paint. By the early 1960s Rauschenberg was being lionized for a series of large, mural-sized 'Combine' paintings that exemplified a subtle attunement to the sensations as well as the surfaces of the modern city street. Like other artists of his milieu—Jasper Johns among them—Rauschenberg's attention was being trained upon the incongruous, the abstract, and the planar in city life; all now subject to a Beat-like sympathy for the broken or the over-used. Contemporary opinion had it that Rauschenberg's originality lay in pasted and painted panels on which, to repeat a verdict of Leo Steinberg, "objects are scattered, on which data is entered, on which information may be received, printed, impressed, whether coherently or in confusion."[5] And yet Dogançay, for his part, was developing a set of translation practices that were distinctively his. For one thing, his attitude to the orientation of signs and surfaces has from the earliest days always been one of respectful adherence to the look of the original, and the 'signature' quality of the anonymous markings of those who made them. Further, he has always preferred to reproduce fragments of wall surface in their mutual relations just as he found them, and with minimal adjustment of color or position,

4 William Seitz, *The Art of Assemblage*, Museum of Modern Art, New York 1961, pp. 76, 89.

5 Leo Steinberg, *Other Criteria*, Oxford University Press, London and New York 1972, p. 67.

rather than to up-end them or combine them casually in the Rauschenberg manner. In large measure his practice has been one of simulation in the spirit of record-keeping, carried out with the collector's rather than the scavenger's eye. And while Dogançay has liked to divert the viewer's attention to entire panels of wall surface encountered on the city's hoardings, or other upright entrances and barriers such as doors, he has generally selected his material with an eye to much older canons of beauty, in which imagery was arranged relationally, sometimes asymmetrically, in the manner sometimes we might feel happy to term 'composed.' Secondly, the doors and surfaces that Dogançay has liked to simulate have generally had a rigor and identity that his American colleagues would generally seek to avoid. A typical Rauschenberg painting of that time was such as to make it resemble, in Steinberg's words, a surface "to which anything reachable-thinkable would adhere. It had to be whatever a billboard or dashboard is, and everything a projection screen is ... dump, reservoir, switching center, abundant with concrete references freely associated as in an internal monologue."[6] Dogançay's attitude to urban surfaces, by contrast, has been one governed by abstract values of color and line, even a radiant intensity, guided by a traveler's optic of curiosity and stimulated by the real time and space of particular locations in the city. Such an anthropological gaze, together with the strenuous work of verisimilitude, has given Dogançay's art a documentary status that the work of his contemporaries in America has generally lacked.

If one doubted Dogançay's commitment to the documentary mode, one has only to notice his ceaseless photographic survey that has taken him to no less than 114 countries since 1975, resulting in perhaps the largest photo-archive of urban surfaces that has ever been compiled—a veritable 'atlas' of the world's surfaces comparable in its scope and ambition with the photographic 'Atlas' compiled by the art historian Aby Warburg that he called 'mnemosyne,' in reference to the tendency of all cultures to memorize and then reproduce in translation their major canonical forms. The difference is that the medium of painting makes documentary a category full of puzzles. After all, the very idea of a document contains the paradox that veracity cannot be delivered without translation into another medium, one with conventions and properties of its own. Indeed, the very concept of 'document' seems to actively mobilize this tension between sociological reportage and the aesthetic, between what might appear 'genuine' in experience and what is composed and therefore contrived inside the work of art.

It is no wonder that the reputation of Kurt Schwitters ran so high in 1950s America, against the background of his engagement with the European city at an earlier period of time of rapid cultural change: His scavenging in the real street, for real materials, was matched only by the artifice and inventiveness of his transportation of them into art. As to Dogançay's own methods, we know that he first encounters walls Schwitters-like, on walks that he describes as 'hunting,' and that, during the process, sketches and photographs are made;

6 Ibid.

while in a complementary process, actual pieces of paper or even whole inscribed surfaces are torn from their hoardings and taken home to the studio. At least since Baudelaire, the first of those activities can be said to be conventional for an artist attuned to 'modern' life. But the second is definitely new, standing as it does somewhere between re-vandalizing the original surface on the one hand, and collecting its fragments anthropologically for study and subsequent use, on the other. For we have to accept that in the work of the studio that follows 'hunting,' Dogançay does not always simulate a section of wall with absolute verisimilitude. He will sometimes reinvent a surface that can resemble rather than faithfully reproduce the reality of the city at a given moment in its history, but in a manner that ensures that its authenticity can be guaranteed. As Dogançay himself puts it, "I usually compose a work based on my observations and memories of different walls. Frequently I mix different impressions I have of different walls, sometimes even in different countries. My works are never exact copies of what I have seen."[7] More relevantly, it is a type of authenticity that can perhaps be called the typical. For I think that Dogançay reconstitutes wall and door surfaces not only because they exist, but because they function as symptoms of the damage and profusion that the culture expresses at its core.

From Beat America we must modulate to Pop. For surely the other context for Dogançay's virtuosity with his painted doors and surfaces is an attitude towards the commercial signifier that was inescapable when the artist was finding his way. Remember that Dogançay already knew European culture well before arriving in America. In fact the European city street, newly adorned with pasted signs for entertainment, for clothing, for medical remedies, and of course signs hung outside shops and eating houses to advertise their trade, had already become a legal and political battleground by the time of the industrial revolution. Jean-Jacques Rousseau had written of the "flux and reflux" of cosmopolitan life, in which, in the experience of one of his novels' heroes, "everything is absurd, but nothing is shocking, because everyone is accustomed to everything."[8] Exponential population growth during the late 18th century, combined with commercial expansion, resulted in laws being passed in the early part of the 19th century in an effort to regulate what was becoming an overwhelming impression of visual clutter in the larger cities. Cleanliness and public order were viewed as incompatible with ungovernable excess; and so politics became a process of control over the burgeoning culture of the street. By the end of the 19th century, visual overcrowding was widely registered as tasteless and mesmerizing at the same time. But it was not until the 1930s that the city street was regarded, at least by artists, as creative in itself; as if inanimate city surfaces were virtually living organisms having personalities and means of expression of their own. To the Surrealist sensibility, cities were locations of spontaneous authentic creation, which the artist needed only to record in order to mark the identity of particular surfaces as being art. When artists

7 "Burhan Dogançay in Conversation with Brandon Taylor," in *Urban Walls: A Generation of Collage in Europe and America*, Hudson Hills Press, New York 2008, p. 38.

8 Jean-Jacques Rousseau, *Julie, ou La Nouvelle Héloise* (1761), in a letter from to Julie from her lover Saint-Prieux.

of the stature of Brassaï or Wols in Paris looked through the lens at cracked and broken city walls, they saw signs that had no author, messages that had no addressee; but that nonetheless spoke just as if they had.

And that attitude of astonishment mixed with reverence emerged in European Pop during the 1950s and 1960s. It erupted with particular force within the vanguard of British Pop culture, at the hands of those who reacted with fascination at the spectacle of urban decay, at the same time as feeling dismay at the gross commercial blandishments of the time. When Richard Hamilton came to compose his list of the elements of the new attitude, he included—in addition to Popular—Transient, Expendable, Low Cost, Mass Produced, Young, Witty, Sexy, Gimmicky, Glamorous, Big Business.[9] Hamilton's sensibility, like Baudelaire's before him and in common with Dogançay's now, was essentially non-Aristotelian; functioning as a receptacle for words and images, original and remaindered, pacifying and aggressive, true and false, in a combination having no resolution but merely presenting themselves as facts—affirming once more that city experience in a time of minimally regulated capitalism resembled a barely coherent flux rather than a stable unfolding of sequential parts. Back in Paris, meanwhile, a group of artists comprising Jean Tinguely, Yves Klein, Daniel Spoerri, Arman, Jacques Villeglé and François Dufrêne were in 1960 being formed into a group called *Nouveaux Réalistes* by the Paris critic Pierre Restany. Restany reiterated approvingly the Dada mantra that 'painting is dead,' and insisted that something like a sociological attitude in *Nouveau Réalisme* was replacing the kind of imaginative embellishment that had hitherto been definitive of art. Further, he claimed that "sociology now comes to the assistance of consciousness … whether this be at the level of choice, the tearing up of posters, the allure of objects, household rubbish, the scraps of the drawing room, or the unleashing of a mechanical susceptibility." His implication was that the materials of the usable city could be translated directly into art, resulting in a 'new realism' of the contemporary human and material world.[10] Dogançay, by now preparing to travel to America, would sooner or later become aware of how stylish and how anthropological was the additive method of Arman's boxes; how Daniel Spoerri's 'trapped' meal tables looked; how Tinguely's machines could mimic the process of urban change; and how Villeglé's torn-poster method would form a complement to his own.

Such were the polarities the Pop revolution was eager to explore: the contradiction between bright colors and urban deprivation; between the hypertrophied rhetoric of advertisers and social disenfranchisement; between wealth and poverty; between humor and desperation; between renovation and decay. And once more we find Dogançay both sympathetic to, and yet beyond, the attitude of his European contemporaries. If anything, he has aligned himself with the methods of American Pop artists such as Andy Warhol, Roy Lichtenstein, and James Rosenquist, who had had a job pasting large-scale posters in Manhattan, before turning that experience towards his art. For we can see that

9 Richard Hamilton, Letter to A. and P. Smithson, January 16, 1957, in Richard Hamilton, *Collected Words, 1953–1982*, Thames and Hudson, London 1982, p. 28, cited in Brandon Taylor, *Collage: The Making of Modern Art*, Thames and Hudson, London 2004, p. 162.

10 Pierre Restany, "Preface," exh. brochure, Galerie Apollinaire, Milan, April 16, 1960, later used as the "Manifesto" of Nouveau Réalisme. For a new edition, see *Manifesto des Nouveaux Réalistes*, with a postface by Denys Riout, Editions Dilecta, Paris 2007, this quotation p. 6.

Dogançay has tended to respect some basic rules of balance and stability in pictures, just as Lichtenstein and Rosenquist would, as well as preserving the uprightness of the image and its component parts in relation to the line of sight. And in common with those Americans, Dogançay has consistently avoided legislating between the good and the bad in urban experience, between the politics of one pasted sign and another. Indeed, though he will consistently oppose all forms of war and violence in his personal politics, he has shared with several others in the Pop generation a calculated reluctance to assert a particular politics in his art. More usually, a canon of high-colored tonality and visual impact has remained for him the essence of urban contradiction that he has wanted the viewers and owners of his pictures to share.

In the light of those cautious affiliations, there is one feature of Dogançay's career that is appropriate to mention here. For despite having lived and worked in America's most vibrant artistic city—albeit with a foot in his native Turkey, an awareness of cosmopolitan Europe, some acquaintance with Scandinavia, and a photographic awareness that has covered the globe—Dogançay has insisted that he has always tried to maintain a distance from other artists. "I wanted to be an autodidact myself," he told me recently in an interview, referring to the French painter Maurice Vlaminck, formerly racing cyclist and journalist, who boasted that he had never had a lesson in painting and had never visited a museum. And although Dogançay has exhibited alongside other artists (and was flattered to have a solo show at the Centre Pompidou in Paris at the same time as the Jackson Pollock retrospective there in 1982); and although he recalls with approval exhibitions that have impressed him by Francis Bacon, Max Ernst, even Marcel Duchamp, he claims to remain stoically above the ebb and flow of artistic fashion, and has been staunch in his refusal to join tendencies or groups. "Even to this day I never hang out with artists," he told me, "because I have a totally different background and milieu" ..."I always wanted to be an individualist and find my own way. I didn't want to be influenced by anybody."[11]

Dogançay's independence serves to explain, perhaps, the uniqueness of his practice as well as the nature of its appeal. It may also explain why variations between the different groups in Dogançay's work follow differences of time or in place, rather than differences between one artistic prototype and another. The *Doors Series*, for example, seems to originate in the over-sized, multiply locked and brutally damaged doors of New York City—very different to doors visible in Europe or the Middle East. It is an observation that can be made without reference to the languages in which their typical prohibitions are written: signs such as 'No Trespassing,' 'Post No Bills,' and the like. The series known as *GREGO* seems to originate in the name of a particular graffitist named GREGO. Armed with a spray can, GREGO declares his love of hockey and Piet Mondrian, and his hatred of drugs, the bomb, and 'fashismus,' seemingly a combination of 'fascism' and 'fashion.' That elusive character may or may not be Dogançay's

11 "Burhan Dogançay in Conversation with Brandon Taylor" (as note 7), p. 36.

other self, prowling the streets at night with messages for the world—we may prefer to remain unsure. The series known as *Cones*, *Ribbons*, and *Breakthrough*, each started in the early 1970s, specialize in a different but related technique which may be called the verisimilitude of the shadow; a more exacting optical version of the more general style of verisimilitude of which Dogançay has become a virtuoso. Though peeling billboards have been present in his pictures from the start, we see in *Breakthrough* the careful simulation of the effects of slanting light on protruding poster edges. Sometimes the protrusions and their shadows are both simulated; whereas on other occasions the protrusions themselves are real, confusing the eye and mind in a game of absence and presence, of two dimensions and three. In *Ribbons*, on the other hand, shadows tend to become elongated and sharp, as on a hot summer's day when the light-source is bright and almost overhead. Here Dogançay makes a nod to the calligraphic traditions of the Middle East. In *Cones*, which perhaps lie furthest from the experience of the street, we see repeated rolled-paper motifs organized as a kind of field-effect that we are sure we have never seen. In these works Dogançay the formal painter gets properly into his stride. The large 1987 work *Symphony in Blue*, to mention the most rigorous and extensive case, shows how a composition based on multiple optical illusions, arranged in equal and repeated parts, can give a painting a subtle and very contemporary life. And then there is *Alexander's Walls*, a series that has a specific source in a walk down Third Avenue one afternoon in 1995, where Alexander's department store was found by Dogançay and his wife to be boarded up, then painted blue for cosmetic effect, and then covered over with black paper in an effort to conceal the disorderly surfaces beneath. The *Alexander* works may seem to come closest to the appearance of stylish Minimalist paintings current some two decades before. However, they no longer register as belonging to that artistic manner, thanks to the power of the documentary motive that charts the ups and downs of rapid commercial turnover in the midtown city, now rendered almost comment-free inside the work of art.

A certain logic of transcription, in that case, appears to be the abiding quality of the project that has occupied Dogançay for so long. While carefully guarding his independence from trends in art, he has been happy to associate with several of those who gravitated to the street; he has exhibited with Jacques Villeglé twice, in 2008 and 2009. But I do not doubt that Dogançay has acted like a sponge to something of New York's philosophical culture during the period of his rising artistic fame. Here for instance is Marshall Berman, accounting for the experience of the modern city, specifically New York, in a widely read book of 1987. It is, Berman argues, one in which all human activity is exposed to vast forces clashing uncontrollably; forces that are characteristic of the city and most intensified there; forces in which, as Marx had put it apropos the 19th-century city, "new-fangled sources of wealth, by some weird spell, are turned into sources of want"; in which, to repeat his famous dictum, "everything seems pregnant with its contrary."[12]

12 Marshall Berman, *All That Is Solid Melts Into Air: The Experience of Modernity*, Verso, London 1987, pp. 18, 20.

And sometimes we feel that, in celebrating urban surfaces while observing the unleashed forces that have caused them, Dogançay has modulated his attitude in the direction of a more openly political stance.

And yet a certain skepticism with regard to the coherency of the urban sign has also been pervasive throughout the period since Baudelaire. Here is Jean Baudrillard in the 1970s, trying to codify the abstract operations of the money economy and giving vent to his suspicion that the urban 'real' was in danger of disappearing under pressure from its own simulations; and once again it is New York that is in the frame. "Now the whole of everyday political, social, historical, economic reality is incorporated into the simulative dimension of hyperrealism," Baudrillard writes. "We already live out the 'aesthetic' hallucination of reality. The old saying 'reality is stranger than fiction,' which belonged to the Surrealist phase of the aestheticization of life, has been surpassed."[13] And finally, I like to imagine that the artist learned something from Jane Jacobs, the urban theorist whose book *The Death and Life of Great American Cities* came out in 1961, just as *The Art of Assemblage* was opening in New York, and which immediately became a focus for discussion about how cities should function for their occupants. Jacobs' account held up a mirror to the city street, to argue, vehemently and by example, not only that cities were contradictory but that they should remain so; that city neighborhoods are most engaging when chaotic and diverse; and that dense populations and quickly changing employment patterns are essential to the city's vitality, including the vitality of the sign and the lively disorder into which it was liable to fall. Beginning with his early experience on 86th Street, I suspect that Dogançay has always been aware of what Jacobs describes as "the intricacy of sidewalk use, bringing with it a constant succession of eyes." In her classic book we find her extolling "movement and change … an intricate ballet in which the individual dancers and ensembles all have distinctive parts, and which compose an orderly whole." And the ballet of the street, Jacobs goes on to urge, against the logic of those who would eradicate the mix, "never repeats itself from place to place, and in any one place is always replete with new improvisations."[14] She was describing the experience of the New York that she and Dogançay both knew; and to which, over many decades and with such mastery, he has given all his creative attention and his time.

13 Jean Baudrillard, "Symbolic Exchange and Death" (1976), in *Jean Baudrillard: Selected Writings*, ed. Mark Poster, Stanford University Press, Stanford 1988, p. 144.

14 Jane Jacobs, *The Death and Life of Great American Cities* (1961), Jonathan Cape, London 1962, p. 52.

RICHARD VINE

The Art of Seeing (Through) Walls

What does it mean to mark on exterior walls in a city, and why would a serious artist spend much of his life echoing that sometimes commercial, sometimes governmental, sometimes social-guerrilla activity in the 'higher' mediums of collage, drawing, print-making, painting, and even tapestry design? That is the mystery at the heart of the half-century career of one of Turkey's leading modernists, Burhan Dogançay.

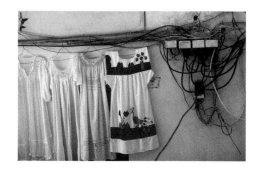

Just how fraught this mode of messaging can be, how charged with interpretive possibilities, is shown by the biblical story of the 'writing on the wall.' In the Book of Daniel, King Belshazzar of Babylon holds a great feast. During the revelry, he calls for sacred vessels of gold and silver, taken from the Temple of Solomon in Jerusalem by his father, Nebuchadnezzar, when he defeated the Israelites and brought them into captivity. Belshazzar's courtiers, wives, and concubines use these now desecrated objects, and within moments a disembodied finger appears, writing a cryptic phrase on a wall of the palace. The king's advisors are confounded, and he resorts to consulting Daniel, a captive Jewish prophet. Daniel tells him that the obscure words should be read as "Thou art weighed in the balance and art found wanting." Before the night is out, Belshazzar is slain and his empire, long under threat, is soon divided between the Medes and Persians.

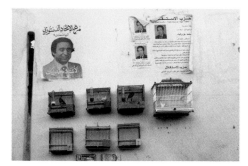

The mysterious, reality-defining logos, especially in the form of writing, has continued to be regarded for centuries as perhaps the purest manifestation of divine will and judgment. ("In the beginning was the Word," says St. John, "and the Word was with God, and the Word was God.") Its occasional link with public walls remains with us today, as we are reminded in "The Sound of Silence" (1964) by American songwriter Paul Simon: "The words of the prophets are written on the subway walls / And tenement halls." Of course, 'prophets' these days tend to be more socio-political than theological. (The major exception, terror-prone religious extremists, have not inspired much contemporary art—unless you count satire and other negative ripostes from liberal artists.) Certainly the agents who have spurred Dogançay's imagination—graffiti writers and poster-pasters—are driven primarily by personal, commercial or societal concerns rather than religious issues. So too were artists like Keith Haring, Kenny Scharf, and Jean-Michel Basquiat, who legitimated street practice and iconography for the professional art world in the 1980s.

What is it about the work of these outsiders (real or self-styled) that would fascinate a man of Dogançay's cultural standing and sophistication? What attracts someone so *urbane* to the gritty and unruly *urban*? It is, I believe, precisely the outlaw temperament of the unknown wall-markers.

From one point of view, this seems unlikely. Dogançay comes from a respectable military family in Ankara. As a young man, he studied economics at the Université de Paris, then worked for years as Director of the Turkish Tourism Department in his homeland and as Director of the Turkish Information Office in New York. He has exhibited his artwork widely and garnered many awards.

Wall in Mexico, 1989

Wall in Morocco, 1984

He is married to a former banker, Angela Hausmann Dogançay, who now manages his business affairs and helps him preside over his own museum in Istanbul. Nevertheless, Dogançay is a man who had to struggle for years—against the demands of social convention, against the cool indifference of the international art system—in order to do his chosen work and live as his truest self.

Again and again, Dogançay confronted walls. First, there was his father's insistence that he train for a 'safe' bourgeois career, half-blocking his artistic training and pursuits. (While at the Université de Paris, Dogançay studied on the side at the Académie de la Grande Chaumière, an independent art school.) Then his professional duties loomed up. (Dogançay sometimes made art in his New York office, during business hours or after.) Only in 1964, at the age of thirty-five, was he able to quit his governmental post and devote himself full-time to art. The émigré painter then faced another barrier, the sheer competitiveness of the New York milieu, which induced a crisis of faith in his own talent and art-career prospects. In 1966, a verbal kick-in-the-pants from Thomas M. Messer, then director of the Guggenheim Museum, helped him break through that wall of despondency.

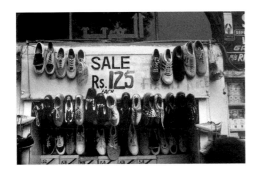

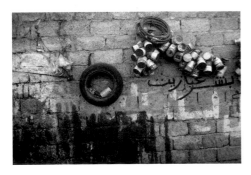

It was, notably, in this period that Dogançay adopted walls as his signature motif. His epiphany occurred in 1963, before a chance 'composition' of torn poster remnants, orange paint, mud and masonry on East 86th Street in Manhattan. Since then, he has traveled the world in search of such rich passages, recording the happy accidents with sketchpad and camera. Meanwhile, he has worked to gain critical acceptance for the term 'wall art', arguing that his examples—and the phenomenon as a whole—are not only esthetically compelling but also, like the modernist abstractions they so often resemble, worthy of critical analysis.

The case is easiest when the source bears clear traces of intentionality. Dogançay's *Gentil Inc.* (1965), for example, reproduces a hand-scrawled list of names and two outline hearts enclosing the names and sentiments of lovers: "Marcelano Loves [indecipherable] True Love" and "Rocco + Shirle." The names, the spellings, the explicit sentiments all suggest low-status backgrounds, street culture, and performative modes of identity. To write on a wall is, after all, to make a public declaration, and the writer's self—even when unnamed or disguised in a *nom de spraycan*—cannot be entirely hidden. Works in the *GREGO Walls Series* (1988–2012) all feature that hipster tag, sometimes accompanied by revealing phrases such as "Loves Hockey and Walls" (*Ice Hockey*, 1993).

Throughout his œuvre, Dogançay evinces a profound respect for the mystique of unseen agency. The individuals who created the vernacular testaments that he records are never revealed, never known. Theirs is an inadvertent art of the people, rising up unbidden and fated to pass unremarked by cultural and political authorities, were it not for Dogançay's intervention—his selection, reproduction, heightening, and exhibition of these anonymous multi-author 'compositions.' In their collective rightness we recognize the social manifestation

Wall in Islamabad, 1988

Wall in Sana, Yemen, 1995

of natural law, a power akin to Adam Smith's invisible hand of the marketplace, or the phantom hand of justice that (ideally, at least) shapes judicial systems.

Directly expressive pieces like *Gentil Inc.* suggest the multiple reasons for which graffitists plant their stylized scrawls in public. The graffiti-writers clearly wish to assert an identity, even if its sign amounts to little more than a contemporary equivalent of an I-was-here handprint on a cavern wall, offering visual proof of physical existence and personal identity. In today's context, however, graffiti is also a challenge to the prevailing social order, a reminder to a city's relatively secure and affluent citizens that there are many others who are disaffected, defiant, and potentially hostile. Such individuals, like their more fortunate compatriots, have a basic need to record—and propagate—the most significant events and feeling in their lives. (Apparently not wishing to overemphasize these sociological elements, Dogançay elides from his archive the countless highly figurative murals to be found in New York and other cities, many of them exalting heroes of Black or Hispanic culture or mourning the victims of drug use and street violence.) Finally, the urban wall-writer is driven by the urge to beautify, by the conviction—however misguided—that his colorful message enhances what is otherwise a destitute or sterile visual environment.

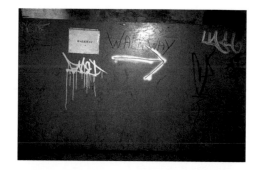

An act so public is not without political ramifications. In Dogançay's *No Trespassing* (1993), a 'Private Property' sign, emblazoned with the titular injunction, is mocked by juxtaposition with an emblem of sexual penetration: a feminine circle-and-cross icon pierced by the shaft of a masculine circle-and-arrow. Whether this is read as a celebration of sex and fertility or as a threat of rape, the graffitist's dismissal of boundaries and privately owned space is unmistakable. The personal and political are melded in transgression. *Spaghetti Brain* (1994) shows a bewildered-looking man's head, its cranium exposed, surrounded by German-language posters evoking political tensions in Asia and Africa, along with a the universal peace symbol—or, rather, an approximation of it, lacking one line and thus resembling the Mercedes-Benz logo with the words "Frieden durch Liebe" (Peace Through Love) distributed in its three fields.

Political intentions can also be inferred, more obliquely, from graffiti artists with a comic bent. Britain's stealthy, pseudonymous Bansky has produced images such as a masked demonstrator with an arm cocked back to hurl not a Molotov cocktail but a bouquet of flowers; a young girl frisking a heavily armed soldier as he stands spread-eagled, facing a wall; and two bobbies passionately kissing on a street corner. In Beijing, during the vast urban renewal push of the late 1990s, Zhang Dali went about condemned neighborhoods, crudely spray-painting his own profile on the walls of buildings slated for demolition. Sometimes he would hammer a hole through the outline of his head to open a view to a new space beyond—a telling metaphor for the losses and gains of China's post-Mao economic reforms and social-engineering projects.

Dogançay, for the most part, forgoes involvement with such politically volatile imagery, choosing instead to concentrate on more amorphous, more

Wall in New York, 1998

Facade of Alexander's Department Store, 1995

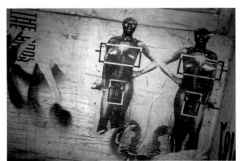

random accumulations of stains, markings, and poster remnants. In series such as *Doors* (1965–2010), *New York Subway Walls* (1967–2002), and *Framed Walls* (2008–ongoing), we see not the assertion of individual personalities or agendas but, rather, the accretion of urban history itself. The window of a closed business has become a virtual billboard for multiple announcements (*Abandoned Restaurant*, 1966); stickers, graffiti, and smears coalesce into a virtual action painting on subway tunnel tiles (*No Future*, 1999); scraps of celebrity photos bring a startling contrast to surrounding debris, flaunting a glamour—and thus a hope of transcendence—denied to the majority, who therefore intensely value these pop-culture icons (*James Dean*, 2008). The universality of this modern phenomenon is attested by the work of other artists in diverse cultures, notably the 1996 photo series *Ruins*, by Beijing's Rong Rong, artfully documenting the tattered pinups that once clung to shattered walls in poor neighborhoods being bulldozed out of existence.

Although Dogançay does not shy away from political references when they are a part of the collective history of a site—slogans like 'Make Love Not War' recur in several languages (*Queens of Hearts*, 2010) and politicians sometimes leap out at us in campaign pictures and words (*Berlusconi*, 2010)—his primary interest lies elsewhere: in the formal serendipity of accumulated shapes, colors, and textures, and in the imaginative flights that these chance juxtapositions can engender. His mentor in this fascination is undoubtedly Leonardo da Vinci, who urged artists to see in wall stains and the complexities of masonry their own fanciful landscapes, battle scenes, human figures, costumes, and faces—a process the Renaissance master found comparable to hearing myriad words in the peeling of bells.

Leonardo's admonition, which on one level may seem simple, almost silly, is in its deeper implications the epitome of Western artistic imaginativeness—the impulse to create something out of nothing, to fill space (that cousin of death's void) with vivid artifacts, to convert scattered retinal data into coherent and meaningful visions, to transform everyday substances (stone, metal, paint, etc.) into tokens of spiritual transcendence. His advice also recalls, in a less expected, less obvious way, the paradoxical use of emptiness in Eastern art—those large vacant areas in traditional paintings, those carefully calibrated distances between sculptural objects that bespeak time, change, and all that transpires in nature, history, and the human heart between one selected visual incident and another.

Dogançay's application of Leonard's principle has taken many forms over the years. The works of the *General Urban Walls Series* (1963–ongoing) follow a cycle from gritty references to formal abstraction and back again. A 1960s-style concern with street life can be seen, for example, in *No Par King* (1966), whose stick-figure drawing and textual reference to the 'royalty' of gang members and hip musicians anticipates Basquiat by two decades. By the 1970s, an interplay among the shapes of letters, tears in paper, and hard shadows had

Wall in Monaco, 1990

Wall in New York, 2009

come to predominate in Dogançay's work, to the near elimination of social allusions, as in *Emerging Zoo* (1974). (Nonetheless, the real world and its messy *cris de cœur* never entirely disappear—witness *Peace Sign in Israel* (1975), with its straightforward antiwar symbols and text.) By the mid-1990s, pictures like *Obsession* (1994) can combine the frivolous (an ad for a men's perfume), the earnest (peace signs again), and the wry (scrawled text reading "Graffiti is Not a Crime"). No aspect of personal or public life, it seems, is excluded from Dogançay's inventory.

Yet the artist has, from time to time, deeply immersed himself in purely formal issues. The series *Breakthrough* (1972–1977) focuses on slashes and tears in a surface paper that reveal, and define shapes on, an underlying sheet of different hue. The color samples that Turkish and Polish workmen daub on walls for their customers to choose are the leitmotif of *Housepainter Walls* (1982–1993). *Ribbons* (1972–1989) reproduces the look of paper torn into strips and mounted on monochrome backgrounds, sometimes creating an Arabic-looking pseudo-calligraphy. *Cones* (1972–1990) engenders the 3D effect of myriad pieces of paper curled into cones on a flat surface. Both of these latter series give co-equal attention to fake shadows, raising the age-old question of what is real and unreal in art, and reminding us how Plato would argue that our apparent reality is populated by mere shadows of the true, transcendent, immaterial Forms.

Even while engaged in these somewhat technical artistic endeavors, Dogançay never divorced himself completely from the turmoil of everyday life, never fully ignored the visual cacophony of the urban environment. Indeed, he seems constantly wary of the seduction of aesthetic distraction. *Doors* exposes the 'self-blinkering' that every socialized individual engages in—and perhaps *must* engage in, if 'normal' life is to proceed. In this series, windows—far from providing visual access to hidden rooms within or the wider world without—keep multiple secrets. Smeared and opaque, covered with signage and added-on postings and inscriptions (*J. Payn Window*, 1966), they offer not transparency and mental liberation, but blockage, obfuscation, and denial. Doors, likewise, are uniformly closed—and often aggressively chained and padlocked (*Green Door*, 1991). Barricades rather than portals, they bespeak all that must be withheld or suppressed, all that must be kept at bay, for a rational social order to prevail.

This is not to say that Dogançay endorses the limitations he observes. He is, after all, a classic *flâneur*—a stroller with a free consciousness. Implicitly rejecting blindness and confinement, especially when self-imposed, he effectively echoes the English mystic, poet, and artist William Blake, who protests in *The Marriage of Heaven and Hell* (1793): "If the doors of perception were cleansed every thing would appear to man as it is, infinite. For man has closed himself up, till he sees all things through narrow chinks of his cavern." Obviously linked to the ancient notion of the wandering prophet, the *flâneur*-seer has a

Wall in Yugoslavia, 1988

Wall in Hungary, 1988

distinguished modern lineage, stretching from the 19th-century French poet Charles Baudelaire, who advocated uncensored emotional candor and artistic modernity, to numerous 20th-century figures: the German-Jewish thinker Walter Benjamin, finding tomes of history, economics, and philosophy embodied in the streets and arcades of Paris; the Situationists, a politically radical international group whose members would occasionally open up their minds through an aimless perambulation known as the *dérive*; and the American writer Jack Kerouac, whose novels such as *On the Road* (1957) and *The Dharma Bums* (1958) turn footloose observation into a hip spiritual quest. For these seekers, the process of life itself has a beauty—and perhaps a cumulative meaning, however random or enigmatic.

Dogançay frequently addresses inhibitions to free movement and clear sight. His *Detours Series* (1966–1995) records a wide variety of detour signs, which, against their cluttered backgrounds, suggest a prohibition of thought and a forced redirection of feelings toward safer—or at least more publicly acceptable—intellectual and emotional domains. *Alexander's Walls* (1995–2000) reflects both the strange beauty and the visual frustration that Dogançay experienced when confronting the black paper used to wrap the abandoned Alexander's department store in midtown Manhattan. Pasted to plywood, the paper made a strangely attractive shroud for a once vital center of commerce, an emporium of the sort that Benjamin found both infused with the past and pregnant with the socio-economic future. *Formula 1* (1990–1991), with its snatches of bright signage and ad images peeking out around wide black swaths, emulates the horizontal lengths of black plastic applied along the race route in Monaco to keep Grand Prix drivers from being distracted. Reality, as all of these examples attest, has a way of defying every attempt to mask it.

Probably no antecedent is more relevant to Dogançay's project than the British writer Aldous Huxley, who in his 1954 book *The Doors of Perception* maintained that everyday life conditions us to ignore or channel down the vast majority of our sense perceptions, much as a reducing valve delimits and controls the rush of water. It is as though, he wrote, there were a door in a wall, beyond which lies a vast unexplored world. Having experimented with mescaline, Huxley was convinced that certain psychotropic drugs can throw open that door, putting us in a state of utter receptiveness both to sensual data and to unorthodox mental associations—a visionary state that is exceptional for most people but common for artists. The post-enlightenment condition he describes could be a biographical sketch of Dogançay in his mature artistic phase: "The man who comes back through the Door in the Wall will never be quite the same as the man who went out. He will be wiser but less cocksure, happier but less self-satisfied, humbler in acknowledging his ignorance yet better equipped to understand the relationship of words to things, of systematic reasoning to the unfathomable Mystery which it tries, forever vainly, to comprehend."

Perhaps it is this wisdom, along with a large body of work of exceptional skill, that major institutions have come to recognize in the later stages of Dogançay's career. In addition to numerous prizes and medals, the artist has been honored with solo exhibitions at the Centre Georges Pompidou, Paris (*Les murs murmurent, ils crient, il chantent...* in 1982), and the State Russian Museum, St. Petersburg (*Walls and Doors* in 1992), as well as a career survey at the Dolmabahçe Cultural Center, Istanbul (*Burhan Dogançay: A Retrospective* in 2001). Now, with the spring 2012 appearance of *Fifty Years of Urban Walls* at İstanbul Modern, the importance of his lifelong theme can be duly appreciated.

An irony, or at least a certain art-historical spiraling, is at play behind Dogançay's signature obsession. From Paleolithic cave paintings to the reliefs of Egypt and other early civilizations, from the murals of Greece and Rome to the tapestries and chapel paintings of Europe in the Gothic age, Western art was largely at one with the walls that, in both a literal and figurative sense, *supported* all that was most sacred—whether the domestic enclave, the imperial court, or the ceremonial precincts of the gods. Only in recent centuries did the discrete, portable picture, independent of context, become the dominant art form in a society that has since grown increasingly mobile and increasingly addicted to the mass circulation of images.

But wall painting, it seems, is too natural, and too expressively valid, to entirely die. Diego Rivera, José Orozco, and David Siqueiros in Mexico, along with the WPA muralists in the U.S., sought to reground their work in a particular place and culture. In a similar fashion, Dogançay moves art forward by, in a sense, moving it back—by returning to the fixed wall and to markings sprung from an urgent local or personal need. Yet he does so in a fully informed manner, sensitive to the realities of the historical moment. Reflecting an era of instant communication and global consciousness, he casts his homage in free-floating art forms (prints, drawings, paintings, and photographs) that can easily transport the signs of one cultural milieu into another—from a grubby subway tunnel in Brooklyn, say, to a pristine museum space in Istanbul—thus speeding and abetting comprehension between disparate peoples.

Walls have played many parts in the global image repertoire. Artists sometimes emphasize their capacity to exclude and protect, sometimes their structural function; concern may center on their ability to confine, or on their freestanding grace. Yet walls gain their greatest notoriety when they fail—the walls of Jericho tumbling before Joshua's army as it invades Canaan after the Egyptian exodus; Hadrian's Wall, completed in the 2nd century AD and slowly losing its power to enforce Roman rule in Britain; the Great Wall of China broached by the Mongols in the 13th century and the Manchus in the 17th; France's futile Maginot Line, swiftly flanked by the Germans in 1940; the Berlin Wall, overrun in 1989 after twenty-eight years of separating the city's Communist sector from the West; ineffectual walls erected today between Israel and the Palestinian West Bank, and between the United States and Mexico.

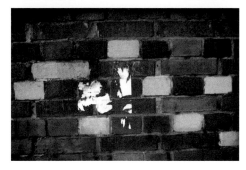

It would seem that poet Robert Frost was right: "Something there is that doesn't love a wall, / That wants it down ..." The art of Burhan Dogançay contributes to a long, ongoing human struggle to combat the forces of division, to open the places and peoples of the world to one another, and to employ art as a universal language that can speak across—and ultimately dissolve—the very walls on which it appears.

New York Subway Wall, 1999

Wall in New York, 1988

CLIVE GIBOIRE

Dogançay's Series: Content & Technique

From 1963, when Dogançay first decided to focus exclusively on urban walls, the art he has produced has been grouped into series, starting with *General Urban Walls* and followed by thirteen others. Some of these series, such as the first one, are ongoing. Others are not. Some series have sub-series, or have at least branched off as detours, forming self-contained groups within the group. It is the very nature of Dogançay's work to surprise us—sometimes playfully, other times perplexingly—and to break the rules that he has established. Thus, as the years have passed, some ongoing series have begun to overlap one another.

Roy Moyer wrote: "All of Dogançay's work is an exploration of his concern with the tragic, the defaced, the false, and the abandoned … His are city paintings, evoking the decay and destruction of the city, the alienated feeling that urban life is in ruins and out of control, and that we cannot put the pieces together again."* Often Dogançay portrays the residue or debris of events that are over, happenings that are long gone, revealing what has been left behind once passion has evaporated, feeling has ended, or life has simply moved forward. Part of the intrinsic spirit of his work is to suggest that nothing is *ever* what it seems.

Dogançay's art is wall art and thus his source is real. Therefore he can hardly be labeled as an abstract artist even though on first acquaintance much of his work appears to be abstract. An atmosphere of conflict between abstraction and realism prevails in the post-Abstract-Expressionist art world and its solution has been of special concern to artists. One argument of modern artists is that technically painting should be considered abstraction—after all what does it primarily consist of other than lines, masses, and colors on canvas or other materials? Yet by varying techniques, painting is able to present reality at any point between the poles of abstraction and picture-perfect realism—and Dogançay works in varying positions between those two poles to present his own notion of reality. Moyer notes that Dogançay has never abandoned realism. He has simply adapted it to an abstract format. In this way, he has been able to resolve both his personal and the more general artistic quest of our time.

Any discussion of Dogançay's series should not only touch on his creative approach and content, but also examine the abundant, and often ingenious, techniques he has developed to transform what he has observed publicly into private, personal statements. Most of the techniques that Dogançay uses to present reality as he perceives it are derived from the very processes to which walls are subjected: *One person writes on a wall. Others comment by adding more scribbles or drawings that may be amorous, ironic, comic, ribald or possibly obscene. Another comes along and scratches out or modifies what has been drafted. Posters are pasted up; later they are defaced, pasted over with another, or torn down. Signs appear. Light casts shadows. Time is forever taking its toll. There is wear and more tear—inflicted both by people and the elements. And so the process continues in an endless, accidental show.* Dogançay more often than not mixes media *con brio*. He may incorporate *objets trouvés*, even affix staples or strings or ropes to cast

* This and all other quotations in this text are taken from the essays that Roy Moyer contributed to the monograph *Dogançay*, published by Hudson Hills Press, New York, in 1986.

shadows on some works or apply smoke—*fumage*—to others. He cannot resist deftly creating *tromp l'œil* effects. Collage is paramount in much of his work, as he feels it is the perfect means to reflect realistically the look of urban walls by irrationally joining various foreign realities on a common ground, just as they become joined on walls themselves. Ofttimes, the large worktables in his studio resemble some sophisticated adult play school as he creates surfaces—scratching, rubbing, gluing, tearing, stenciling, spraying, and also spilling liquids to create patterns and textures—to capture his subject.

Dogançay may have started out as a simple observer and recorder of walls, but he fast made a transition to points where he could express a wide spectrum of ideas, feelings, and emotions in his work. As his vision continued to broaden, series have come into being, driven both by content and technique. This retrospective exhibition, which brings all fourteen series together, clearly shows how close is the bond between Dogançay's content and technique—even to the point that in some series, such as *Breakthrough*, *Ribbons*, and *Cones*, technique has almost become one with the subject in intensity and emotion.

I

General Urban Walls

1963–ongoing

Dogançay was first drawn to urban walls by their beauty, spontaneity, directness, and temporal relevance. He affirms, "Every artist is interested in walls because they mirror and are part of our society." The paintings in this first series started with literal renditions of urban walls, as an attempt to record both their explicit historical evidence—of events, actions, and emotions that had passed—and the inherent beauty of chance composition. Some of the early works eloquently captured what Dogançay had encountered in the street: "Abstract Expressionism acted upon by the elements, painted by nature herself, and selected for its casual beauty."

From that reservoir he began to transform the public walls he had observed into his very own private ones. These signature walls, which increasingly made use of mixed media, especially collage, bear witness to all sorts of messages such as 'No War,' 'Graffiti is Not a Crime,' 'Frieden durch Liebe' (Peace Through Love), and the quintessential 'Post No Bills.' Frequently other languages come into play, when Dogançay incorporates material he has gathered on his world travels. Defaced political propaganda figures alongside endless names, drawings, and scribbles. The compositions, which usually fill the canvas from edge to edge, are sometimes somber and dingy, while others are brightly colored. Through the incorporation of references to political, societal, philosophical, moral, and artistic currents and mores, the works may evoke humor, poignancy, or run a whole gamut of other emotions and feelings.

1
BILLBOARD. 1964
Gouache and collage on cardboard
58.1 x 50.2 cm (22.9 x 19.8 in.)
The Solomon R. Guggenheim Museum, New York,
Consular Corps Committee of the City of New York,
Department of Public Events

2
GENTIL INC. 1965
Oil on canvas
76.2 x 61 cm (30 x 24 in.)
Dogançay Museum, Istanbul

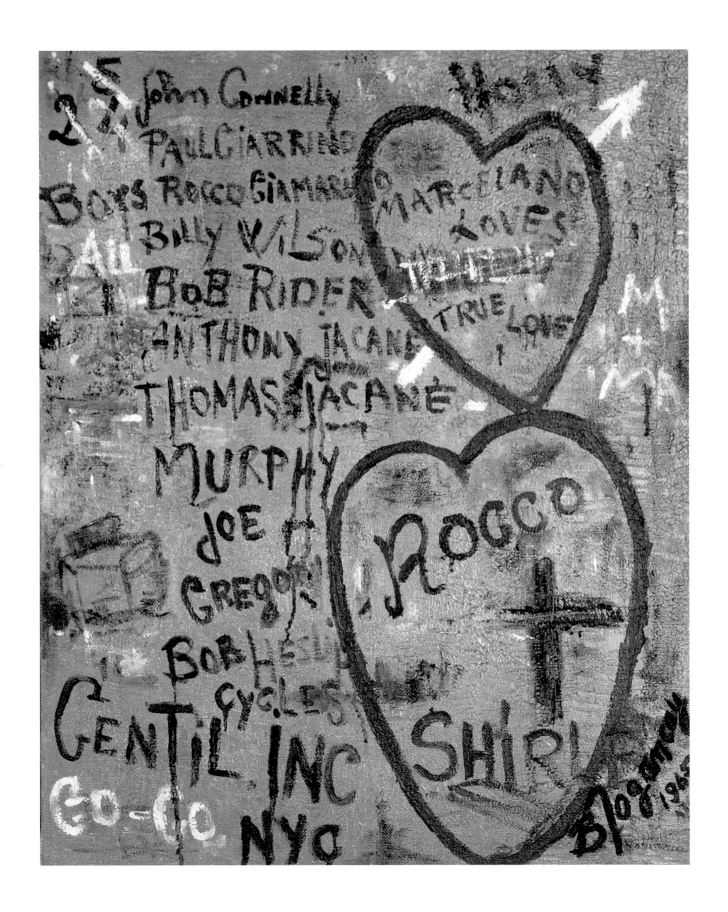

3
BARRY GOLDWATER. 1965–1989
Collage, acrylic and fumage on canvas
127 x 88 cm (50 x 34.6 in.)
Collection of the artist

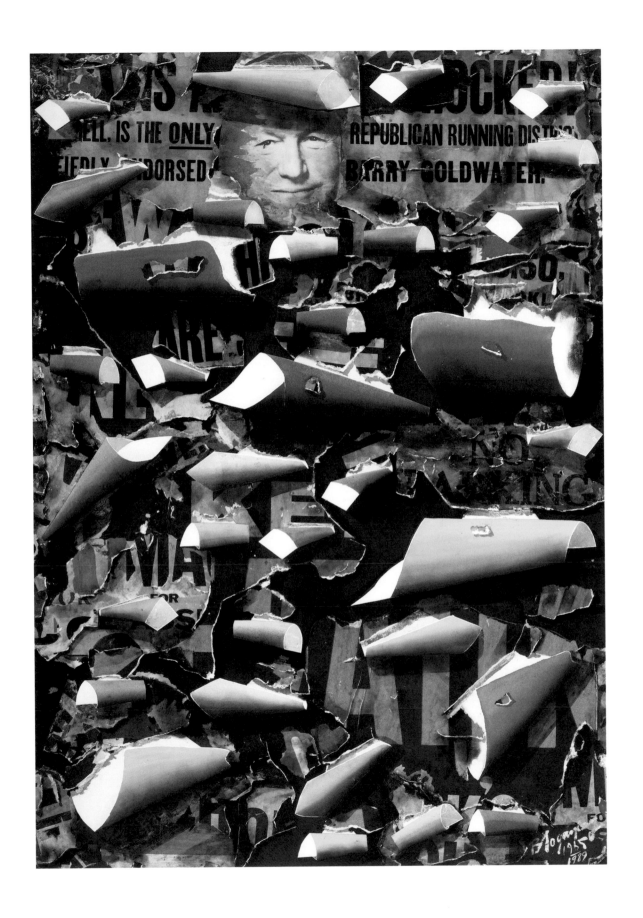

4
BARBRA. 1965
Oil and collage on canvas
76.2 x 61 cm (30 x 24 in.)
Dr. Nejat F. Eczacıbaşı Foundation Collection

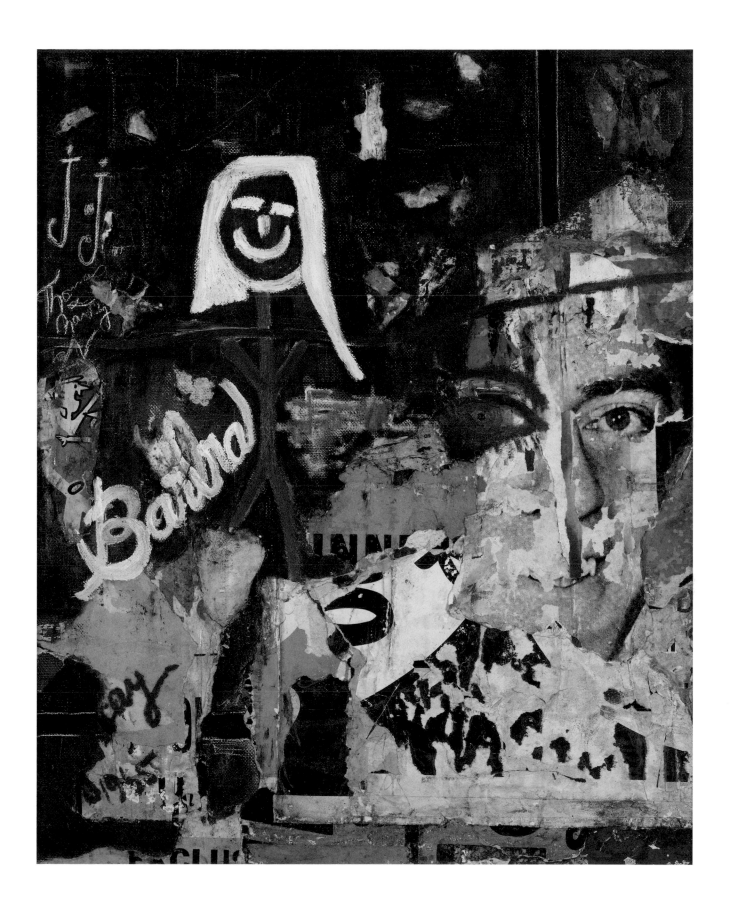

5
CHIPPED WALL. 1966
Oil and sand on canvas
122 x 122 cm (48 x 48 in.)
Dogançay Museum, Istanbul

6
NO PAR KING. 1966
Oil on canvas
61 x 76.2 cm (24 x 30 in.)
Collection of Kennedy Museum of Art,
Ohio University, USA

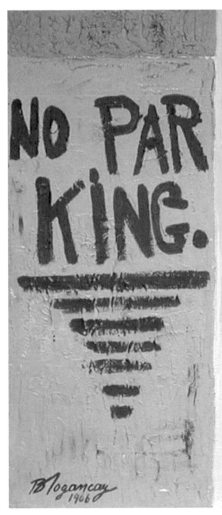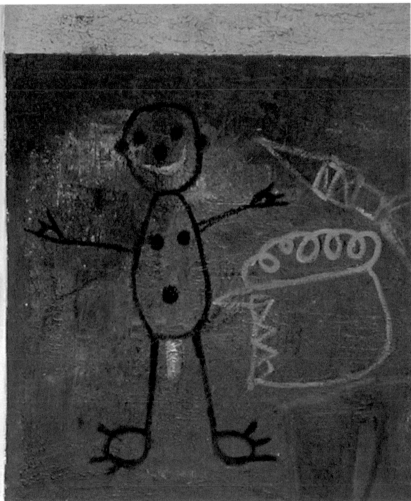

7
DETERIORATION. 1966
Oil and collage on canvas
152.4 x 203.2 cm (60 x 80 in.)
Collection of Kennedy Museum of Art,
Ohio University, USA

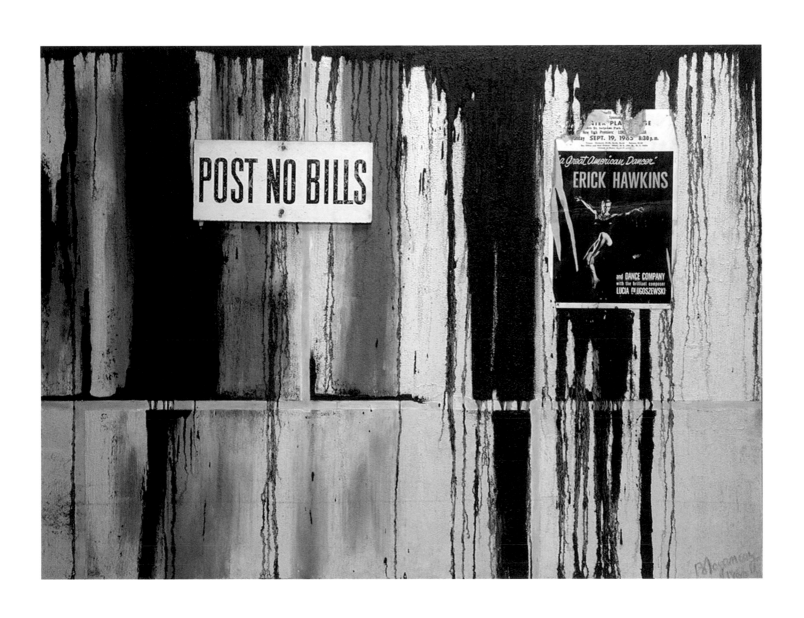

8
NO. 2 WALL: FREE AGAIN. 1966
Oil, collage and mixed media on canvas
152.4 x 203.2 cm (60 x 80 in.)
Georgia Museum of Art, University of Georgia
Gift of Nuri Eren

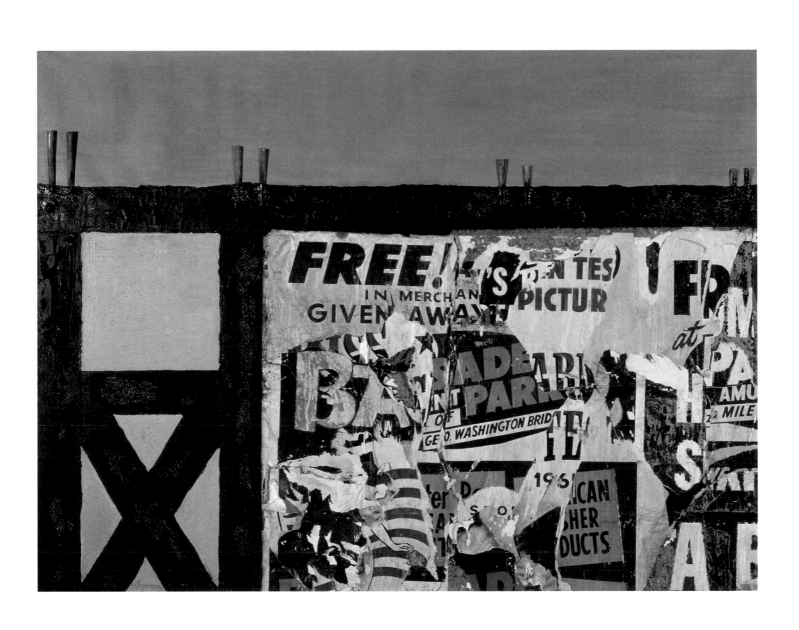

9
OFF. 1966
Oil and mixed media on canvas and Masonite
122 x 203.2 cm (48 x 80 in.)
The Snite Museum of Art,
University of Notre Dame

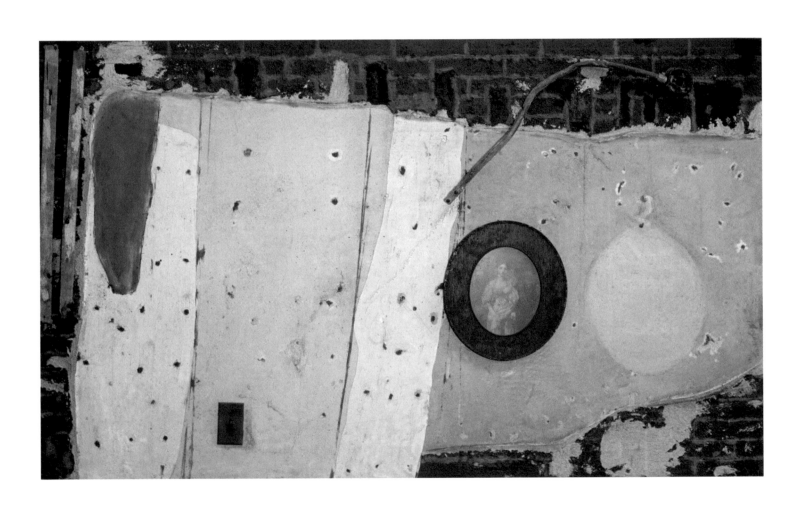

10
JOHNSON & HUMPHREY II. 1967
Oil on canvas
121 x 121 cm (47.6 x 47.6 in.)
Collection of the artist

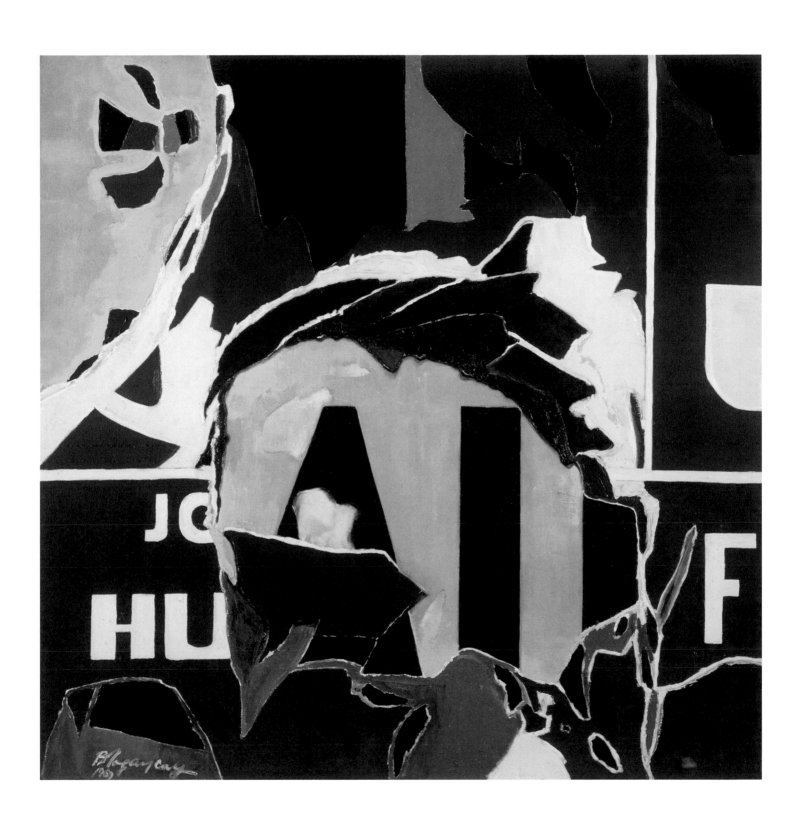

11
IN THE BEGINNING. 1969
Oil on canvas
101 x 76 cm (40 x 29.9 in.)
Collection of the artist

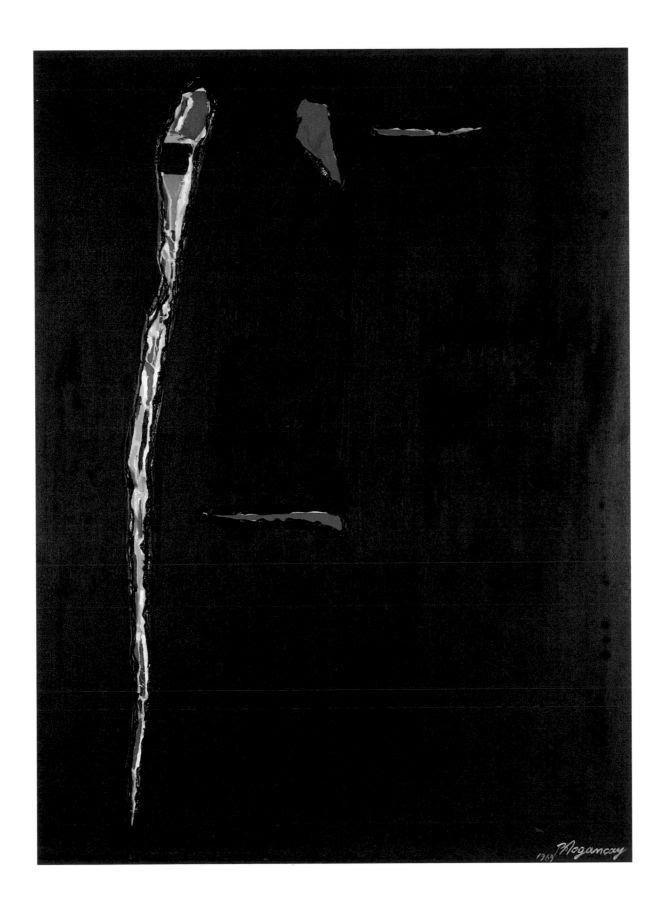

12
NEW YORK PUZZLE. 1969
Oil on canvas
122 x 122 cm (48 x 48 in.)
Staatsgalerie Stuttgart

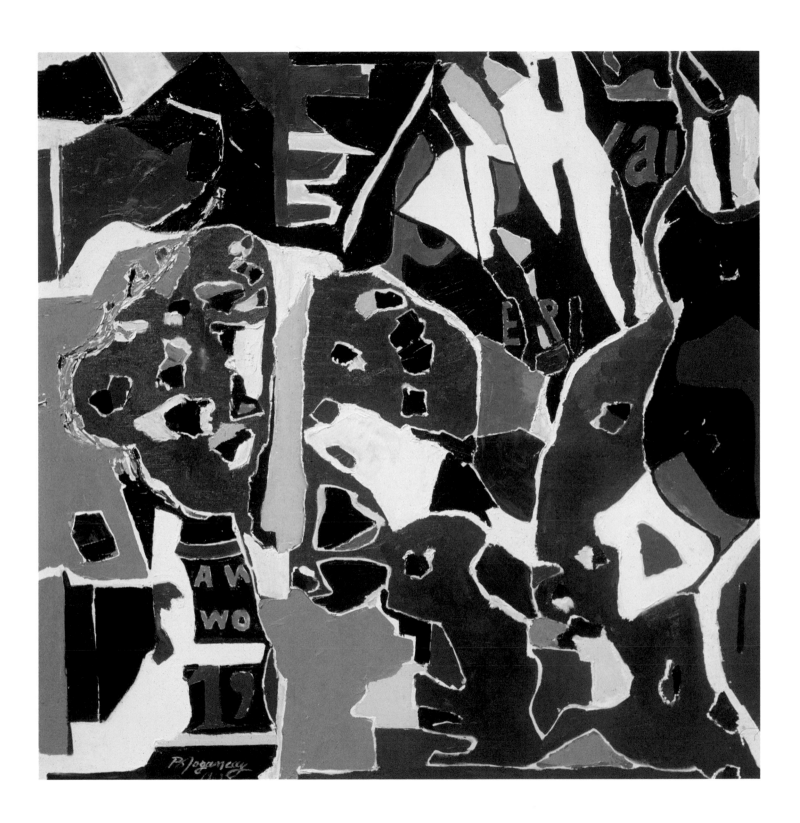

13
COMPOSITION: TORN POSTER. 1970
Acrylic and sand on canvas
152.4 x 127 cm (60 x 50 in.)
Private collection, Switzerland

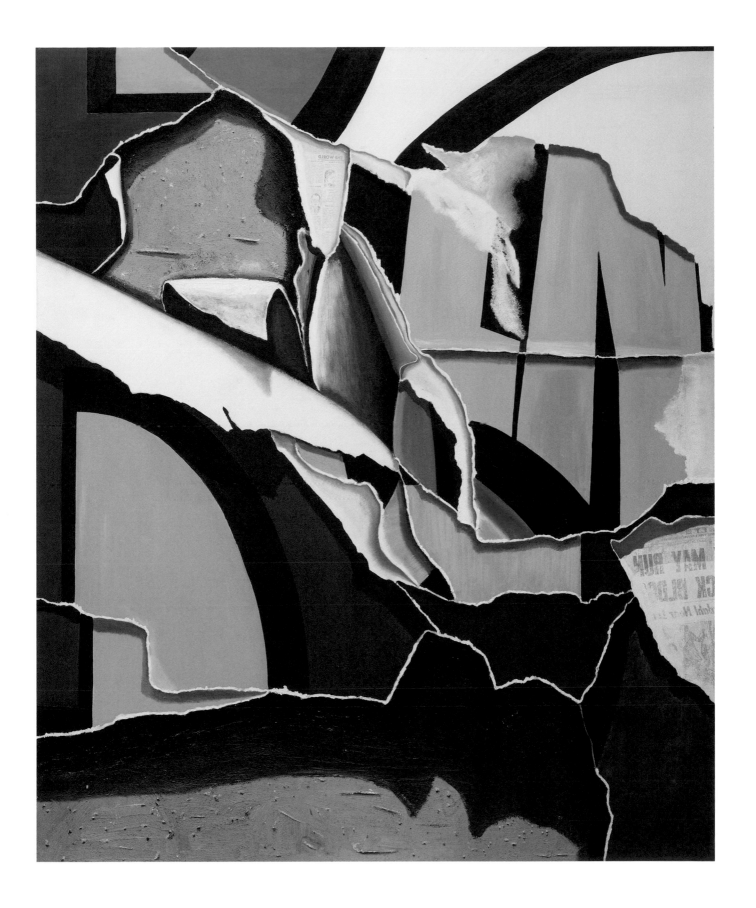

14
FROM WALLS 70: NO. 45. 1970
Acrylic on canvas
152.4 x 152.4 cm (60 x 60 in.)
Dr. Nejat F. Eczacıbaşı Foundation Collection

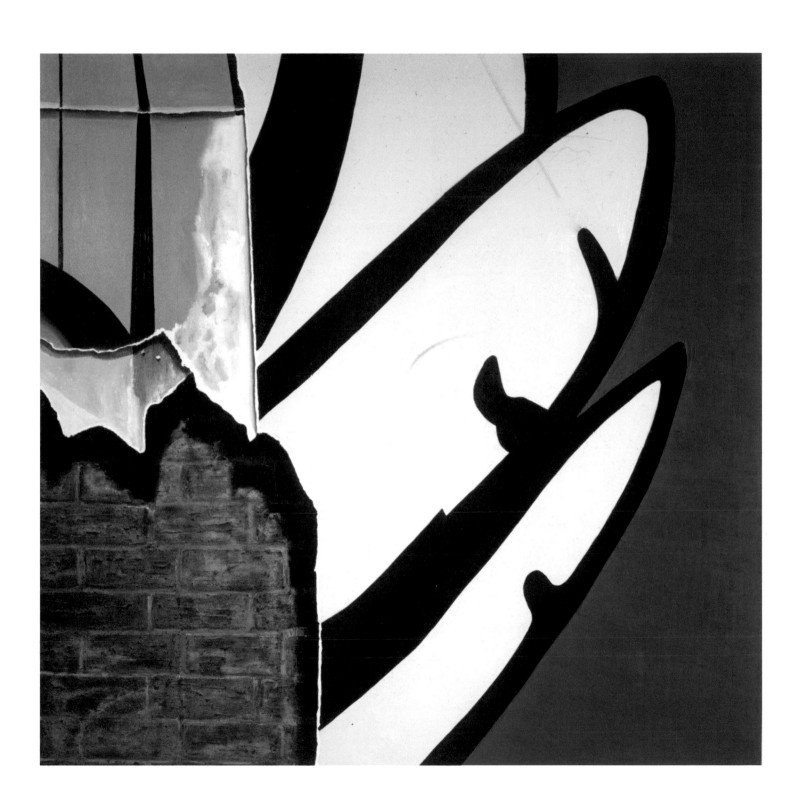

15
DOUBLE O. 1970
Acrylic on canvas
127 x 127 cm (50 x 50 in.)
Collection Benjamin Kaufmann, Zurich

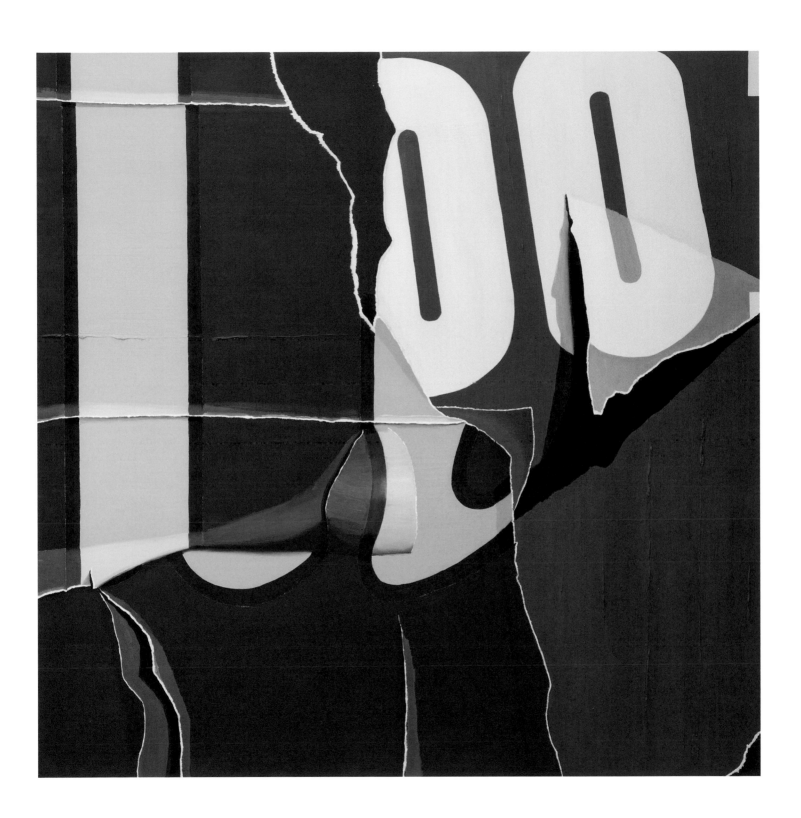

16
MAGIC FIVE. 1970
Acrylic on canvas
122 x 122 cm (48 x 48 in.)
Öner Kocabeyoğlu Collection

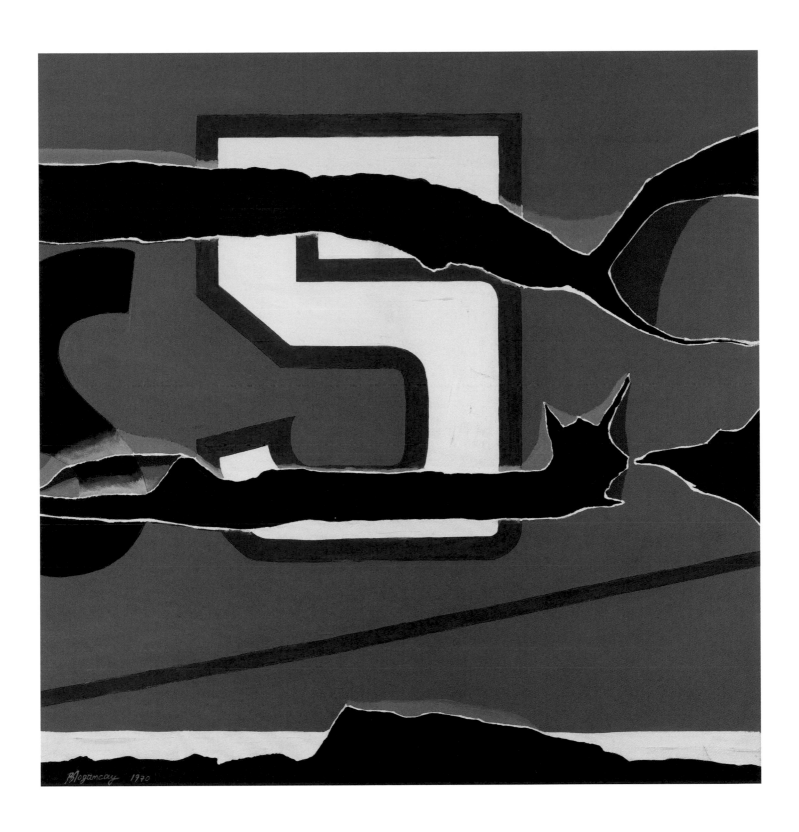

17
WALLS 71: NO. 23. 1971
Acrylic and sand on canvas
152.4 x 152.4 cm (60 x 60 in.)
Private collection

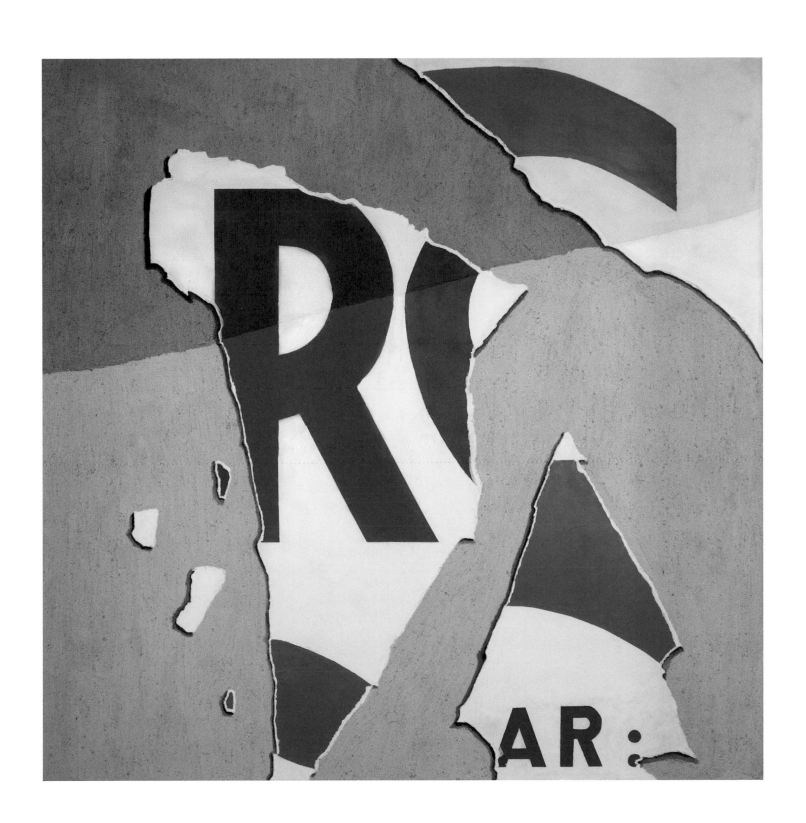

18
SIX & FIVE. 1972
Acrylic on canvas
152.4 x 152.4 cm (60 x 60 in.)
Dr. Nejat F. Eczacıbaşı Foundation Collection

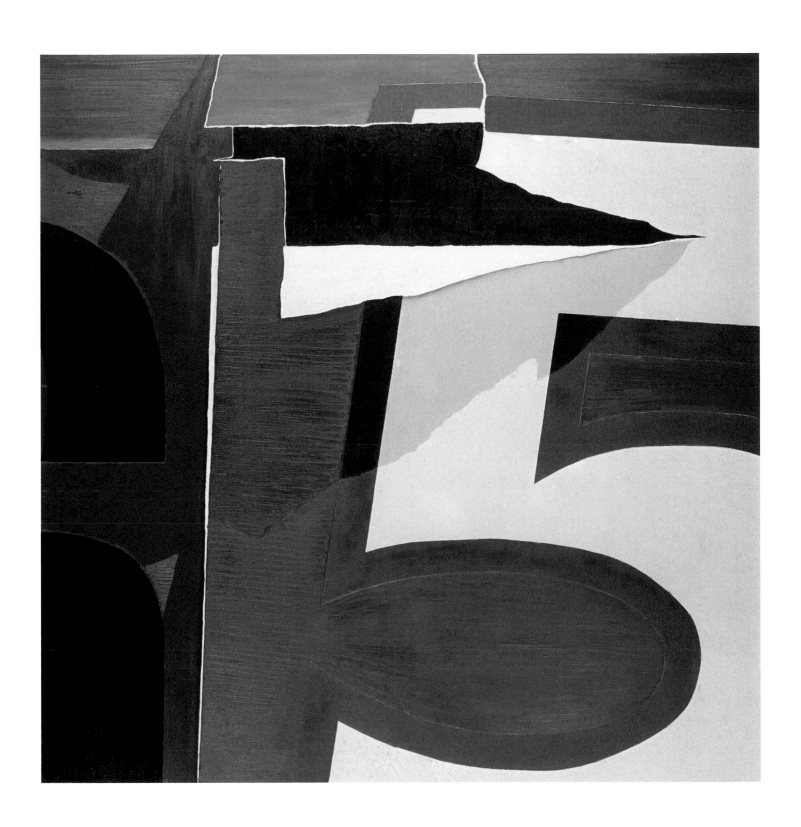

19
TRIANGLE A LA CHASE. 1972
Acrylic on canvas
127 x 89 cm (50 x 35 in.)
Casa dell'arte Collection

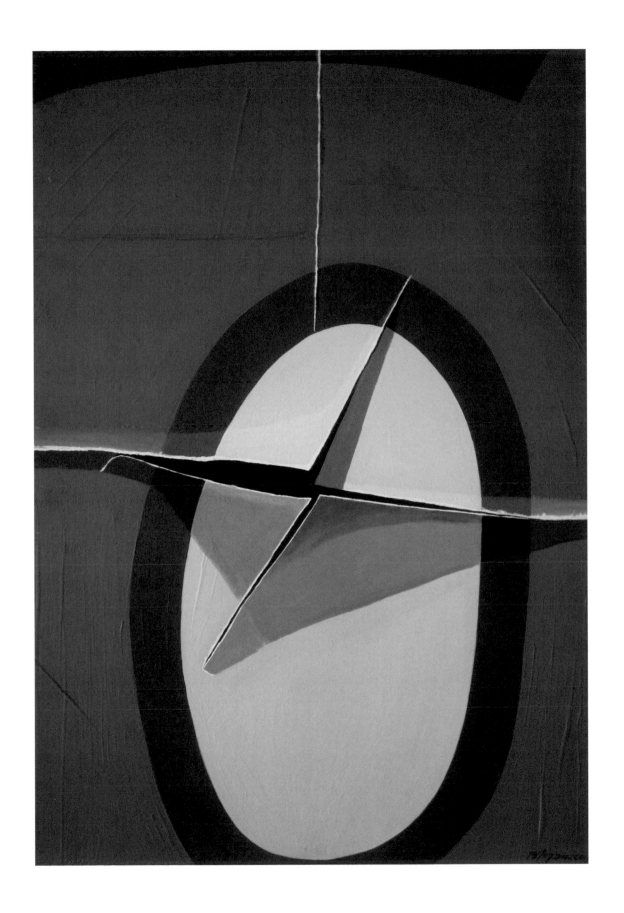

20
EMERGING ZOO. 1974
Acrylic on canvas
127 x 88.9 cm (50 x 35 in.)
Collection of Kennedy Museum of Art,
Ohio University, USA

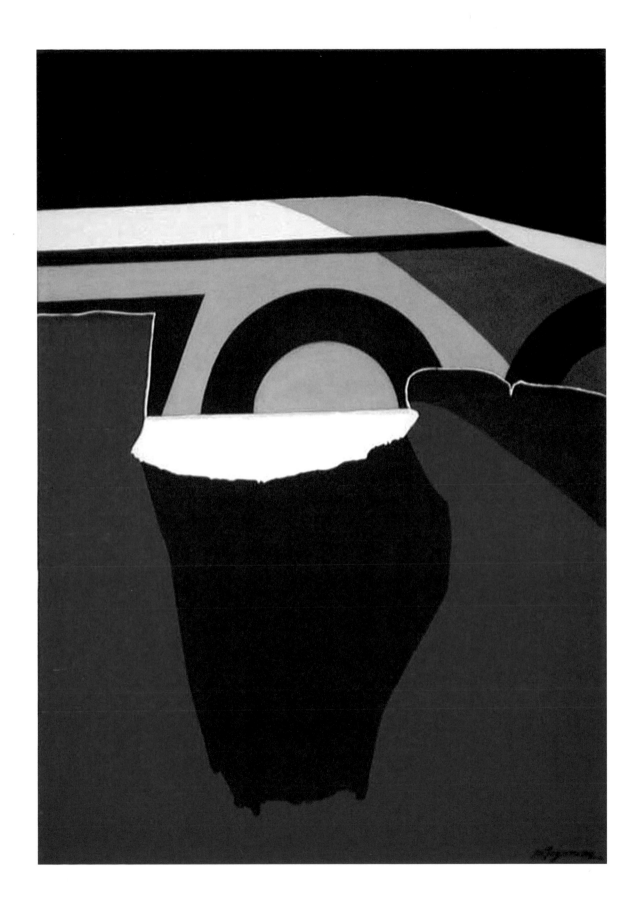

21

PEACE SIGN IN ISRAEL. 1975

Acrylic, collage and sand on canvas

122 x 122 cm (48 x 48 in.)

Collection of the artist

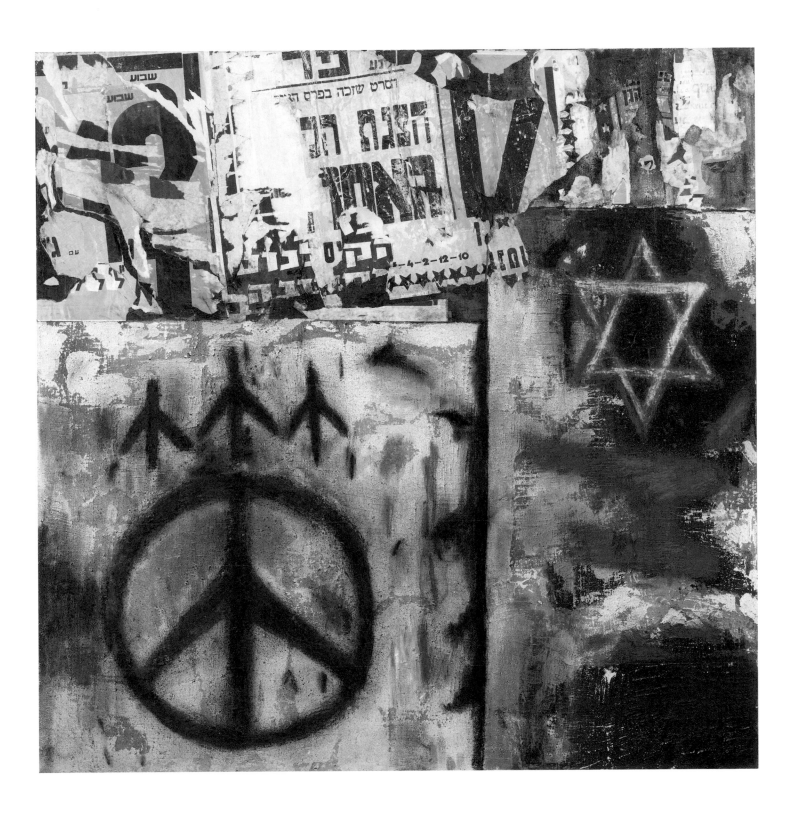

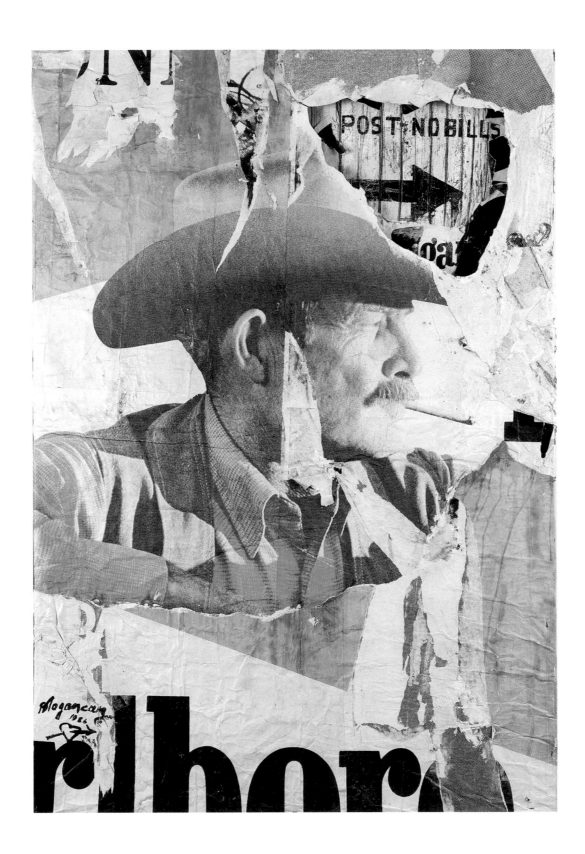

23
BLUE SWISS WALL. 1993
Collage, acrylic, staples and mixed media on
wood panels mounted on canvas
152.4 x 127 cm (60 x 50 in.)
Collection of the artist

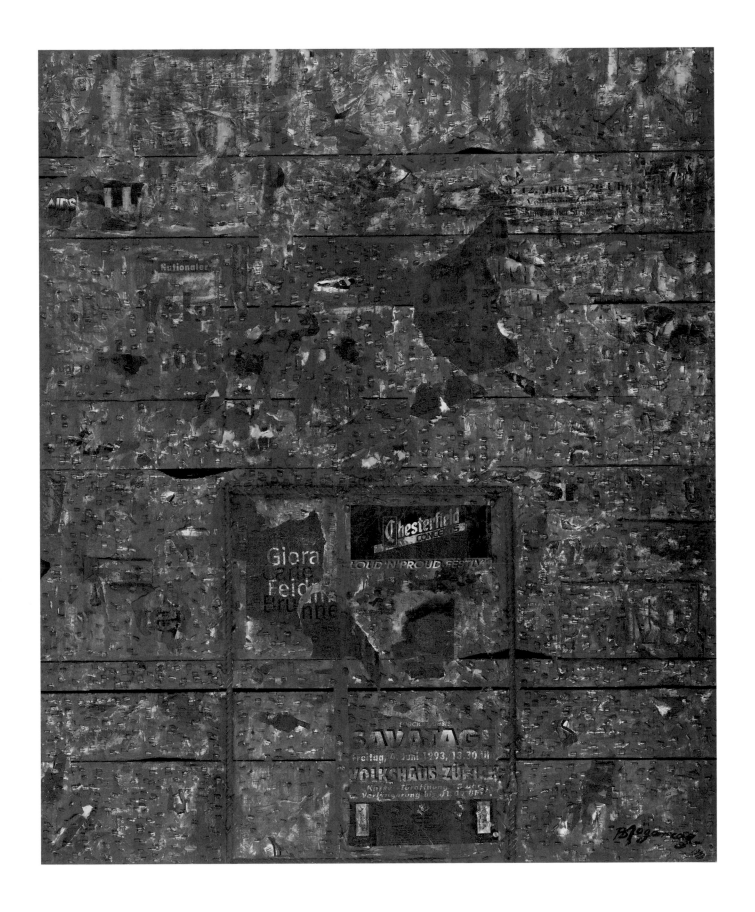

24
SWISS HOLOZAN. 1993
Collage, staples and coffee stains on
wood panels mounted on canvas
152 x 127 cm (59.8 x 50 in.)
Collection of the artist

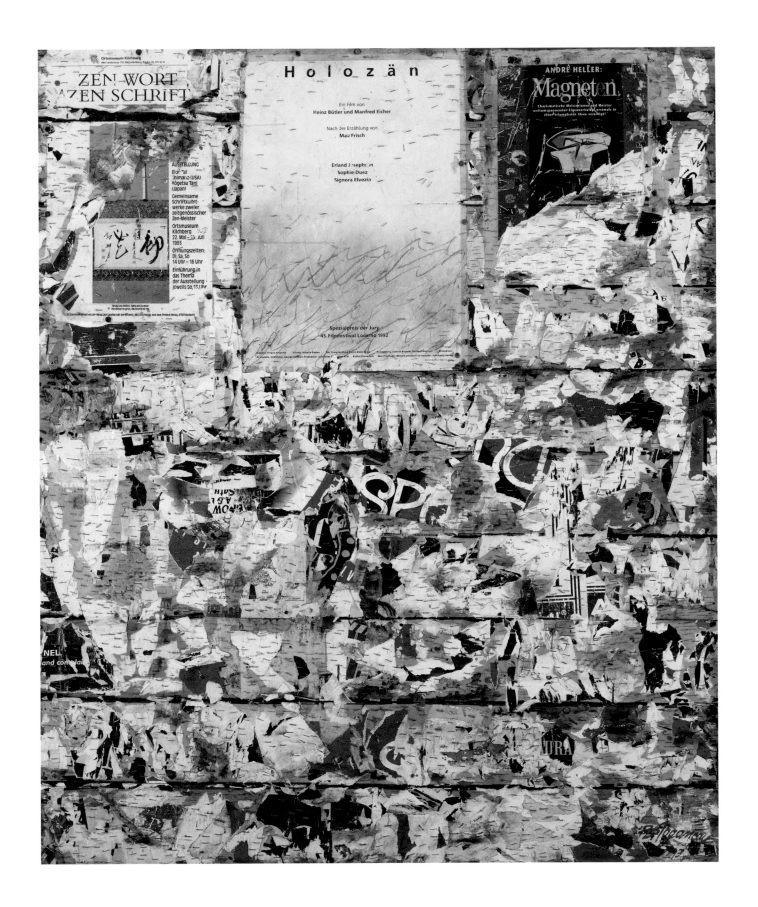

25
SWISS WALL II. 1994
Acrylic, collage and mixed media on
wood panels mounted on canvas
127 x 152.4 cm (50 x 60 in.)
Collection of Kennedy Museum of Art,
Ohio University, USA

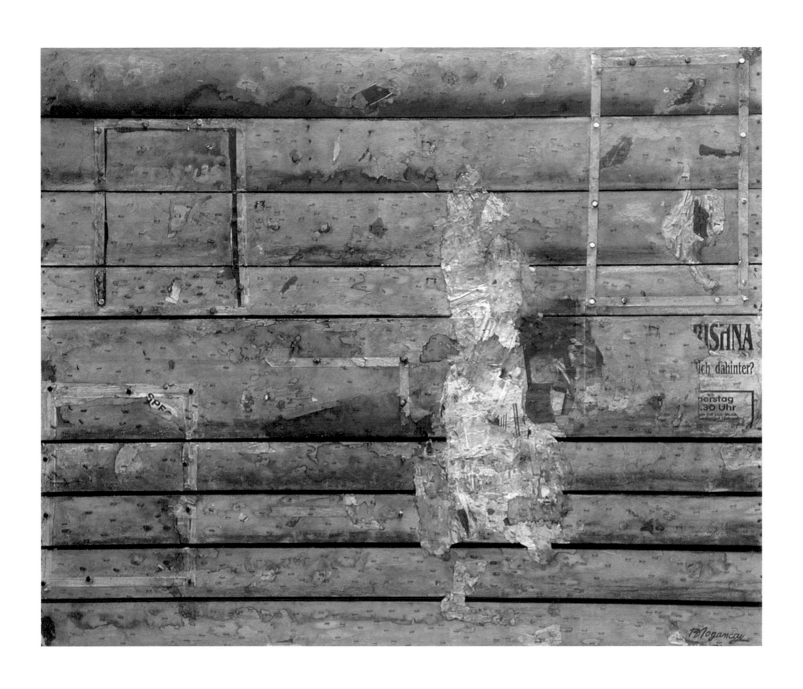

26
OBSESSION. 1994
Acrylic, collage, wood and coffee stains on canvas
147.3 x 188 cm (58 x 74 in.)
Collection of the artist

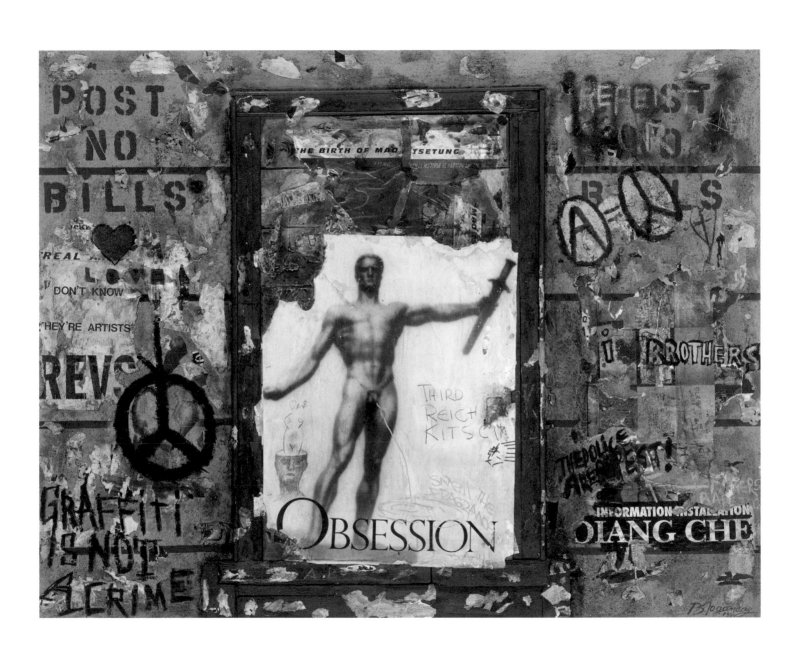

27
SPAGHETTI BRAIN. 1994
Collage, acrylic and mixed media on
wood panels mounted on canvas
127 x 153 cm (50 x 60.2 in.)
Collection of the artist

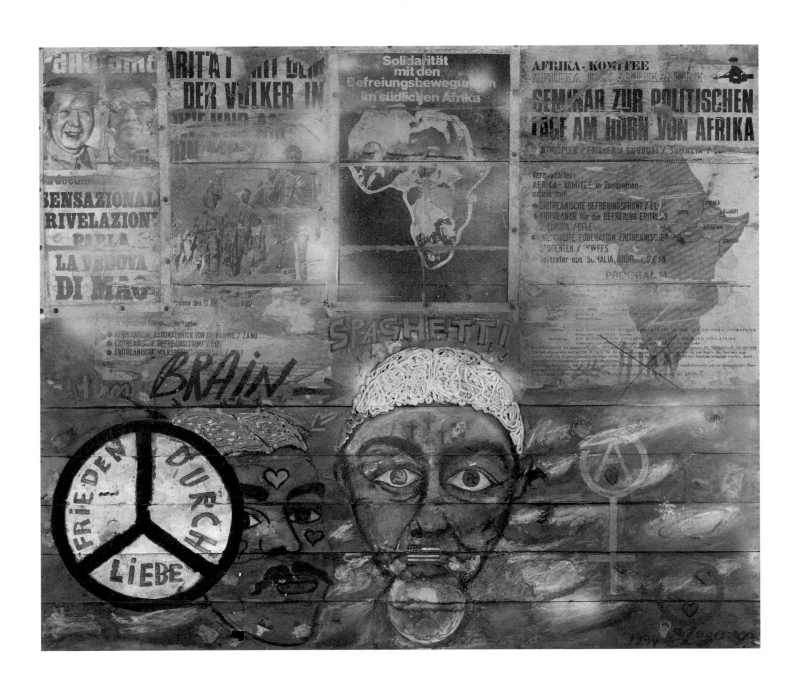

II

Doors

1965–2010

Mevlana Jelaluddin Rumi, the 13th-century Persian poet and mystic, wrote:

> *They say doors and windows may be opened from heart to heart, from mind to mind. But there is no need for doors and windows, if there are no walls.*

Doors form an integral part of walls, so not surprisingly they were the focus of the second series Dogançay conceived. Some doors in his *Doors Series* appear to be transformed *objets trouvés,* possibly rescued from demolition sites, but actually each work has been created painstakingly from scratch. There are single doors and double doors, often complete with doorknobs or handles, locks and hinges, possibly with padlocks and chains. They come in various shapes and sizes. Graffiti covers some and profuse collage others. There are bright and colorful ones, while others are more minimalist or conservative, even elegant. Dogançay's doors are not usually portals that open to other places beyond, and what lies beyond them—if anything—seems of little importance. They are simply doors for doors' sake; doors that have served their purpose—that promise nothing further, though their presence is everything. Each one seems to have a tale to tell, yet we can only surmise what it might be.

Where there are walls and doors, there are inevitably windows. As part of the *Doors Series,* Dogançay created three windows, one of which was later acquired by the Pinakothek der Moderne, Munich, and another one by the Walker Art Center, Minneapolis.

28
ABANDONED RESTAURANT. 1966
Painted wood frame, stickers, adhesive tape
and acrylic on Plexiglas
85 x 115 cm (33.5 x 45.3 in.)
Bayerische Staatsgemäldesammlungen-
Pinakothek der Moderne München
Donation to the American Patrons of the Pinakothek

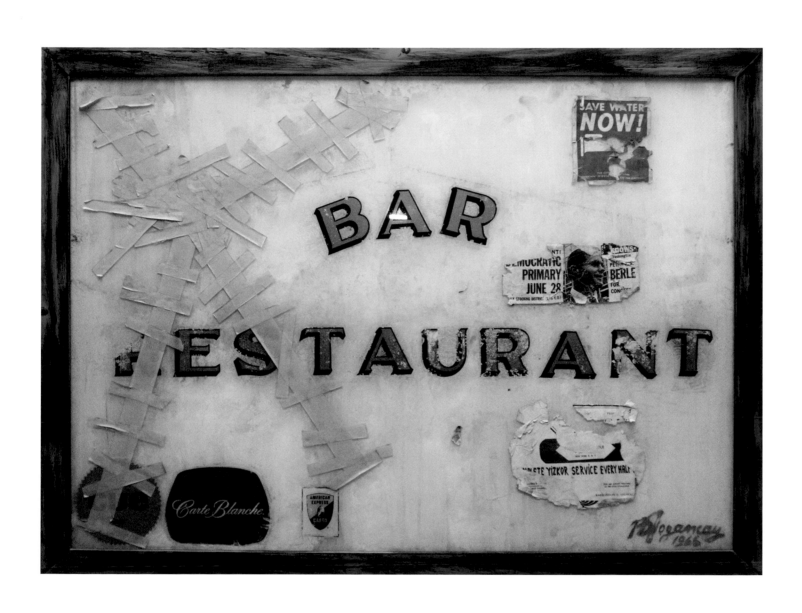

29
J. PAYN WINDOW. 1966
Painted wood frame and acrylic on Plexiglas
85 x 115 cm (33.5 x 45.3 in.)
Collection Walker Art Center, Minneapolis
Donated by Chanda Alseth in honor of
Marilyn Carlson-Nelson, 2010

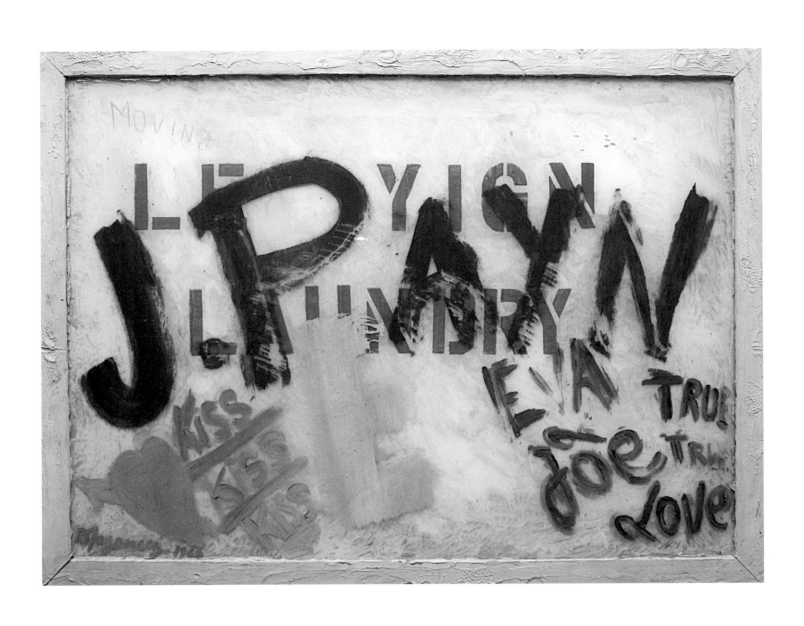

30
GREEN DOOR. 1991
Acrylic, chain, lock, hinge, velvet cloth,
Plexiglas, sand and wood on canvas
158 x 101.6 cm (62.2 x 40 in.)
Dogançay Museum, Istanbul

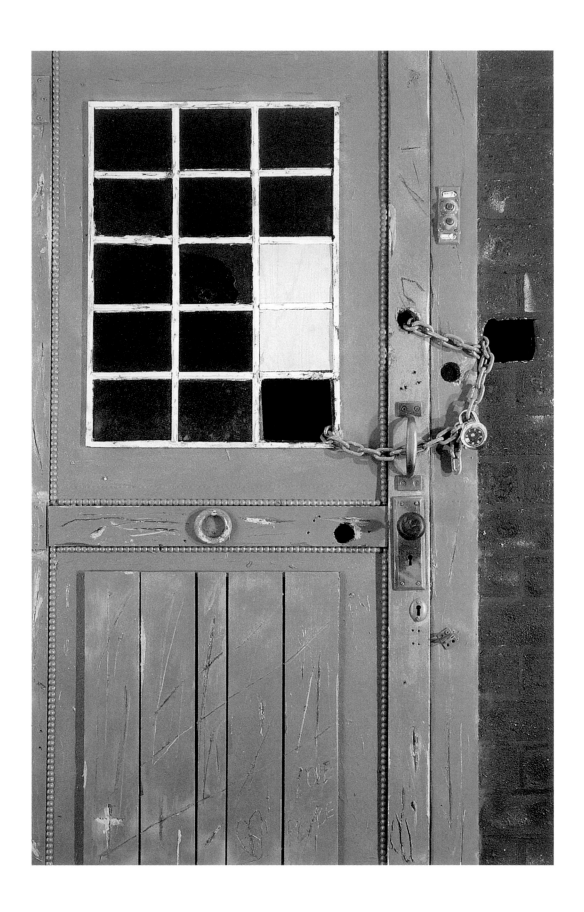

31
DEAD MEAT. 1991
Acrylic, metal doorknob, Plexiglas and
mixed media on canvas
155 x 75 cm (61 x 29.5 in.)
Dr. Nejat F. Eczacıbaşı Foundation Collection

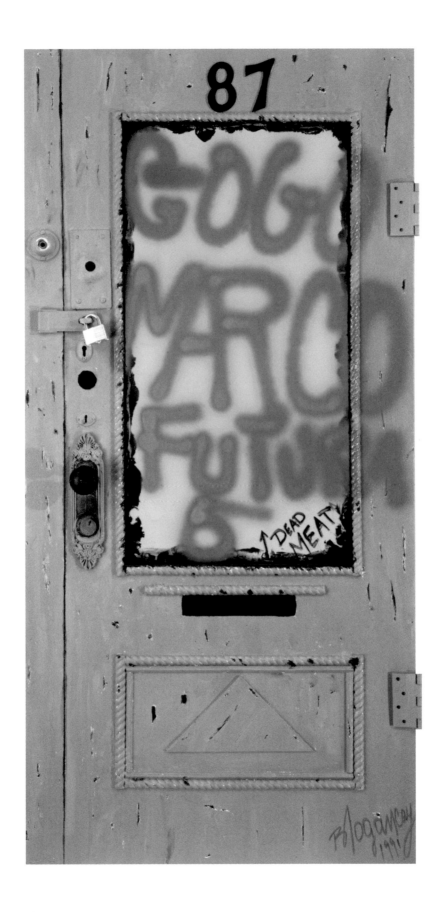

32
3 LONG 2 SHORT. 1991
Acrylic, metal doorknob, sticker and
mixed media on canvas
155 x 100 cm (61 x 39.4 in.)
Dr. Nejat F. Eczacıbaşı Foundation Collection

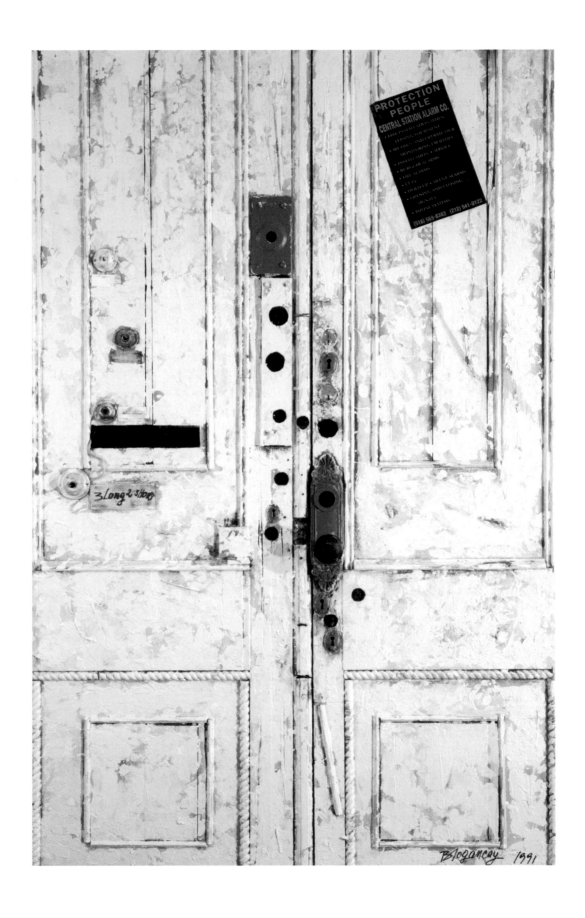

33
MIDNIGHT BLUE. 1991
Acrylic, chain, lock and mixed media on canvas
155 x 87.5 cm (61 x 34.4 in.)
Dr. Nejat F. Eczacıbaşı Foundation Collection

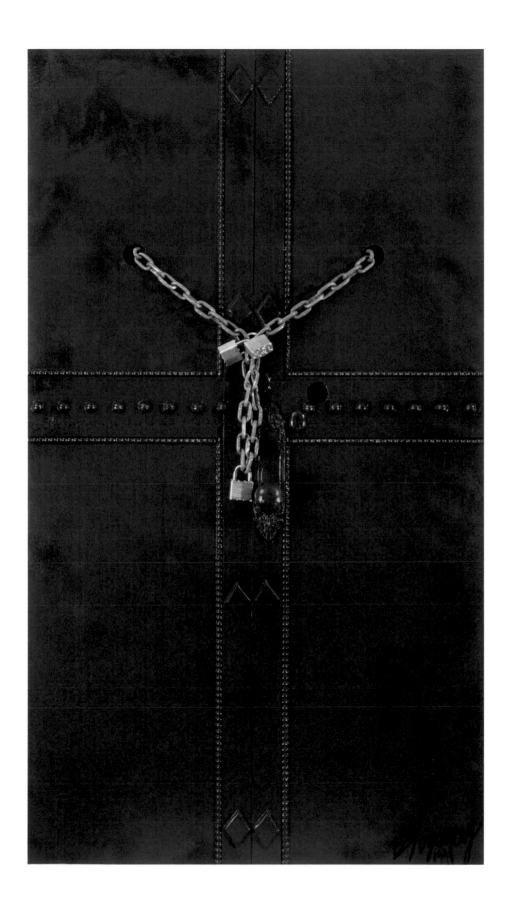

34
LITTLE ODESSA. 1993
Collage, acrylic, metal door handles,
metal house number sign, Plexiglas and
mixed media on canvas
177.8 x 127 cm (70 x 50 in.)
Dr. Nejat F. Eczacıbaşı Foundation Collection

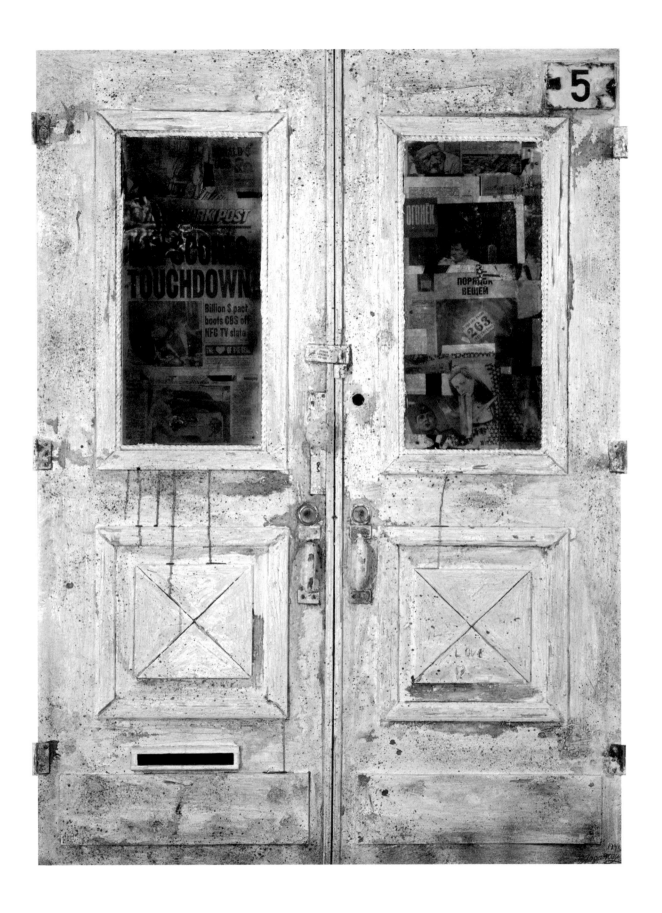

35
BEWARE. 1993
Collage, acrylic, metal door handle and
mixed media on canvas
127 x 152.4 cm (50 x 60 in.)
Dr. Nejat F. Eczacıbaşı Foundation Collection

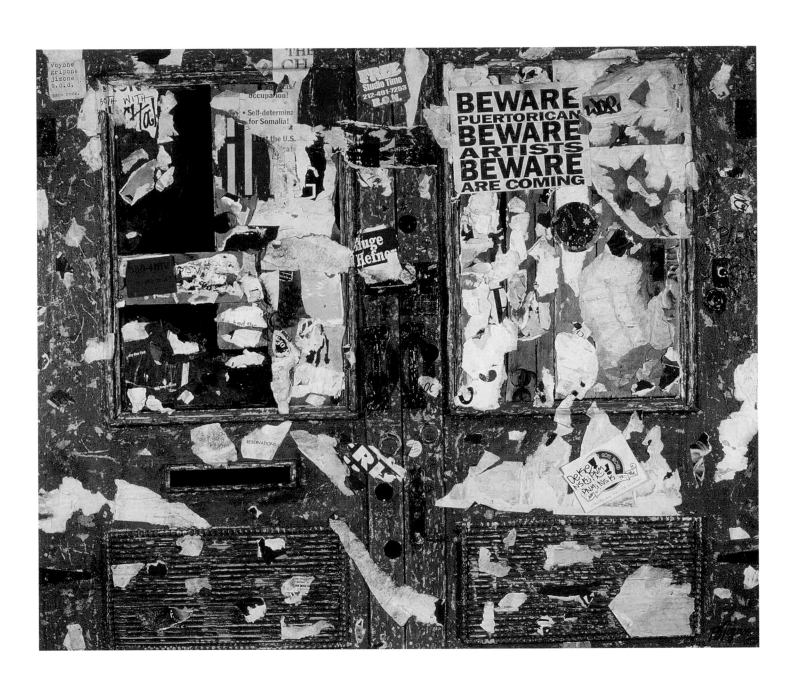

36
GATEWAY TO GUYANA. 1994
Acrylic metal hinges, coffee stains and
mixed media on canvas
188 x 228.6 cm (74 x 90 in.)
Dr. Nejat F. Eczacıbaşı Foundation Collection

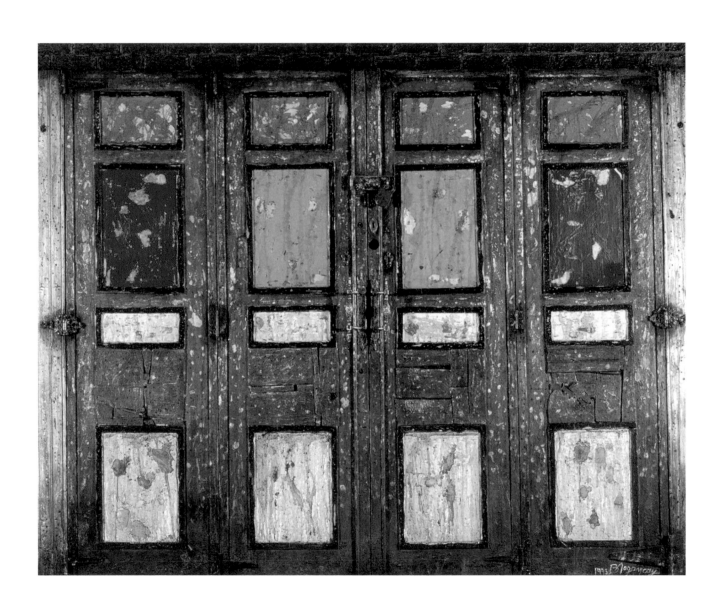

Detours

1966–1995

In her 1994 essay "Dogançay: A Heroic Quest,"* Eleanor Flomenhaft wrote: "Detours are the twists and turns that all our lives must and will take. As a subject for a series, life's many meanderings had already begun to excite Dogançay by 1966." While he created a handful of works in his *Detours Series* in the mid-1960s, it was only in the 1990s that he revisited this concept with renewed focus and vigor. In the interim, during which he had been traveling the highways and byways of intense creative process, on some level the word 'Detour' had no doubt become empowered with additional significance for him.

The early *Detours* works were part and parcel of the *General Urban Walls Series,* but the 1990s *Detours* emerged as a distinctive, freestanding group of their own. Inspired by those wooden barriers or fences that are prominently erected to announce an alternate route in the road with the word 'Detour' and arrows to indicate the direction to follow, the later paintings are less restrained and tend to be more elaborate. They are all distinguished by what appear to be a grid of horizontally placed planks or boards, created by acrylic, mixed media with collage, and most often with wooden panels mounted on canvas.

Unlike the *Doors,* closed and sealed to the past, that seem to exist only in the here and now, the *Detours* paintings not only open up our recent past— questioning where we have just arrived from—but also point tantalizingly towards the unseen, a yet unknown, future to which we are heading.

37
DETOUR. 1966
Oil and mixed media on canvas strips
mounted on wood
122 x 122 cm (48 x 48 in.)
Private collection, Düsseldorf

* Introduction to the catalogue *Dogançay: Doors & Walls*, edited by Eleanor Flomenhaft and Clive Giboire, published in 1994 to accompany an exhibition at the Nicholas Alexander Gallery in SoHo, New York.

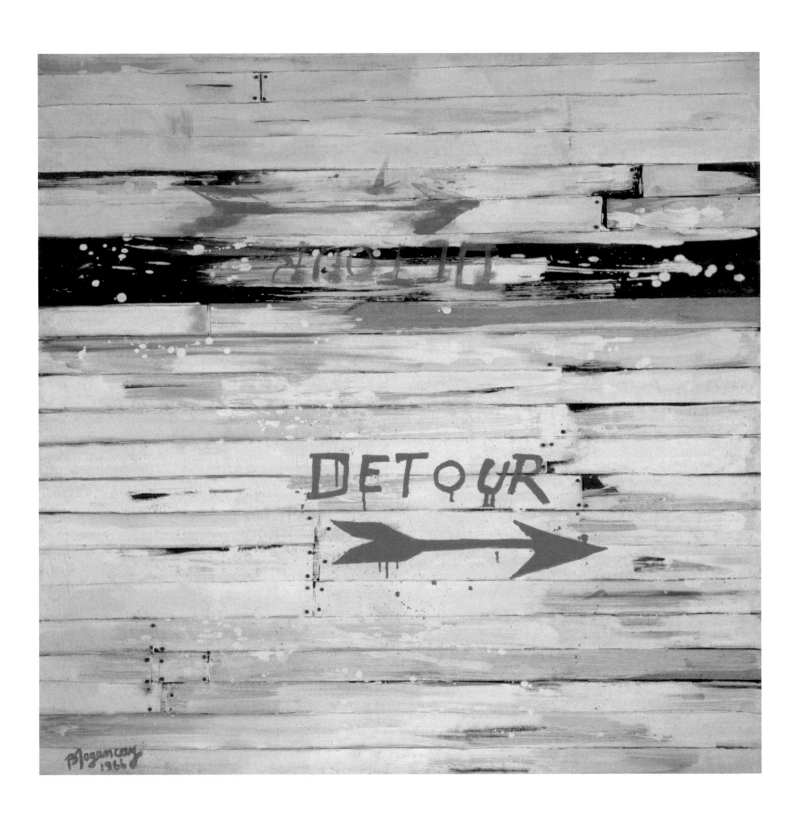

38
DETOUR V. 1994
Acrylic and mixed media on canvas
127 x 152.4 cm (50 x 60 in.)
Collection Musée de Grenoble

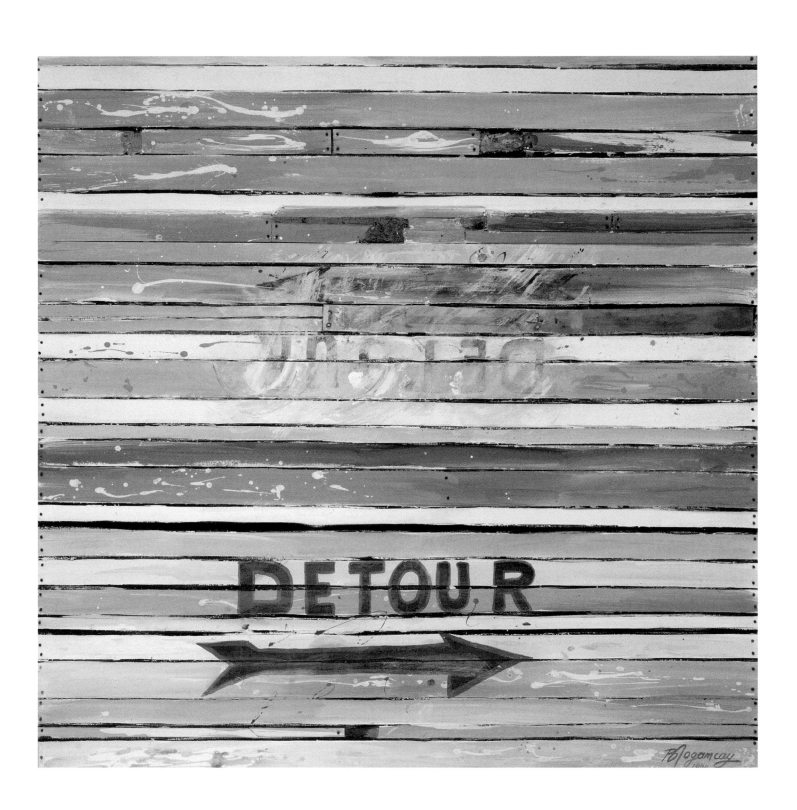

39
DETOUR EXIT. 1994
Acrylic, collage and mixed media on canvas
127 x 152.4 cm (50 x 60 in.)
Collection of Kennedy Museum of Art,
Ohio University, USA

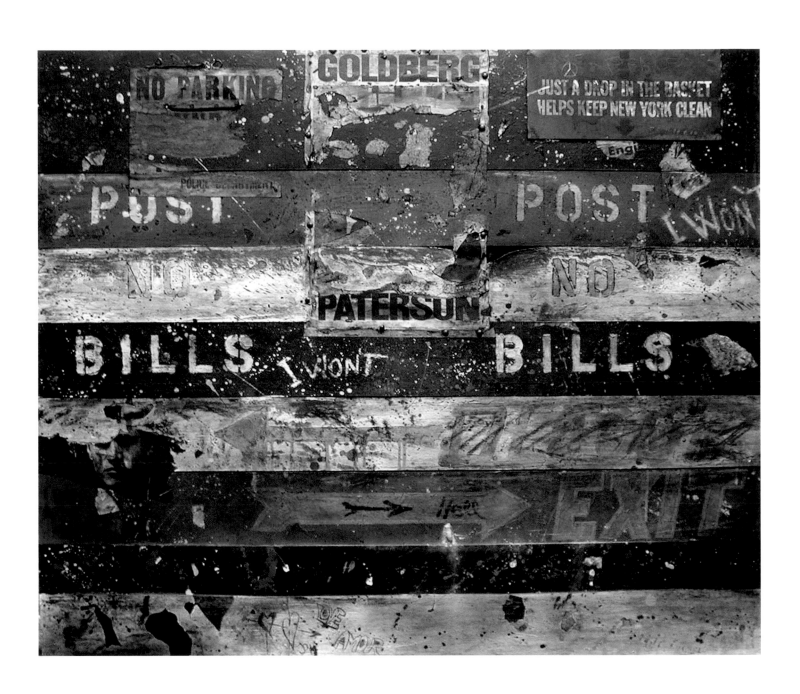

40
AFİŞ YAPIŞTIRMAK. 1995
Collage, acrylic and mixed media on
wood panels mounted on canvas
130 x 162 cm (51.2 x 63.8 in.)
Collection of the artist

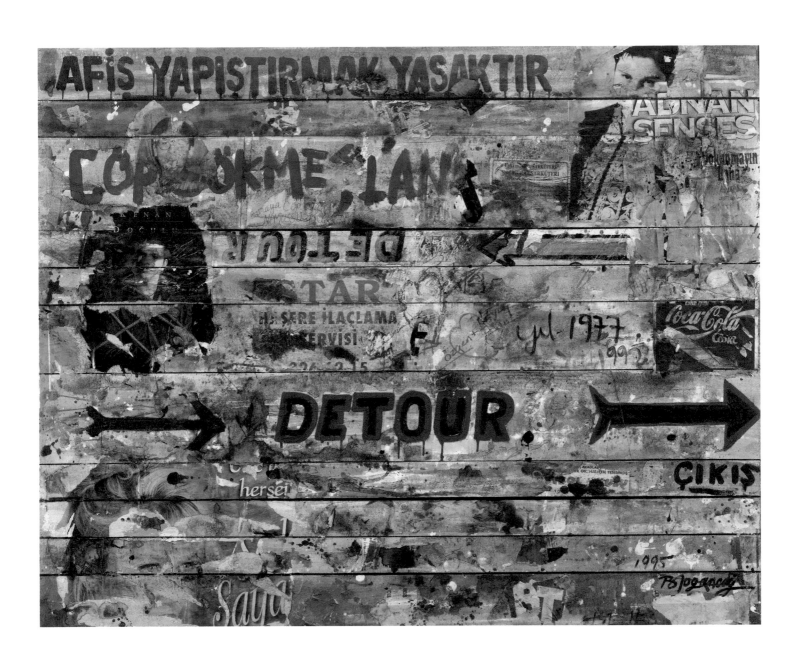

41
ABORTO. 1995
Collage, acrylic and mixed media on
wood panels mounted on canvas
127 x 152.4 cm (50 x 60 in.)
Collection of the artist

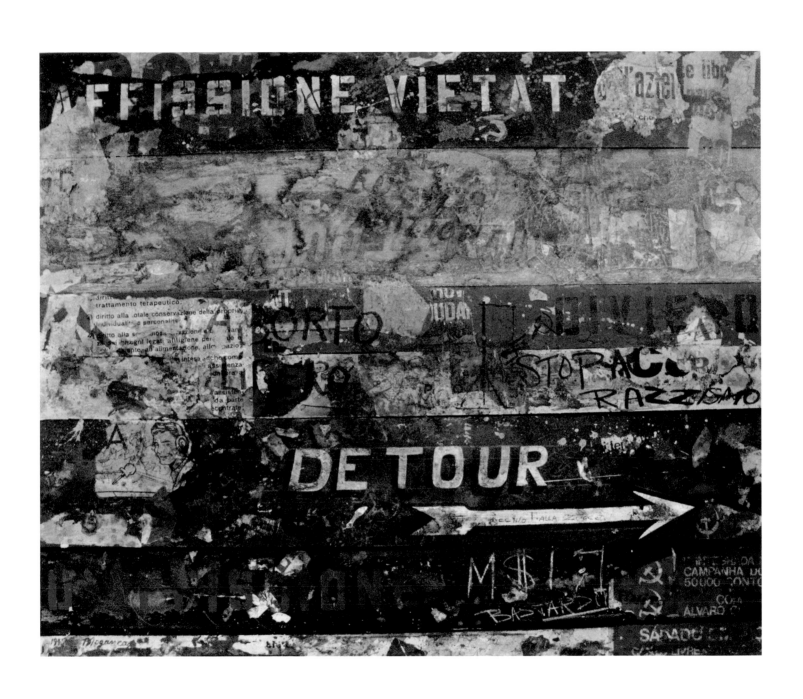

42
SANS BLAGUE. 1995
Collage, acrylic and mixed media on
wood panels mounted on canvas
152.4 x 127 cm (60 x 50 in.)
Dr. Nejat F. Eczacıbaşı Foundation Collection

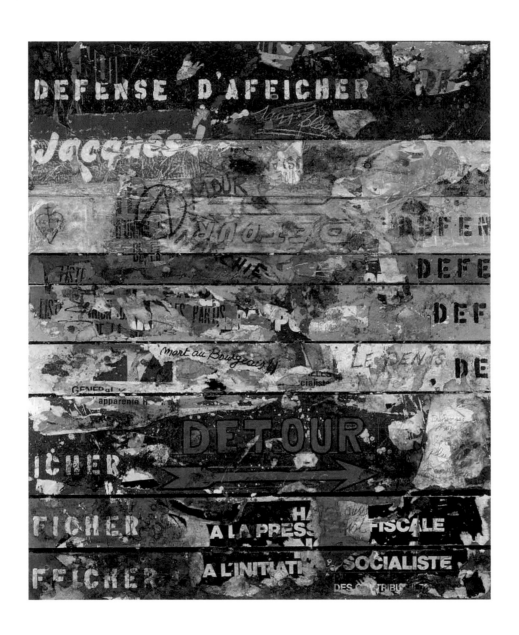

43
STOP CRACK. 1995
Collage, acrylic and mixed media on canvas
152.4 x 127 cm (60 x 50 in.)
Collection of Kennedy Museum of Art,
Ohio University, USA

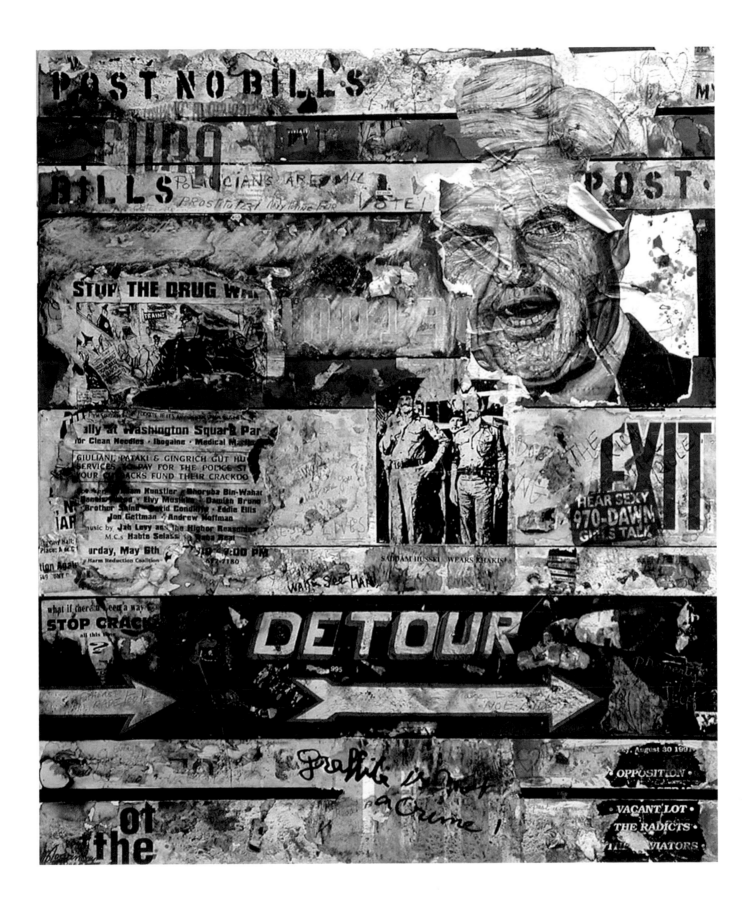

New York Subway Walls

1967–2002

In the 1960s and 1970s, the New York subway was systematically in decline but celebrated for the wild, graffiti-covered cars that rattled down its tracks. It was inevitable that Dogançay would be drawn to the untutored spontaneity of this work by disenfranchised, disillusioned inner-city youth that was polarizing New Yorkers. Yet this art with its desire to deface—implicit in graffiti—was far too public and contrived for Dogançay's personal artistic focus. What he sought for his *New York Subway Walls Series* was elsewhere—places where the myriads of regular daily users and abusers of the subway system had left their more subtle marks. He examines the interactions of these unseen people on the subway's walls and tries to piece them together, yet "like their authors finds little hope of arranging the pieces in any way that would put the world back in order." Though some paintings in the *Subway Walls Series*, like some in the *General Urban Walls Series*, are carefully managed attempts at havoc control or damage repair, still the paintings seem to underscore that once broken, nothing can ever be correctly repaired again.

Dogançay's fascination for creating paintings in the *Subway Walls Series* continued through the beginning of the millennium, some years after the New York's Metropolitan Transit Authority had undertaken a purge of graffiti and embarked upon a major system-wide renovation of subway stations, which in turn gave rise to a new subway series, the *Blue Walls of New York Series.*

44
SUBWAY WALL. 1967
Oil on canvas
152.4 x 152.4 cm (60 x 60 in.)
Collection of Kennedy Museum of Art,
Ohio University, USA

45
BLAZING STAR. 1999
Mixed media on Masonite tiles mounted on canvas
122 x 122 cm (48 x 48 in.)
Dr. Nejat F. Eczacıbaşı Foundation Collection

46
GO AD. 1999
Acrylic and mixed media on Masonite tiles
mounted on canvas
122 x 122 cm (48 x 48 in.)
Öner Kocabeyoğlu Collection

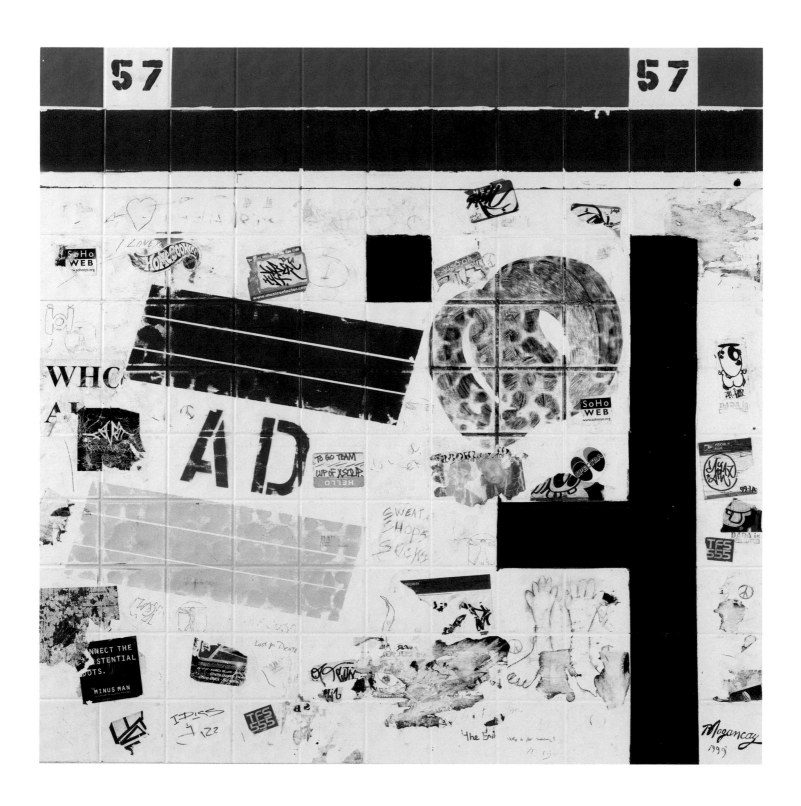

47
NO FUTURE. 1999
Mixed media on Masonite tiles mounted on canvas
122 x 122 cm (48 x 48 in.)
Collection of the artist

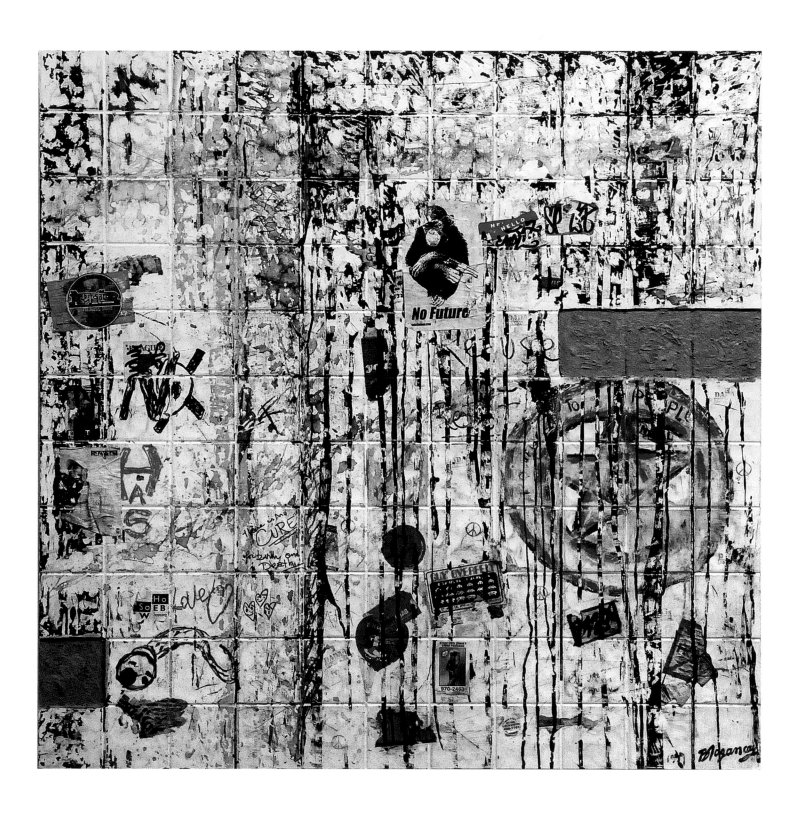

48

YELLOW ADA. 2002
Mixed media on Masonite tiles mounted on canvas
127 x 177.8 cm (50 x 70 in.)
Collection of the artist

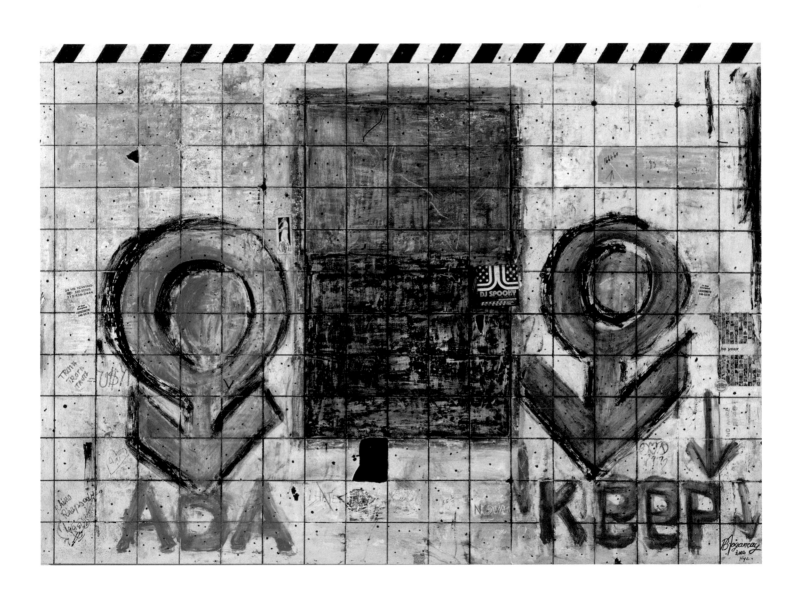

V

Breakthrough

1972–1977

The 1969 Tamarind Lithography Workshop Fellowship in Los Angeles marked a key turning point for Dogançay as an artist. Working in this untried medium obliged him to totally rethink his composition and to organize his images graphically with more space and areas of flatter, brighter colors. The result was that elements within his work gained greater force, being set off on grounds where they had more space to breathe. The *Breakthrough Series,* and two other series that Dogançay was gestating at the time, would be greatly influenced by this new approach.

"What lies beyond the wall?" asks Moyer. "It is remarkable how Dogançay is able to make one dream of events that are not depicted. Using the surface of the painting to entice one to speculate about what is not shown, he employs a teasing ambiguity between the front and the back of the canvas." In the *Breakthrough Series,* Dogançay takes the teasing further. These predominantly red works apparently comprise two layers, with the bottom one appearing to be 'breaking through' the top, which in turn is curling away from the bottom. Shadows cast by the top layer create striking three-dimensional effects. This appropriately named series was also a distinct breakthrough for Dogançay in his exploration of walls. It heralded the *Ribbons* and *Cone Series* that were to follow almost immediately after and that would take this concept further.

49
BORN TO BE FREE. 1973
Acrylic on canvas
152.4 x 152.4 cm (60 x 60 in.)
Private Collection

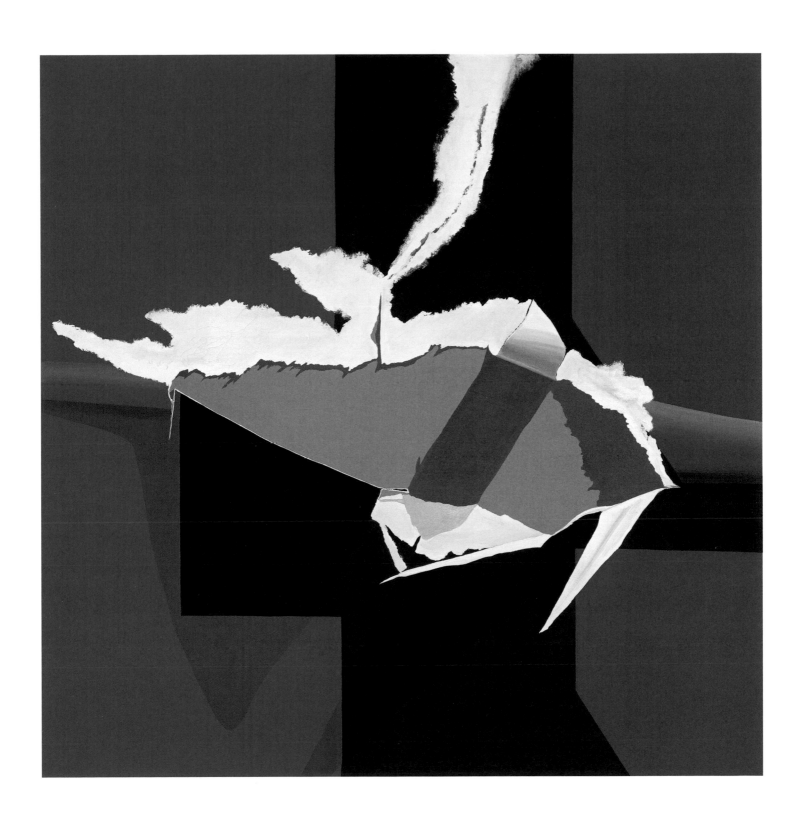

50
RED & BLACK COMPOSITION NO. 5. 1974
Acrylic on canvas
152.4 x 152.4 cm (60 x 60 in.)
The Solomon R. Guggenheim Museum, New York
Gift, Mrs. E. T.H. Kjellstrom, 1974

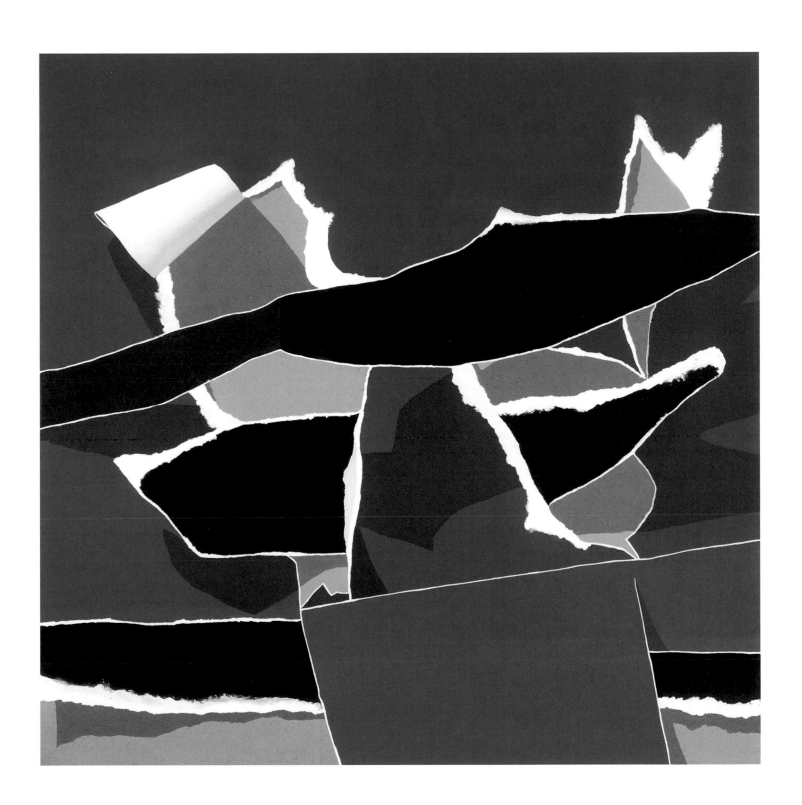

51
RED & BLACK COMPOSITION NO. 10. 1974
Acrylic on canvas
152.4 x 152.4 cm (60 x 60 in.)
Collection Georg Guggenberg, Vienna

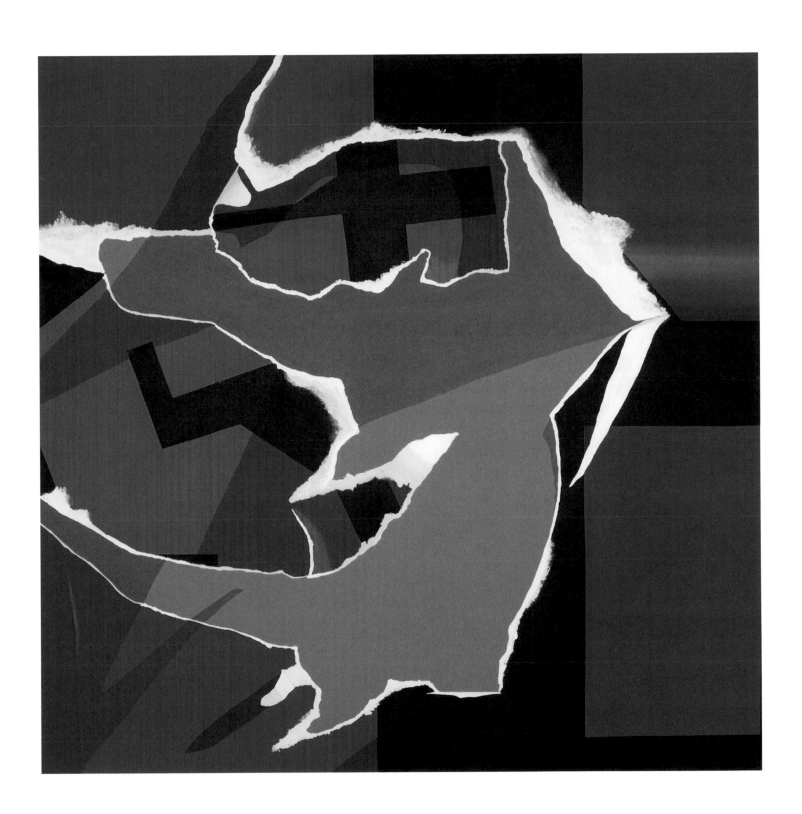

VI

Ribbons

1972–1989

It was with his *Breakthrough Series* that Dogançay emerged from the artist as observer to the artist as speaker. For his *Ribbons Series*, he absolutely put aside textured wall surfaces and started to employ solid colored grounds of gray or vivid blues, as well as white or black ones, symbolic of light and shade. Dogançay plays convincingly with light and shadow in these deceptively orderly and disciplined works, but while more refined and seemingly abstract, they are firmly based on the artist's observation of walls. "Reality was no longer the surface, but that which lay behind it: elements from inside the wall burst forth, invading our space."

"Throughout his career he has been concerned with a tactile picture plane, from which objects project into the viewer's space." In *Ribbons*, Dogançay's work eloquently demonstrates this battle for volume, which to all appearances reaches out beyond the surface. From a jagged hole ripped through the background, a profusion of torn shreds of paper or ribbons burst into our space, and they or the shadows they cast form elegant calligraphic shapes. Having observed them frequently on walls, the soft-edged tears are of great importance to Dogançay—they are used to bring personality and depth to the image. Together with its immediate predecessor, *Breakthrough*, this series can be classified as *trompe l'œil* collage—it looks like collage, but the eye is actually being tricked. *Trompe l'œil* has long been used to test a realistic painter's ability and Dogançay's use of it certainly attests to his skill.

The *Ribbons Series* provided the basis for the metal shadow-sculptures and Aubusson tapestries that Dogançay was to introduce in the 1980s.

52
HARİTA. 1977
Acrylic on canvas
122 x 122 cm (48 x 48 in.)
Bell Holding Collection

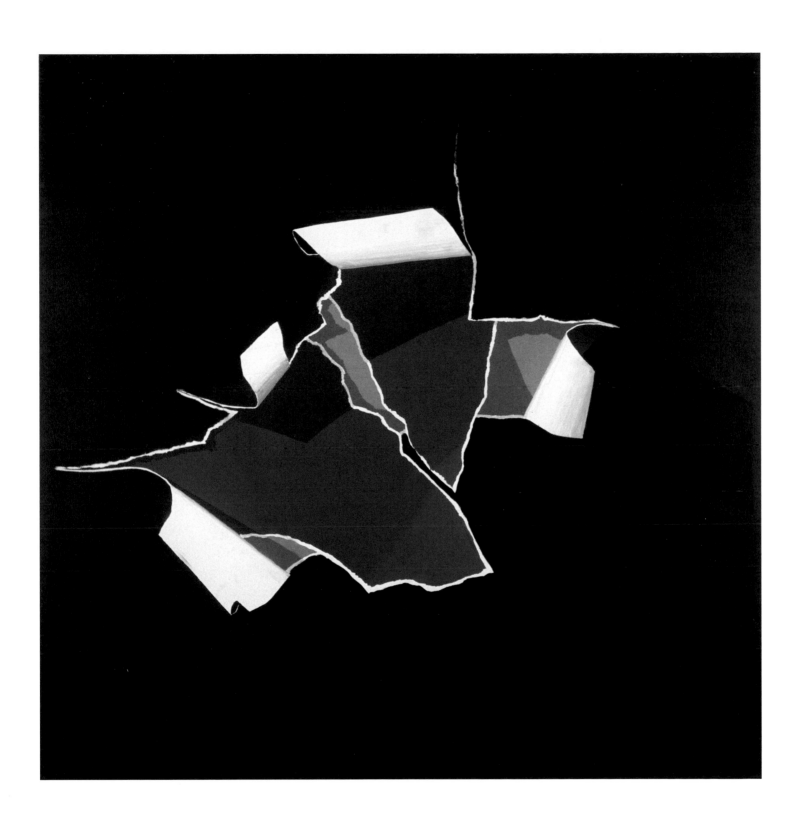

53
RED ELEPHANT. 1977
Acrylic on canvas
122 x 122 cm (48 x 48 in.)
Ekspo Faktoring A.Ş., Istanbul

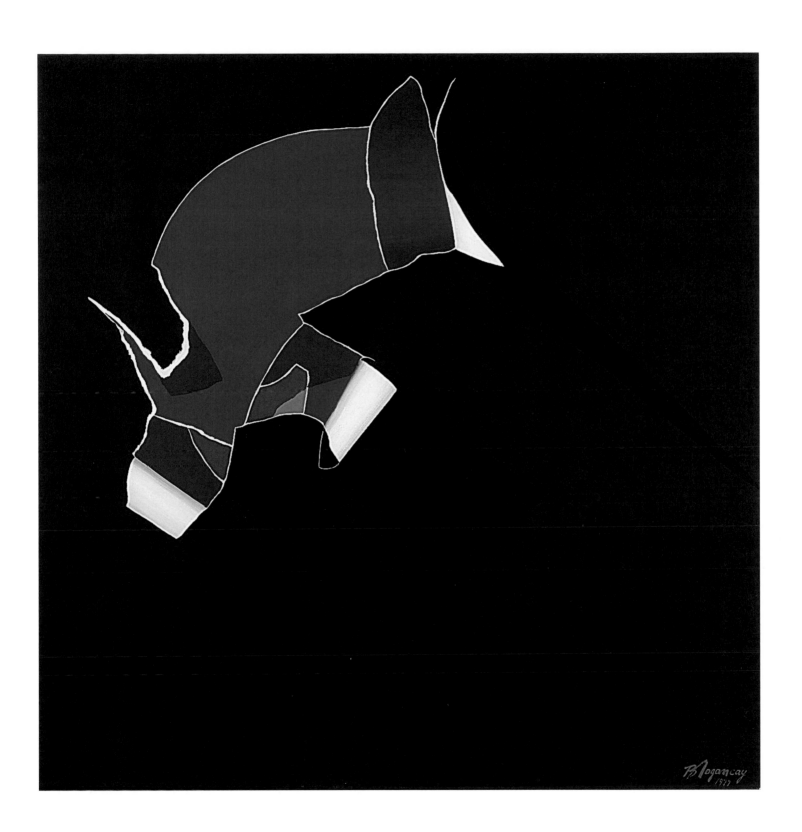

54
LOFTY RIBBONS. 1978
Acrylic on canvas
167.6 x 152.4 cm (66 x 60 in.)
The British Museum, London

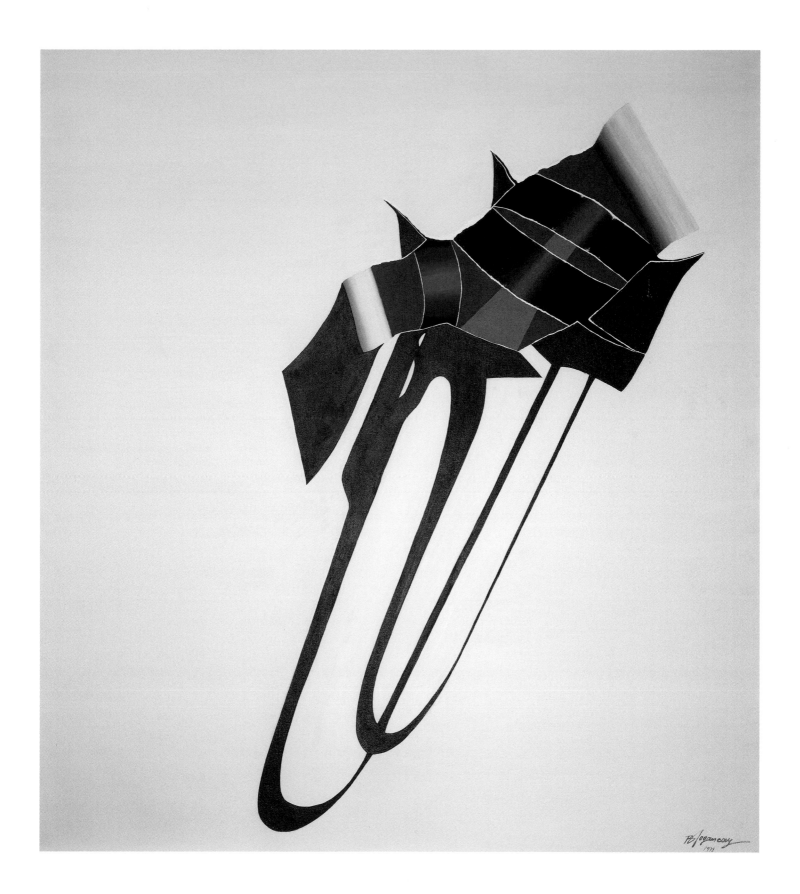

55
HOMAGE TO CALLIGRAPHY. 1978
Acrylic on canvas
152.4 x 152.4 cm (60 x 60 in.)
Louisiana Museum of Modern Art, Humlebæk,
Denmark
Donation: Burhan Dogançay and the Turkish Embassy,
Copenhagen

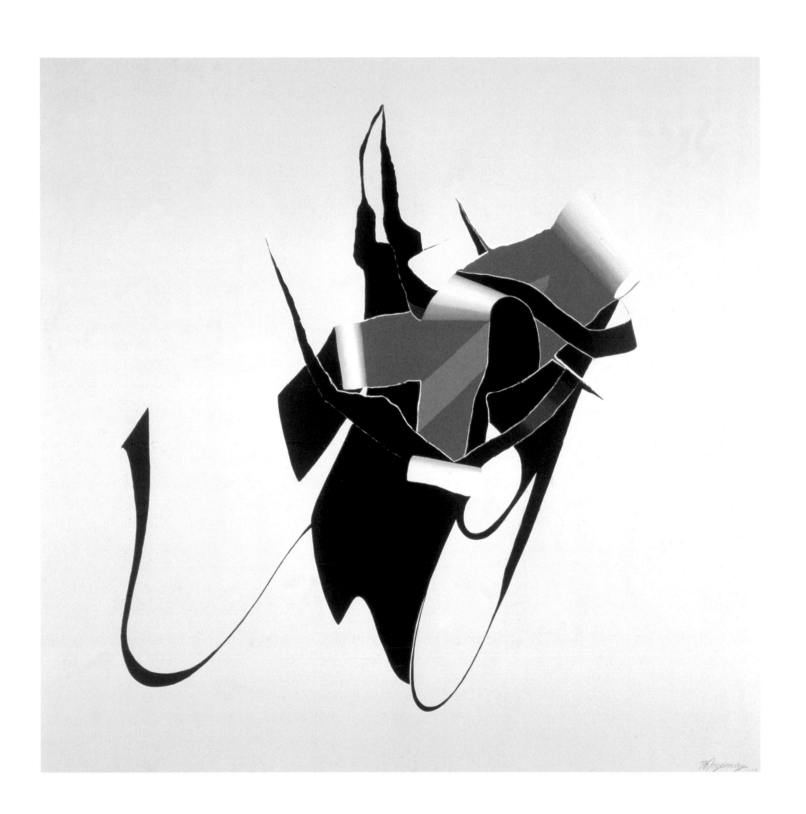

56
FLAMINGO. 1981
Acrylic on canvas
203.2 x 101.6 cm (80 x 40 in.)
Collection Nil and Oktay Duran

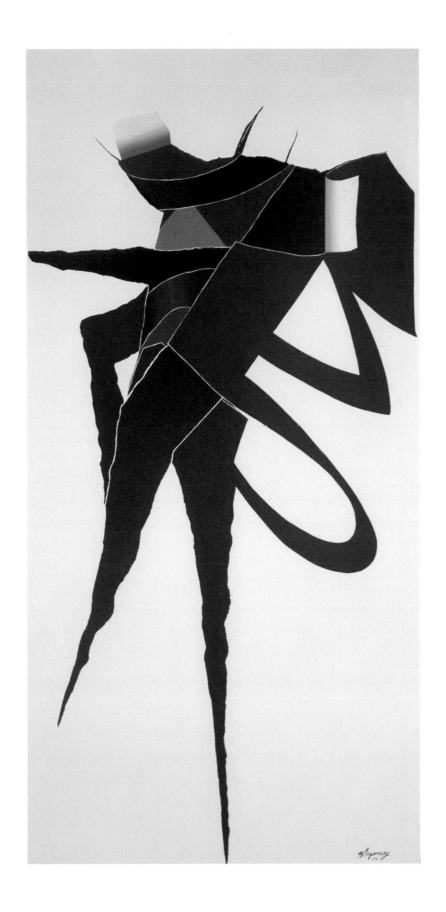

57
BLOSSOM. 1985
Acrylic on canvas
127 x 91.4 cm (50 x 36 in.)
Yıldız Holding A.Ş. Collection

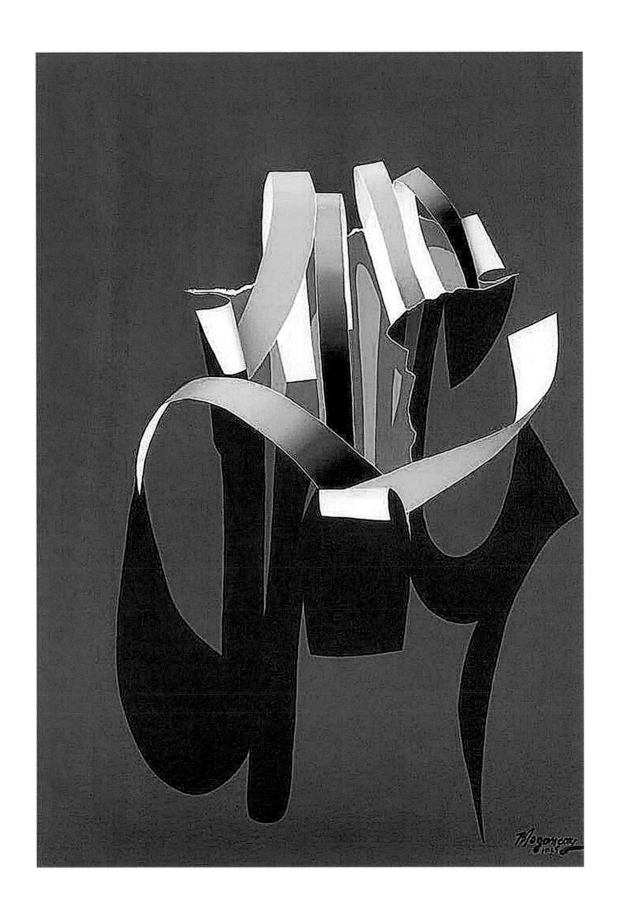

Cones

1972–1990

Cones often appear as a phenomenon of walls, for torn posters frequently curl up under the influence of the elements and human touch. For the *Cones Series*, Dogançay took these elements away from the context of walls. Cones of torn paper have been glued collage-fashion to the ground along with scraps of ripped-up posters or other elements positioned to peep through from behind. While the placement appears random, actually it is very carefully planned and meshed. If you are tempted to reach out and touch one of the bulbous appendages, you might be surprised to discover that it is merely a painted illusion.

Most of the *Cones* paintings are relatively small format, but they pack a tremendous visual punch. A bright palette, predominant in reds and blues, accounts for some of the paintings, but another group has a very sober, duotone look. Particularly for these, Dogançay used *fumage*, a technique with which he had recently started to experiment. *Fumage*, made popular in the 1930s by some members of the Surrealist movement, uses smoke, in most cases from a candle, to make patterns and textures on a work's surface. Dogançay is one of the few contemporary artists to have used *fumage* extensively; he has produced over 600 works using this technique, and nearly a quarter of them are in the *Cones Series*.

58
CONE ON A WALL. 1972
Acrylic on canvas
152.4 x 152.4 cm (60 x 60 in.)
Yalçın Ayaslı Collection

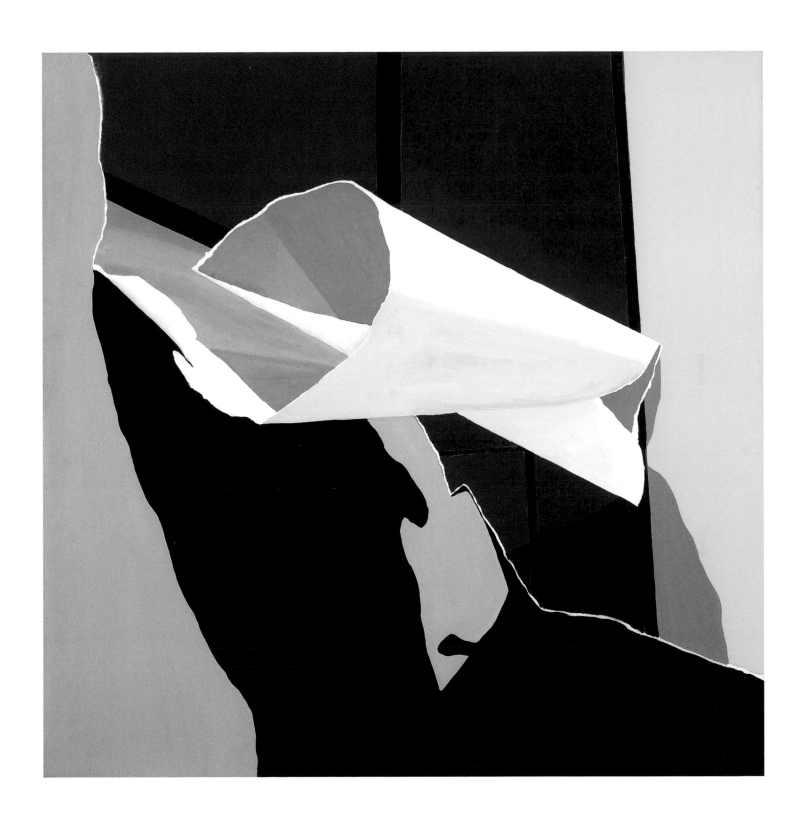

59
LEGS DIAMOND. 1984
Collage, acrylic and fumage on canvas
127 x 127 cm (50 x 50 in.)
Öner Kocabeyoğlu Collection

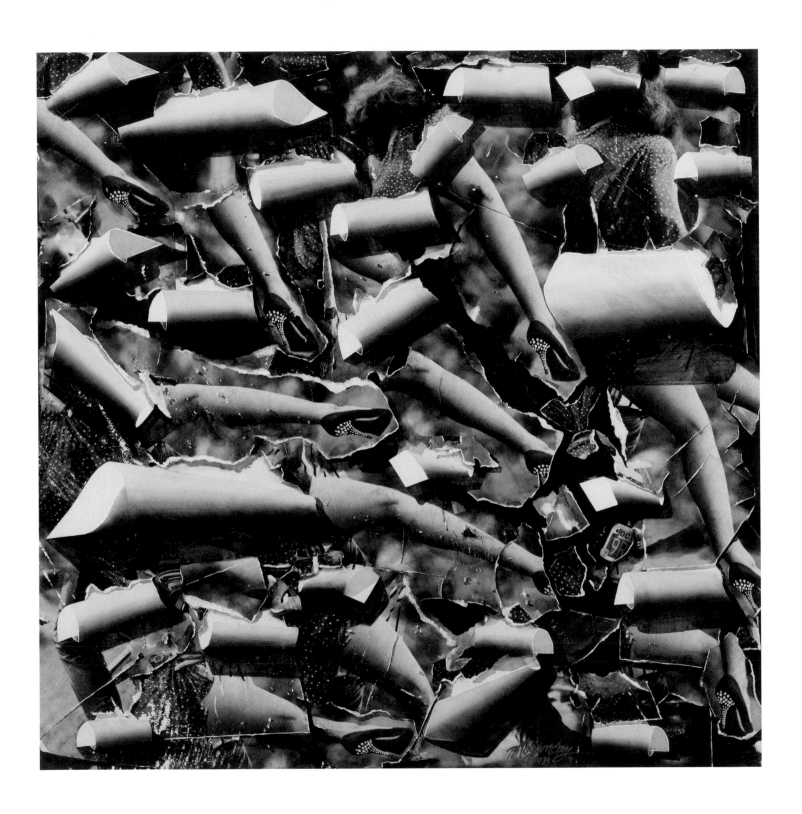

60
LIFE IS CALLING. 1986
Acrylic and collage on two stacked canvases
127 x 92 cm (50 x 36.2 in.)
Oya and Bülent Eczacıbaşı Collection

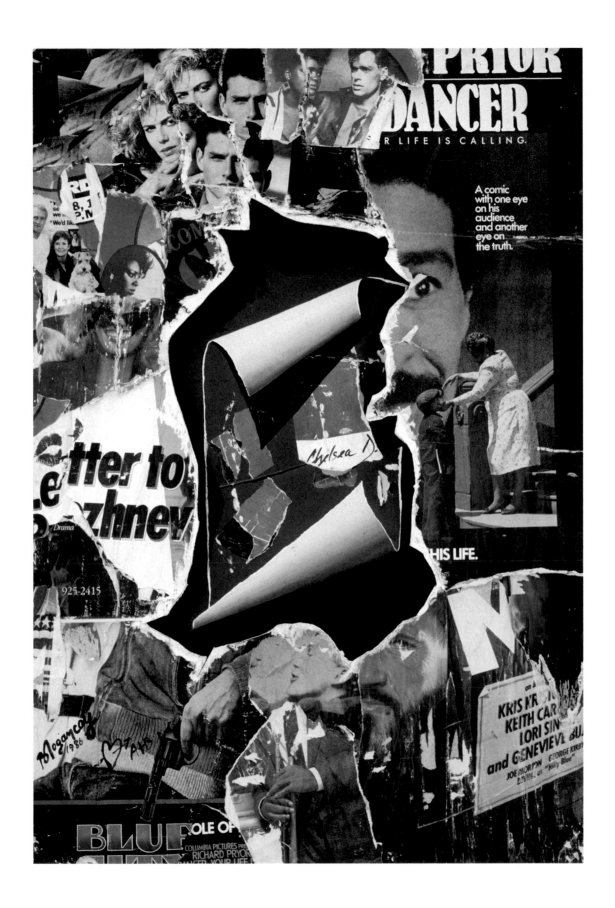

61
HOLEPUNCH. 1986
Collage and acrylic on two stacked canvases
76.2 x 61 cm (30 x 24 in.)
Dr. Nejat F. Eczacıbaşı Foundation Collection

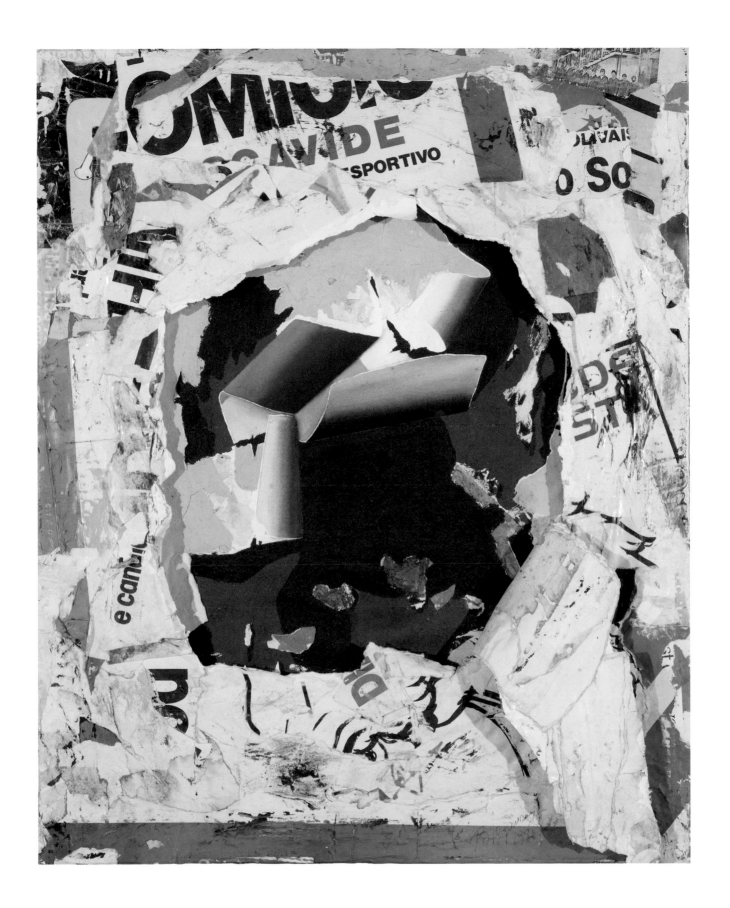

62
DOUBLE ABSTRACTION. 1986
Acrylic, collage and mixed media on
two stacked canvases
115 x 195 cm (45.3 x 76.7 in.)
Öner Kocabeyoğlu Collection

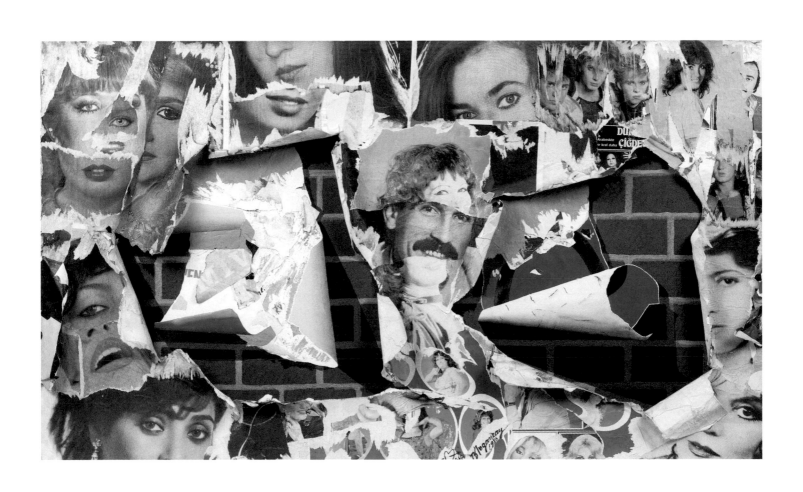

63
UNTITLED # 12. 1986
Acrylic on canvas
76 x 101.6 cm (29.9 x 40 in.)
Collection of Kennedy Museum of Art,
Ohio University, USA

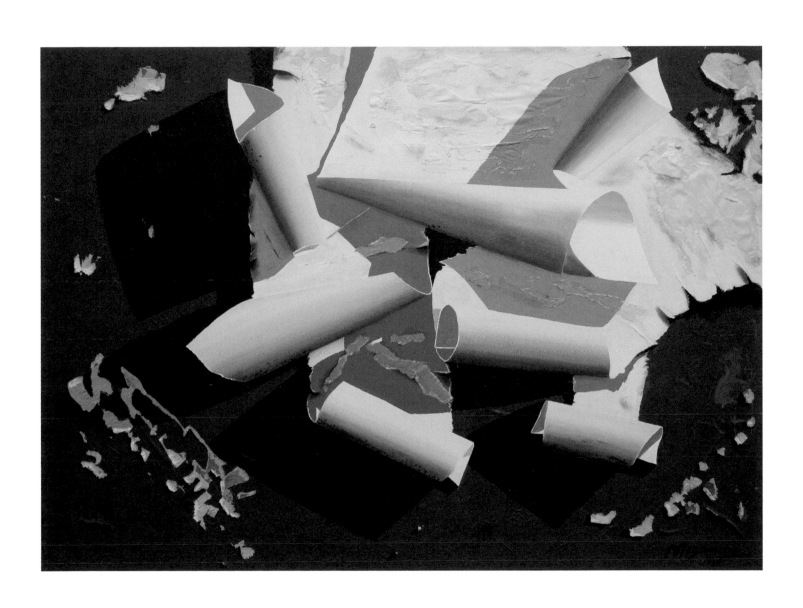

64
UNTITLED # 13. 1986
Acrylic on canvas
76 x 101.6 cm (29.9 x 40 in.)
Collection of Kennedy Museum of Art,
Ohio University, USA

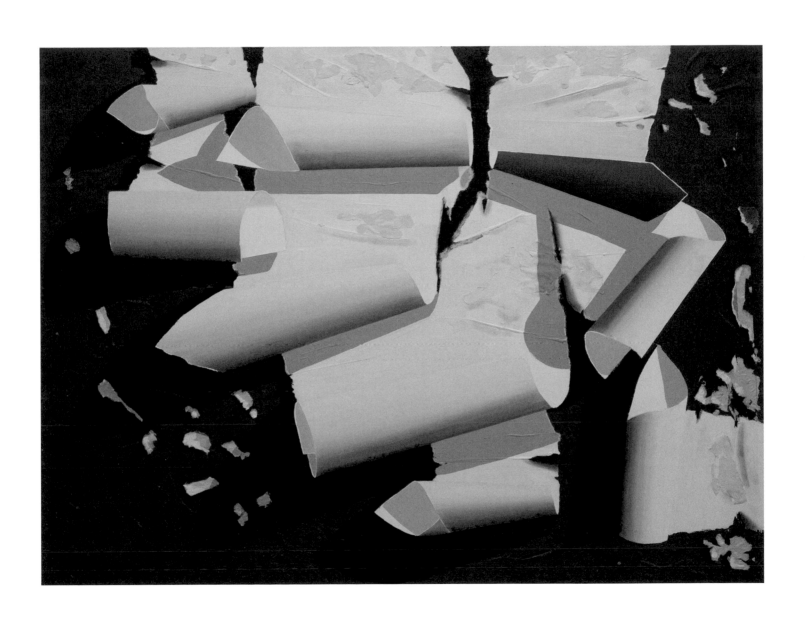

65
MARTHA GRAHAM. 1986
Collage and acrylic on two stacked canvases
130 x 90 cm (51.2 x 35.4 in.)
Öner Kocabeyoğlu Collection

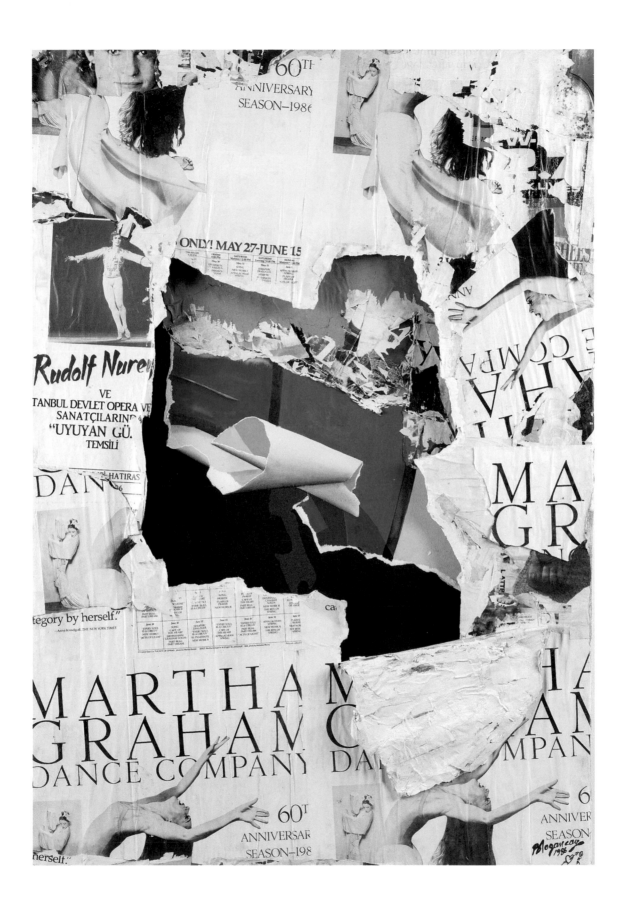

66

MAGNIFICENT ERA. 1987

Collage, acrylic, gouache and fumage on canvas

166.4 x 368.3 cm (65.5 x 145 in.)

İstanbul Modern Collection / Eczacıbaşı Group

Donation

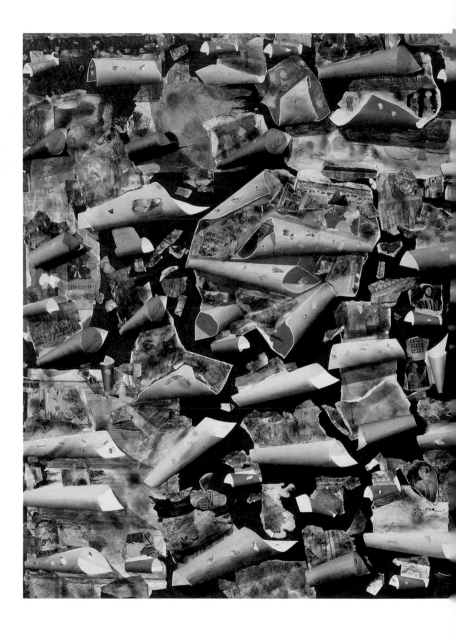

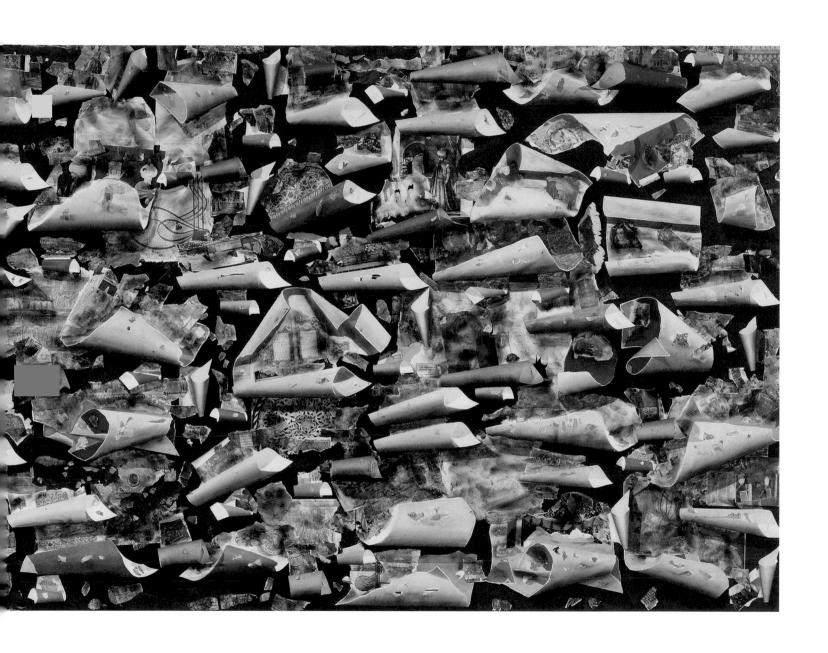

67

SYMPHONY IN BLUE. 1987
Collage, acrylic, gouache and fumage on canvas
164 x 287 cm (64.6 x 113 in.)
Yıldız Holding A.Ş. Collection

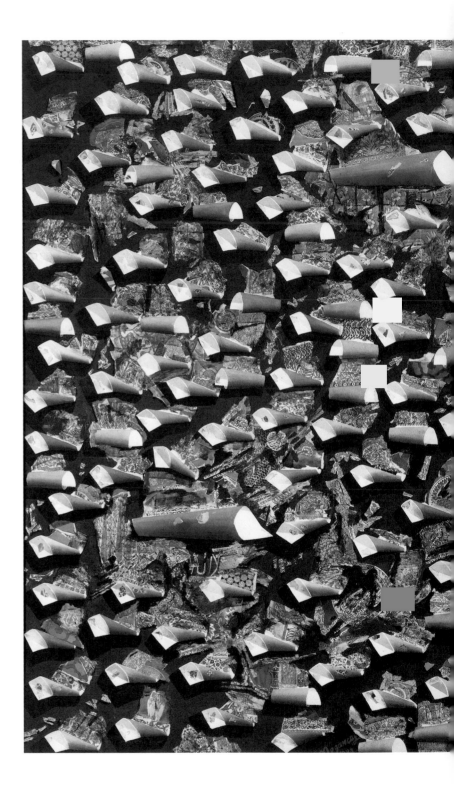

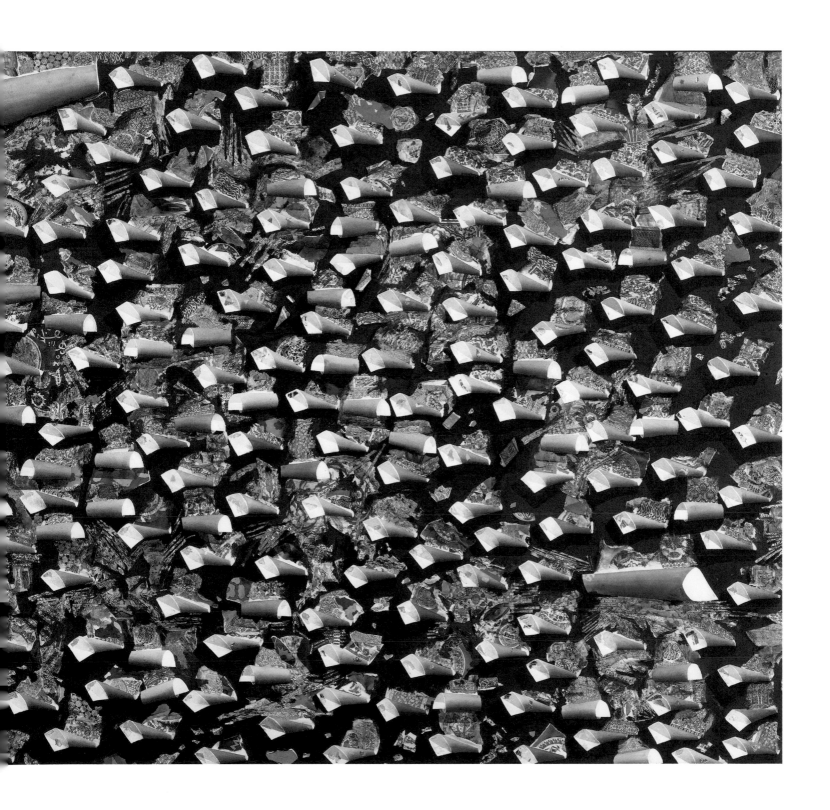

68
MADONNA. 1987
Collage, acrylic, gouache and fumage on canvas
122 x 229 cm (48 x 90.2 in.)
Dr. Nejat F. Eczacıbaşı Foundation Collection

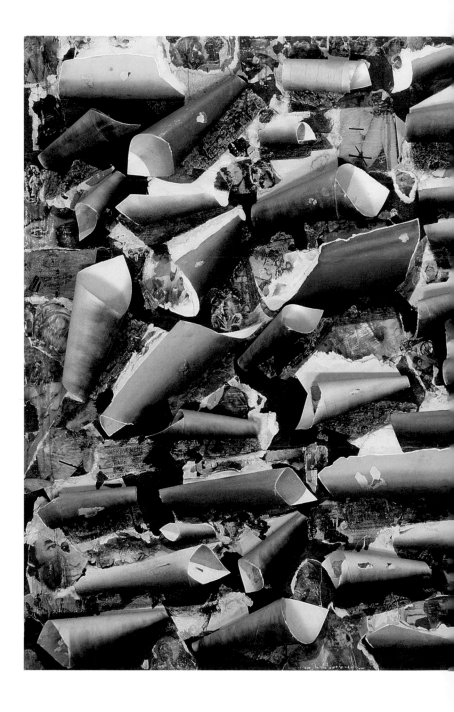

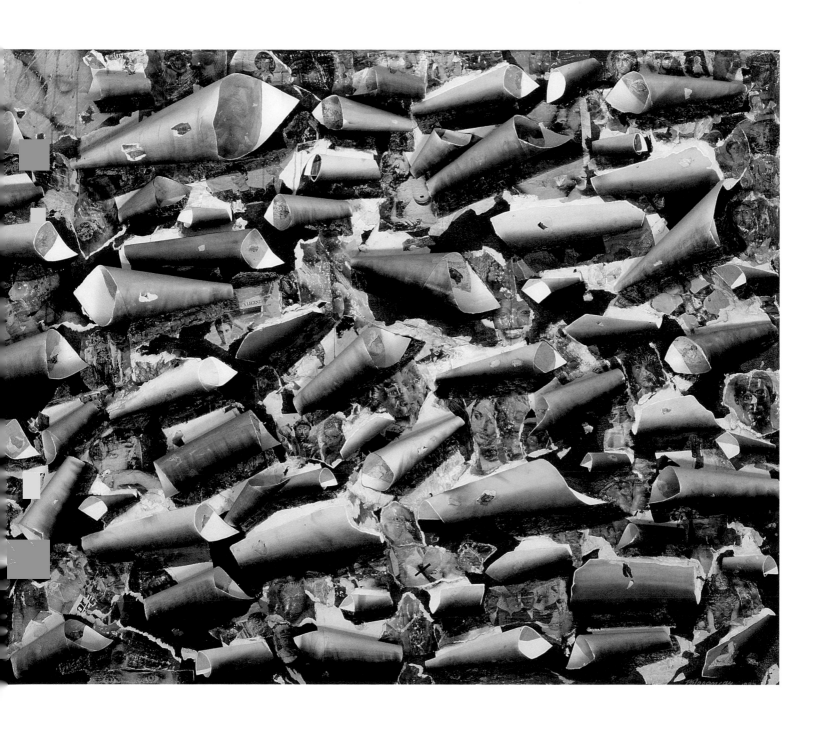

69
HEAR IT WITH YOUR HEART. 1988
Collage and acrylic on two stacked canvases
122 x 127 cm (48 x 50 in.)
Dr. Nejat F. Eczacıbaşı Foundation Collection

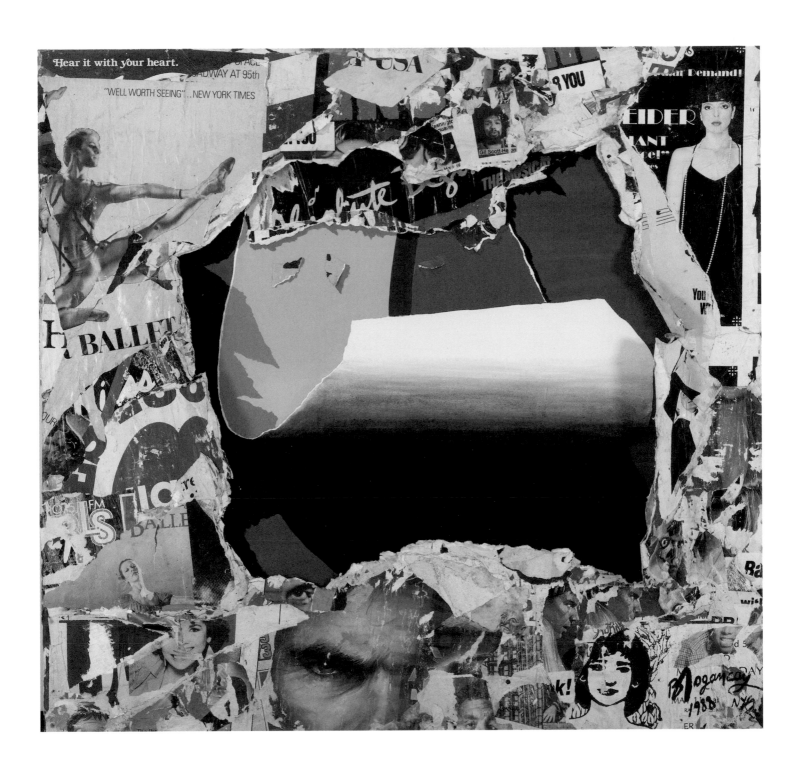

70

FROM THE WALLS OF ITALY. 1989
Collage, acrylic and fumage on canvas
102 x 102 cm (40.2 x 40.2 in.)
Collection of the artist

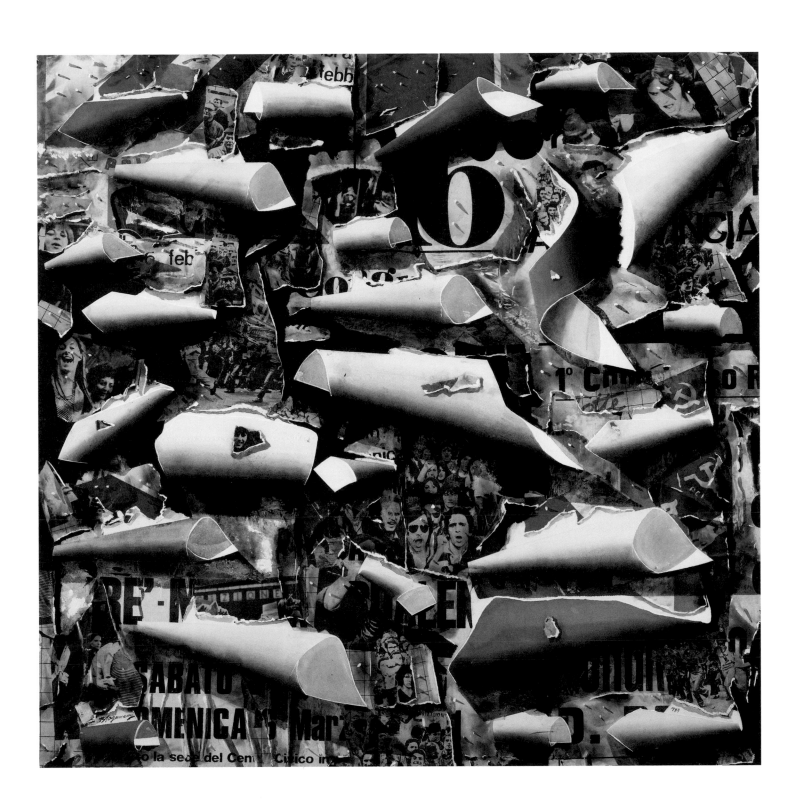

71
BOTTOMS AND PUNKS. 1989
Collage, acrylic and fumage on canvas
102 x 102 cm (40.2 x 40.2 in.)
Collection Mrs. J.G. Freistadt, Vienna

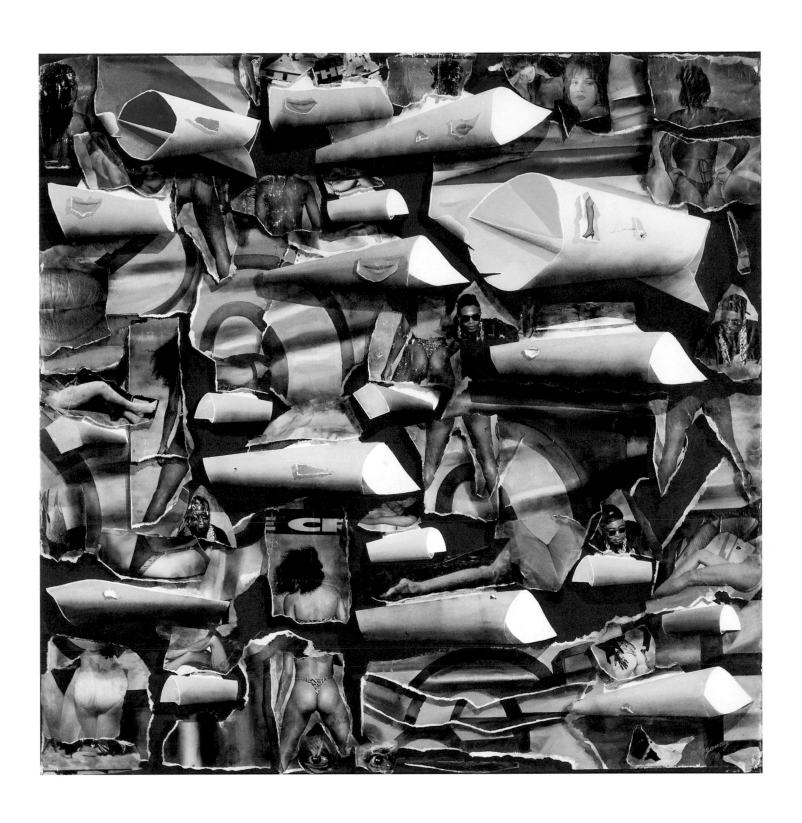

72
THORNED POSTERS. 1989
Collage, acrylic and fumage on canvas
127 x 127 cm (50 x 50 in.)
Dr. Nejat F. Eczacıbaşı Foundation Collection

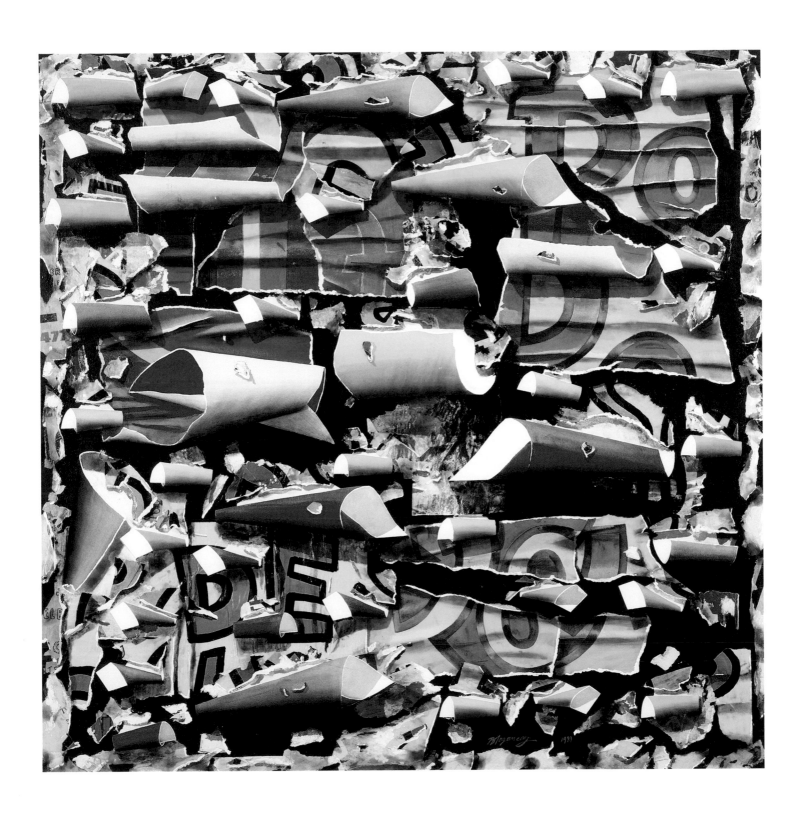

73
NERUDA. 1989
Collage, acrylic and fumage on canvas
102 x 127cm (40.2 x 50 in.)
Moderna Museet, Stockholm
Bequest of Mrs. L. Bengtsson

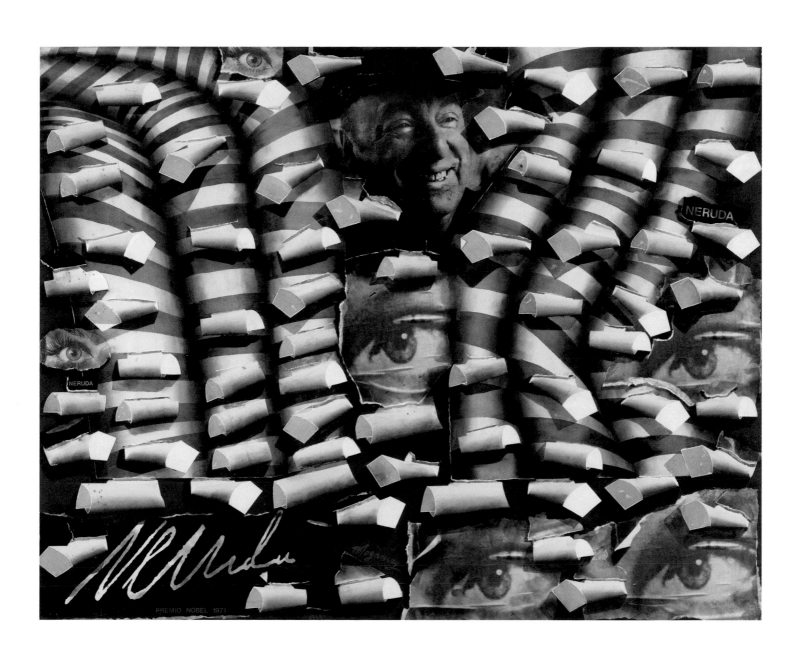

74
KINDER. 1989
Collage, acrylic and fumage on canvas
102 x 102 cm (40.2 x 40.2 in.)
Sprengel Museum, Hanover

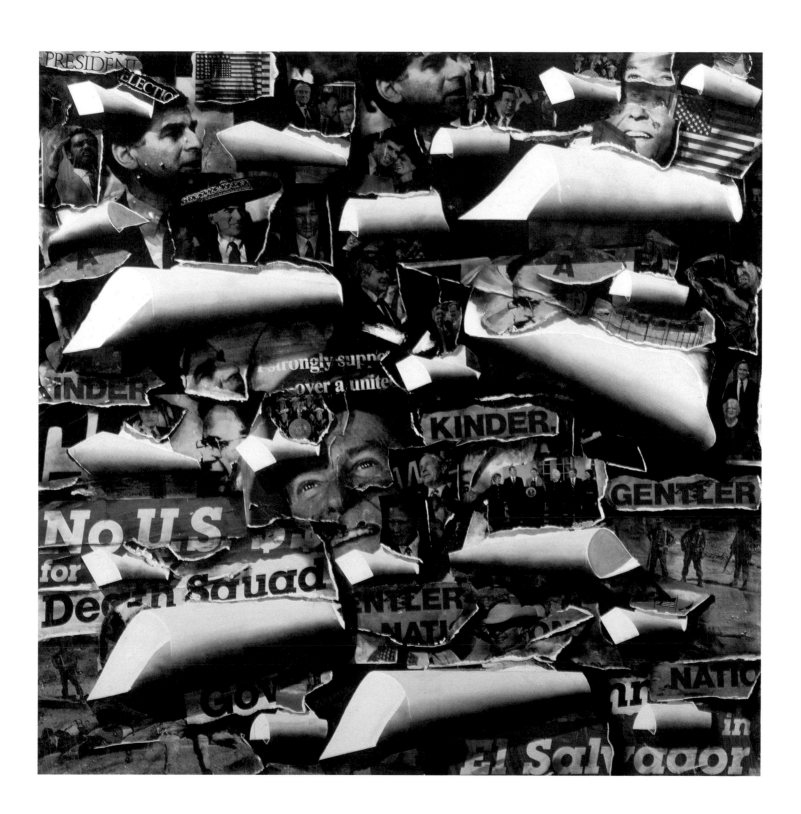

75
A RENAISSANCE. 1990
Collage, acrylic and fumage on canvas
102 x 127 cm (40.2 x 50 in.)
KUNSTEN Museum of Modern Art Aalborg

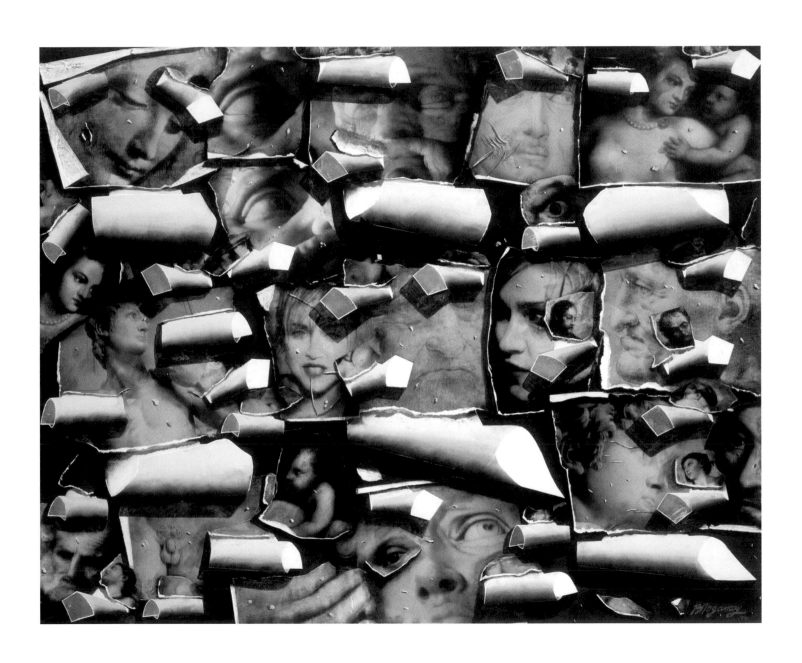

76
HORSE POWER. 1990
Collage, acrylic, gouache and fumage on canvas
101.6 x 101.6 cm (40 x 40 in.)
Museet for Fotokunst-Brandts Klaedefabrik,
Odense, Denmark

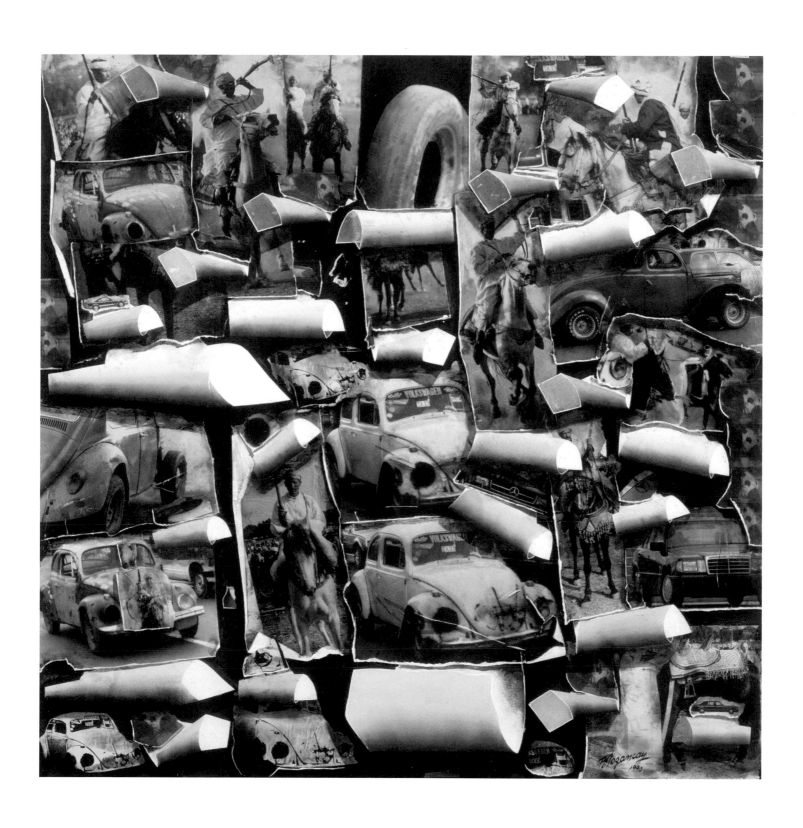

Housepainter Walls

1982–1993

Dogançay was inspired to create this series by walls he had seen in Turkey and Eastern Europe on which housepainters had painted test color swatches alongside an indication of the paint's cost per square meter.

77
THE CIRCUMCISER. 1990
Acrylic, collage and crayon on canvas
107.5 x 177.5 cm (42.3 x 70 in.)
Dr. Nejat F. Eczacıbaşı Foundation Collection

78
GARBAGE. 1990
Acrylic and mixed media on canvas
107.5 x 177.5 cm (42.3 x 46.3 in.)
Dr. Nejat F. Eczacıbaşı Foundation Collection

79
SIX GRAYS. 1990
Acrylic, chalk and pastel on canvas
110 x 180 cm (43.3 x 70.9 in.)
Collection of the artist

80
ISTANBUL. 1990
Collage and acrylic on canvas
89 x 146 cm (35 x 57.5 in.)
Dr. Nejat F. Eczacıbaşı Foundation Collection

81
VIDEO STARS. 1990
Collage, acrylic and mixed media on canvas
95 x 160 cm (37.4 x 63 in.)
Collection of the artist

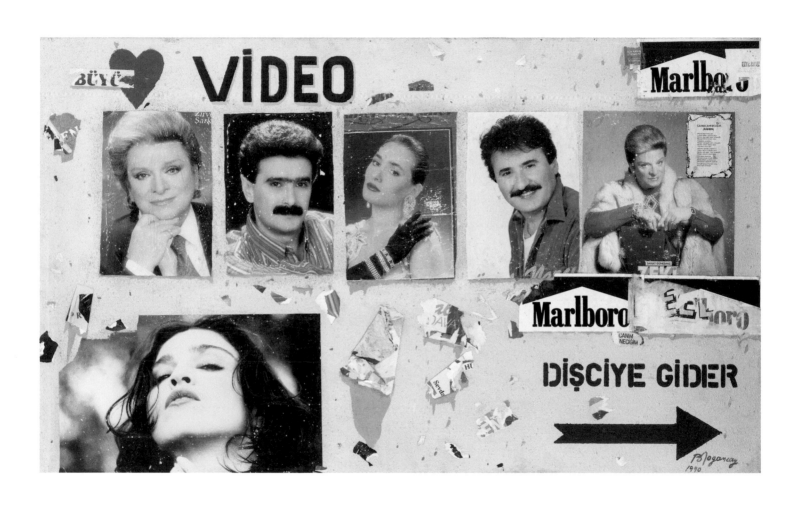

GREGO Walls

1988–2012

While walking through New York's SoHo one day in the mid-1980s, Dogan-çay came across a wall of multicolored painted bricks signed with the tag of graffiti artist GREGO. Wondering why they are not multicolored in reality, Dogançay says he was moved to bring color and joy to simple bricks. It took approximately three years before the resulting *GREGO Walls* appeared. This is typical of Dogançay's gestation and conceptualization process for any new series; he has mulled every aspect over in his mind, down to the most minute of details, before ever approaching a canvas to produce the first painting.

When he first encountered works by GREGO, Dogançay was captivated by what he saw: the colored bricks with their Mondrian-like primary palette would provide a structure or framework for defiantly direct outpourings of a social or political nature. GREGO fast became an alter ego for Dogançay, enabling him to demonstrate through artwork how walls speak of issues that address those passing by. In reply to his friends who speculated that GREGO was probably just a figment of his rich imagination, Dogançay retorted: "I can imagine how GREGO looks. He is perhaps uneducated, but he's his own person. This kid and I think the same way." Although GREGO was probably a real person, Dogançay did undoubtedly start to channel through him, introducing cultural references and images that would probably not have been familiar to a late-20th-century inner-city kid. Nevertheless GREGO's style and syntax were always carefully preserved as issues such as the A-bomb, drugs, violence, and crime emerge in the paintings to underscore the many failings of our society and the tragedies of our modern world.

82
GREGO-NYA. 1991
Collage, acrylic and mixed media on canvas
130 x 162 cm (51.2 x 63.8 in.)
Oya and Bülent Eczacıbaşı Collection

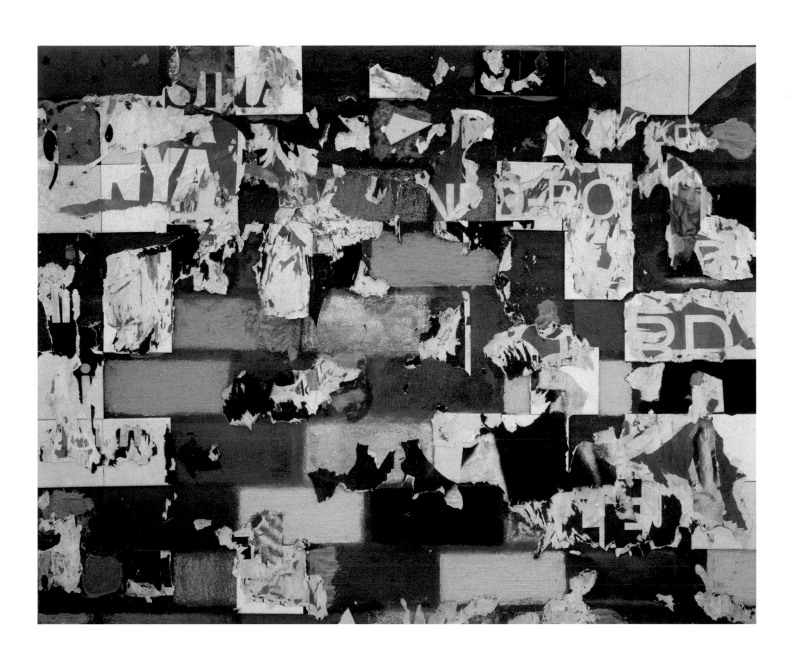

83
ICE HOCKEY. 1993
Collage, acrylic and mixed media on canvas
127 x 127 cm (50 x 50 in.)
Dr. Nejat F. Eczacıbaşı Foundation Collection

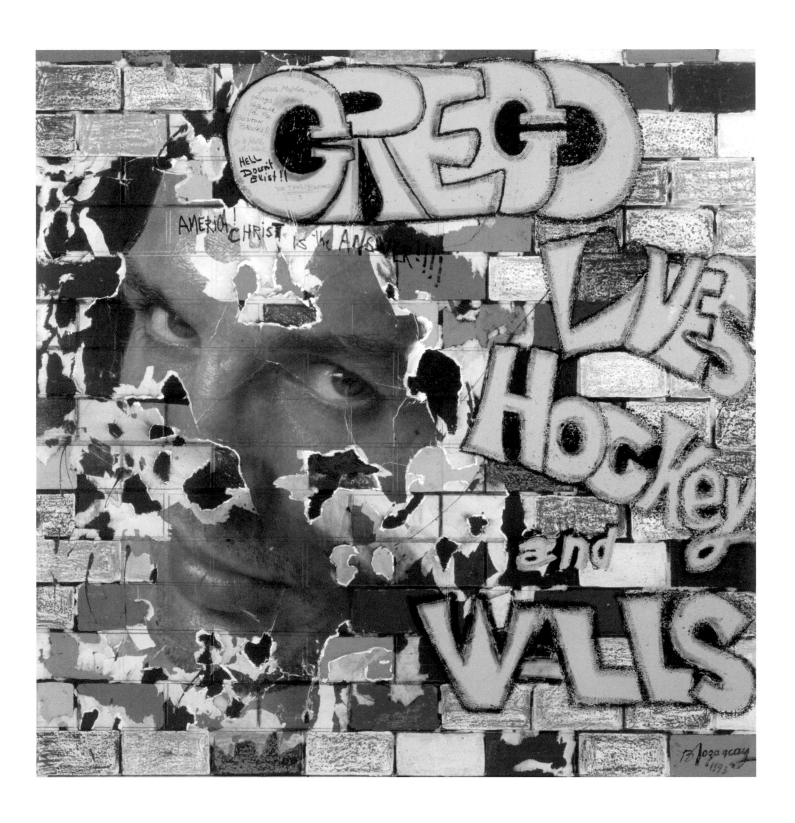

84
GREGO'S WALL I. 1993
Collage, acrylic and mixed media on canvas
114.3 x 162.6 cm (45 x 64 in.)
Şerife and Mehmet Ali Babaoğlu Collection

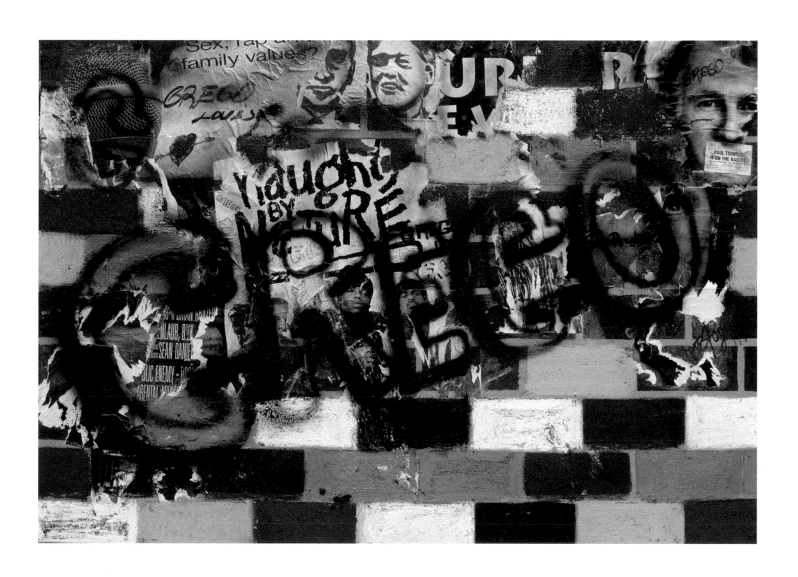

85
A WALL IN NEW YORK. 1993
Collage, acrylic, ceramic tiles, wooden blocks,
sand and mixed media on canvas
130 x 162.5 cm (51.2 x 64 in.)
Collection of the artist

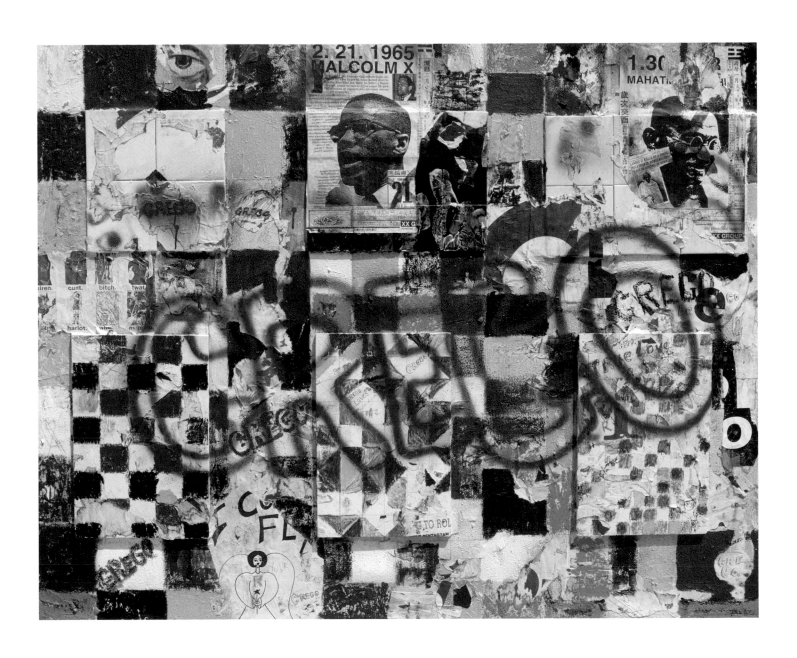

Formula 1

1990–1991

Works in the *Formula 1 Series* were inspired by Dogançay's visit to Monaco at the very end of the 1980s, during the Formula 1 Grand Prix. During this event advertisements and other images on the walls of the route the race follows are covered by black plastic to ensure that drivers' eyes are not distracted. All the *Formula 1* paintings incorporate shiny black plastic stretched across mixed media, which mostly include assemblage.

86
YELLOW BOX. 1990
Collage, acrylic, black plastic and wood on canvas
101.6 x 101.6 cm (40 x 40 in.)
Collection of the artist

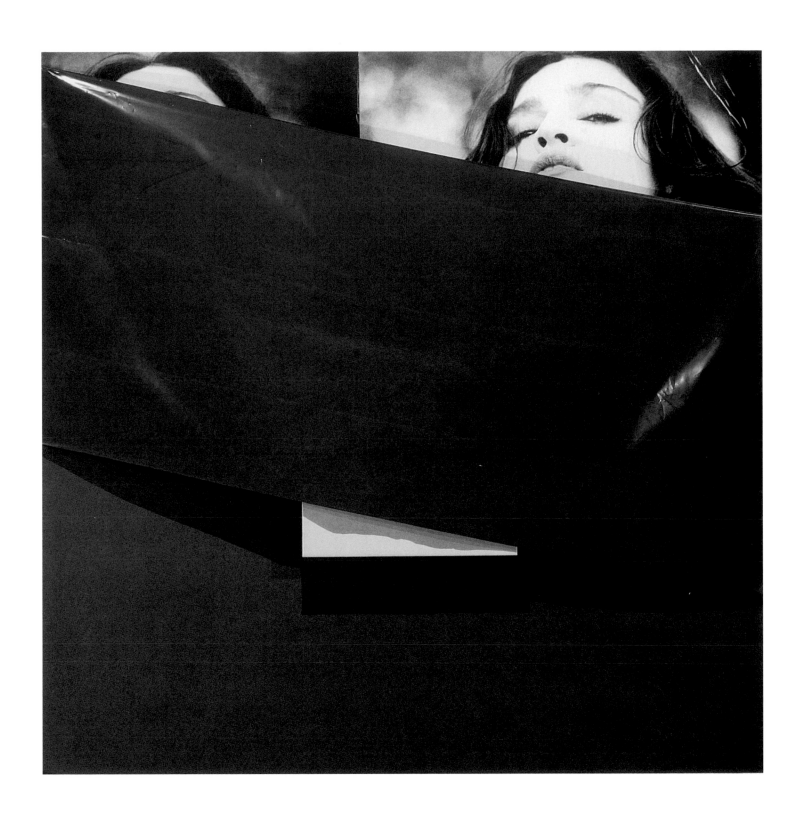

87
DUMMY N. 1990
Collage, acrylic, black plastic and
wood on canvas
101.6 x 101.6 cm (40 x 40 in.)
Collection of Kennedy Museum of Art,
Ohio University, USA

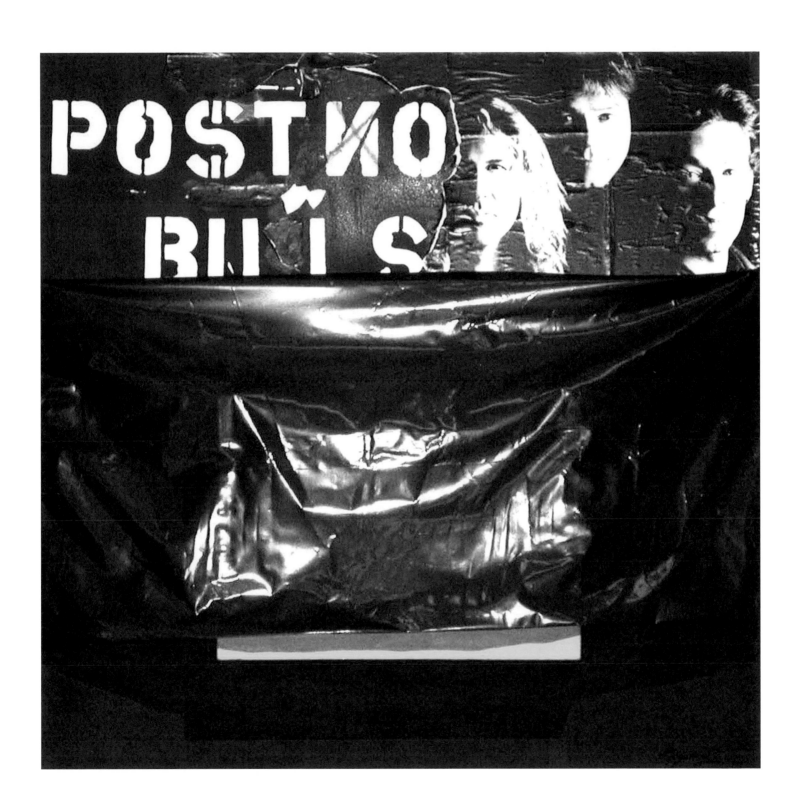

88
BIG T. 1991
Acrylic and black plastic on canvas
129.5 x 162.6 cm (51 x 64 in.)
Dr. Nejat F. Eczacıbaşı Foundation Collection

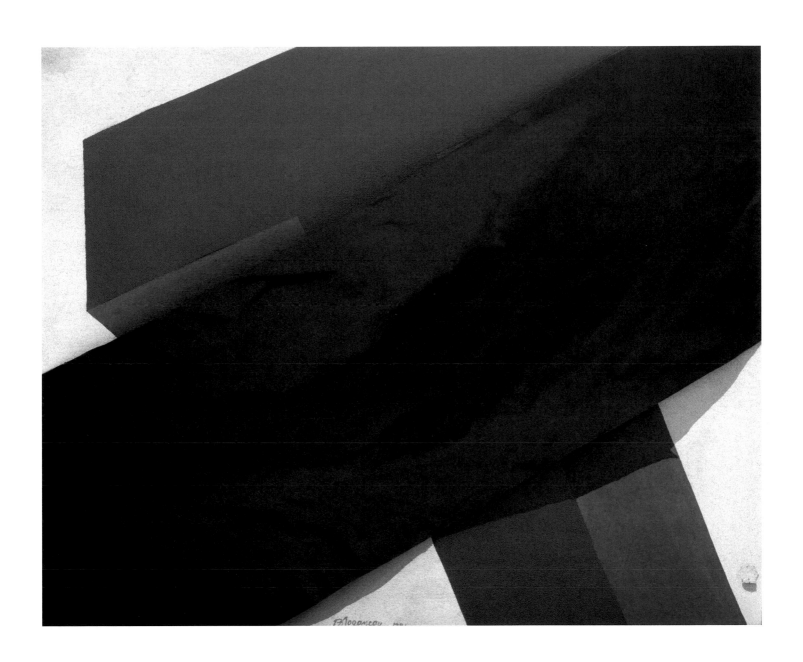

89
DURAN'S LOGO. 1991
Acrylic, black plastic, and wood on canvas
162.6 x 129.5 cm (64 x 51 in.)
Collection Nil and Oktay Duran

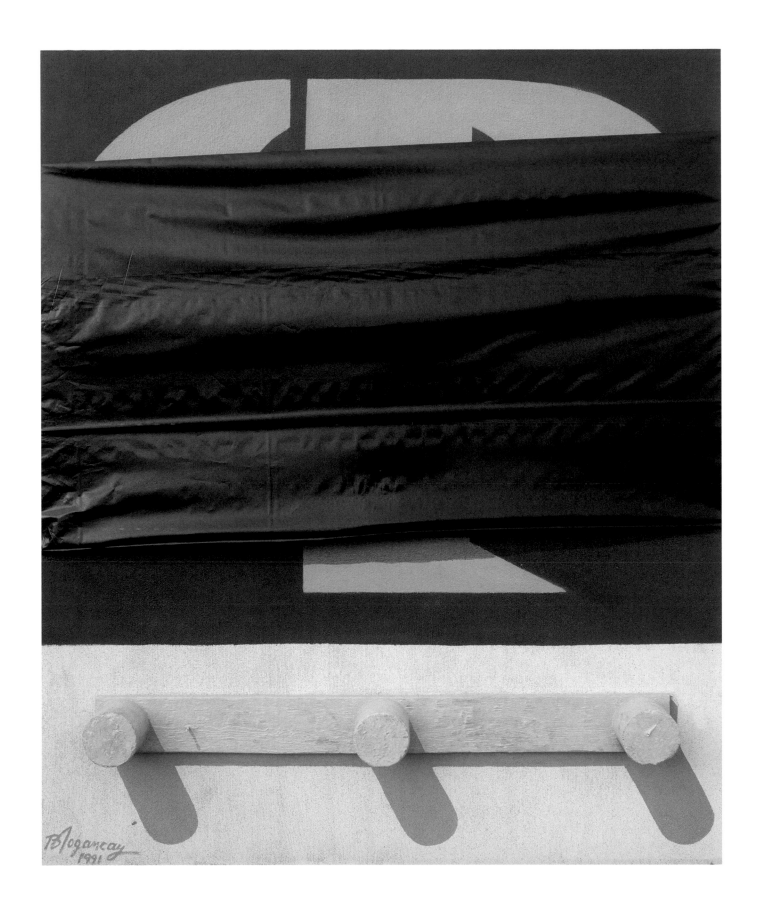

90
CANO. 1991
Acrylic, black plastic and mixed media on canvas
81.3 x 114.3 cm (32 x 45 in.)
Öner Kocabeyoğlu Collection

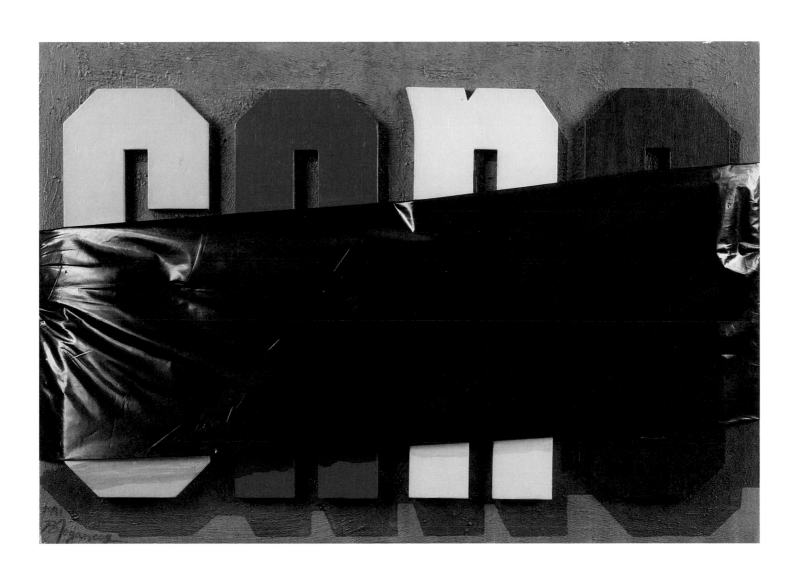

XI

Double Realism

1990–2009

All the works from the *Double Realism Series* incorporate an astonishing variety of objects, which Doğançay actually found on walls, and which demonstrate his ongoing preoccupation with chiaroscuro in his work. In these masterful shows of light and shadow, it is never immediately apparent whether the shadows are real or painted. Great pleasure may be derived from contemplating the amazing shadow shapes thrown by the objects on to relatively neutral-colored grounds. The stickers, labels, and other scraps of collage material that Doğançay chose to apply to many of these works bring with them more than a touch of Surrealism or Dadaism.

91
WOOL AND MADONNA. 1990
Acrylic, poster and wool on canvas
147.5 x 147.5 cm (58.1 x 58.1 in.)
Dr. Nejat F. Eczacıbaşı Foundation Collection

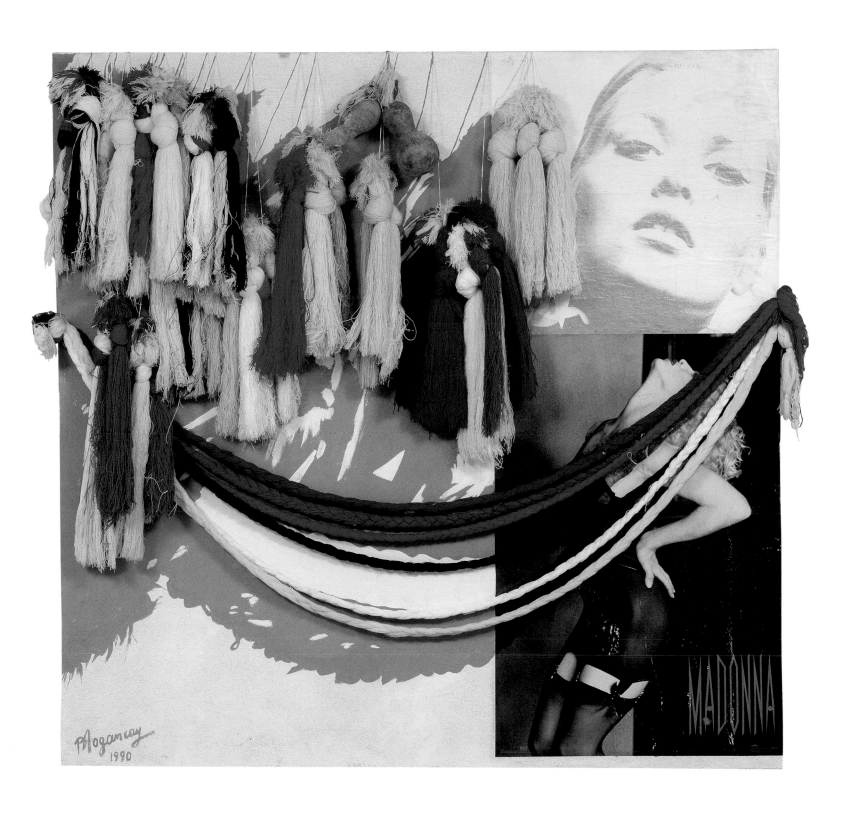

92
DISTORTED SHADOWS. 1990
Acrylic and mixed media on canvas
80 x 114 cm (31.5 x 44.9 in.)
Dr. Nejat F. Eczacıbaşı Foundation Collection

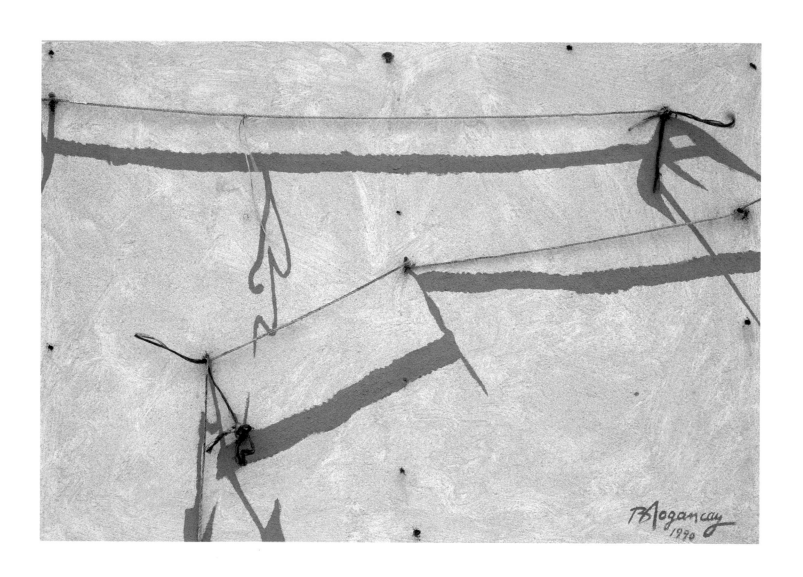

93
TELEPHONE BOXES (39). 1990
Acrylic and mixed media on canvas
112.5 x 160 cm (44.3 x 63 in.)
Dr. Nejat F. Eczacıbaşı Foundation Collection

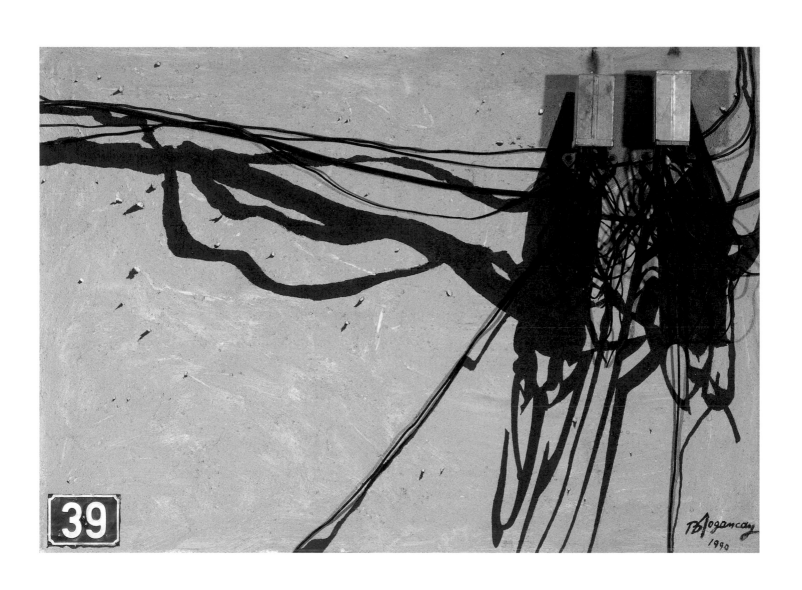

94
15,000 TL @ PAIR. 1991
Acrylic and mixed media on canvas
114.3 x 162.6 cm (45 x 64 in.)
Dr. Nejat F. Eczacıbaşı Foundation Collection

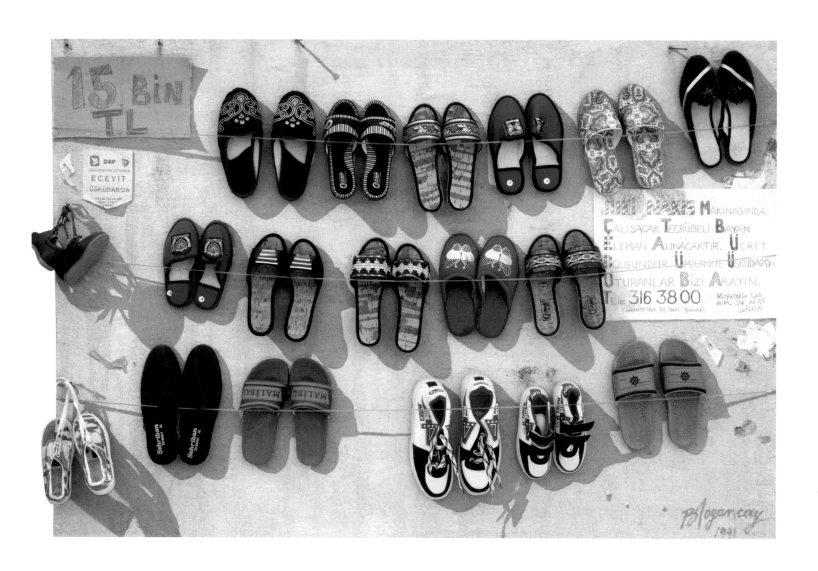

95
A WALL IN ISTANBUL. 1991
Collage and mixed media on canvas
132 x 166 cm (52 x 65.4 in.)
Öner Kocabeyoğlu Collection

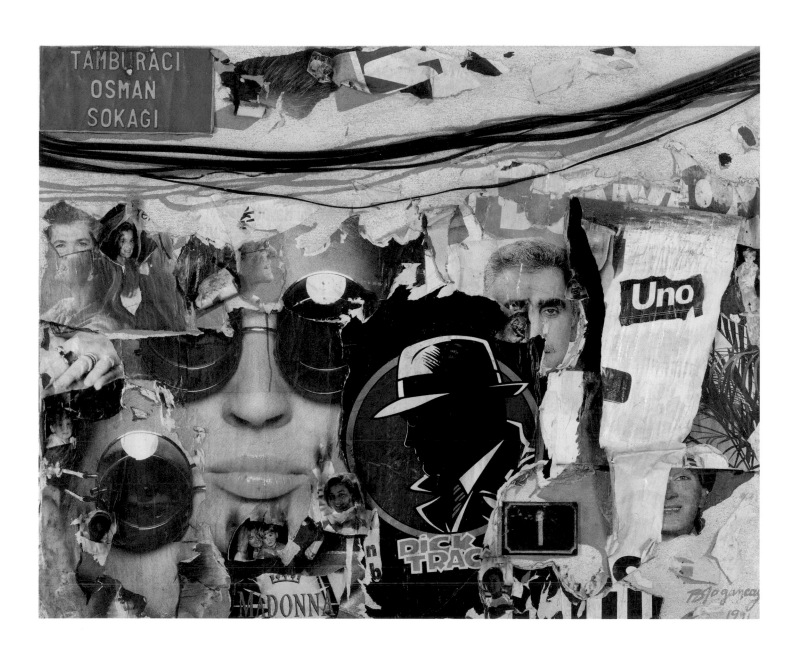

96
NO TRESPASSING. 1993
Acrylic, metal sign, rope, wood and
coffee stains on canvas
152.4 x 203.2 cm (60 x 80 in.)
Collection of Kennedy Museum of Art,
Ohio University, USA

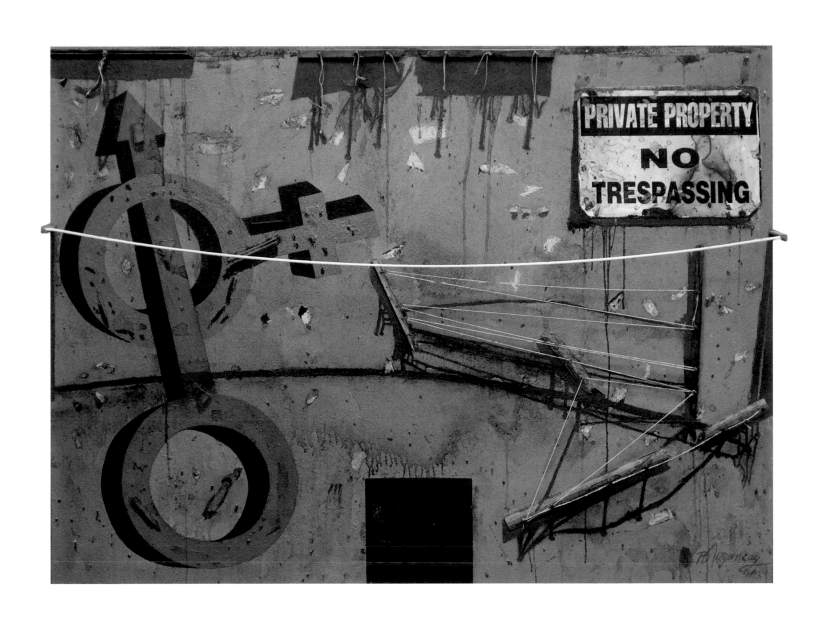

97
LIFESAVER V. 1994
Acrylic, rope, wood and lifesavers on canvas
172.7 x 213.4 cm (68 x 84 in.)
Collection of Kennedy Museum of Art,
Ohio University, USA

98

LASTİKÇİ ADA. 2008
Collage, acrylic, pastel, wood, cement, sand,
tires, chain, tire caps, Krylon spray, coffee stains
and car repair accessories on canvas
157 x 206 cm (61.2 x 81.1 in.)
Collection of the artist

99

STONE WALL. 2008

Collage, acrylic, cement, sand, coffee stains,
Krylon spray, motor oil, tires, metal sign and
repair accessories on three canvases
238 x 474 cm (93.7 x 186.6 in.)
Collection of the artist

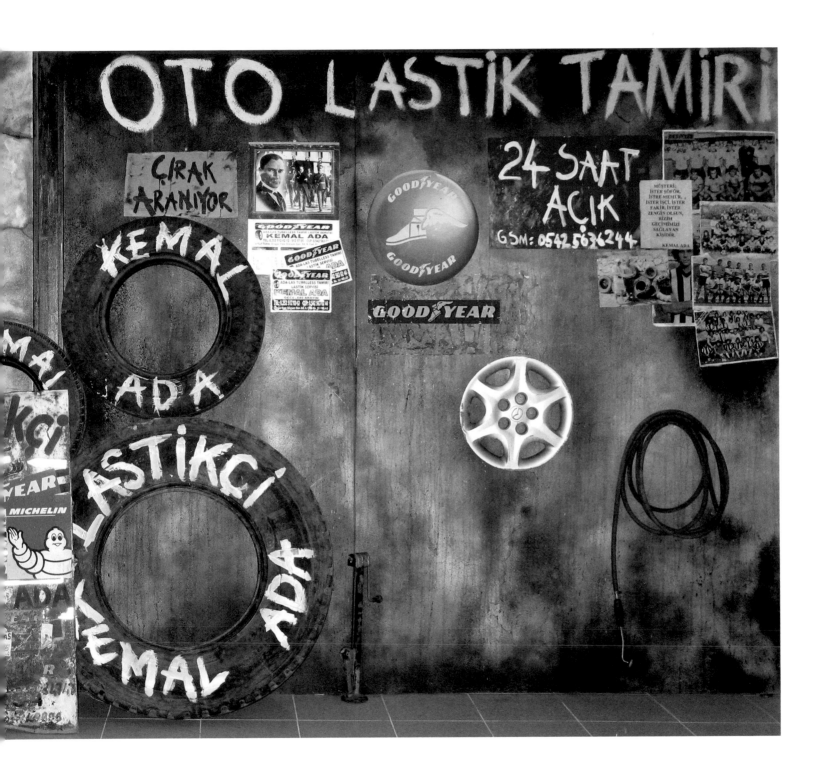

100
LA CAGE AUX FOLLES. 2009
Collage, acrylic, sand, cement, string,
dried eggplant, lantern, 4 birdcages, sieve,
wooden block and collage on canvas
158 x 237 cm (62.2 x 93.3 in.)
Collection of the artist

101
WALL STREET TANGO. 2009
Collaged poster in frame, acrylic, wooden tracks,
rubber tire, and empty oilcans on canvas
203 x 142 cm (79.9 x 55.9 in.)
Collection of the artist

Alexander's Walls

1995–2000

The *Alexander's Walls Series* originated in New York in the early 1990s. Their inspiration was provided by the once popular Alexander's department store in mid-Manhattan, which had gone out of business in 1992. The abandoned building, which covered an entire block, was boarded up awaiting demolition and development. Soon its exterior was covered with posters and graffiti. To make the abandoned site more acceptable in this affluent part of town, the boards were treated to a cosmetic paint job, but that too soon bore the marks left by passersby and the assault of the elements—in a continuing process of addition and subtraction. Later, they were treated to a covering of black paper. As the paper showed signs of wear and tear, colors from various posters, stickers, and graffiti started to appear and show through holes, cracks, and rips in the black ground.

When Dogançay saw the bright colors showing through the rips and tears, they looked to him like flowers in a splendid garden. He had always been looking for walls like these, "so beautiful, so unbelievable, so huge." The first day he noticed them, he ran home immediately to his apartment just a few blocks away to fetch his sketchbook and camera. Thereafter, he visited the site frequently as it provided a mine of inspiration. "As always, I found myself painting in my head, far in advance of ever touching canvas," he adds.

The *Alexander's Walls Series* comprises approximately sixty large-scale paintings and numerous studies, whose elegant overall blackness with colors seeping through has made a strong impression on many viewers. The series is often regarded as an ultimate refinement of Dogançay's wall art.

102
ALEXANDER NO. 18. 1995
Acrylic on paper collaged onto canvas
127 x 152 cm (50 x 59.8 in.)
Dr. Nejat F. Eczacıbaşı Foundation Collection

103
METEOR. 1995
Acrylic on paper collaged onto canvas
102.9 x 127 cm (40.5 x 50 in.)
The Solomon R. Guggenheim Museum, New York
Gift, Tom and Remi Messer, 2003

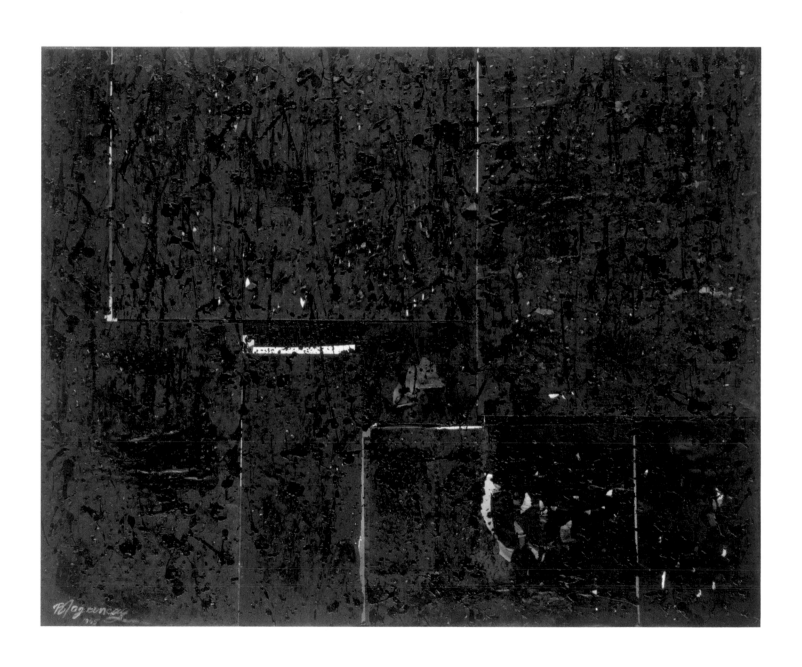

104
RED DOT ON BLACK. 1996
Acrylic on paper collaged onto canvas
102 x 127 cm (40.2 x 50 in.)
Collection of the artist

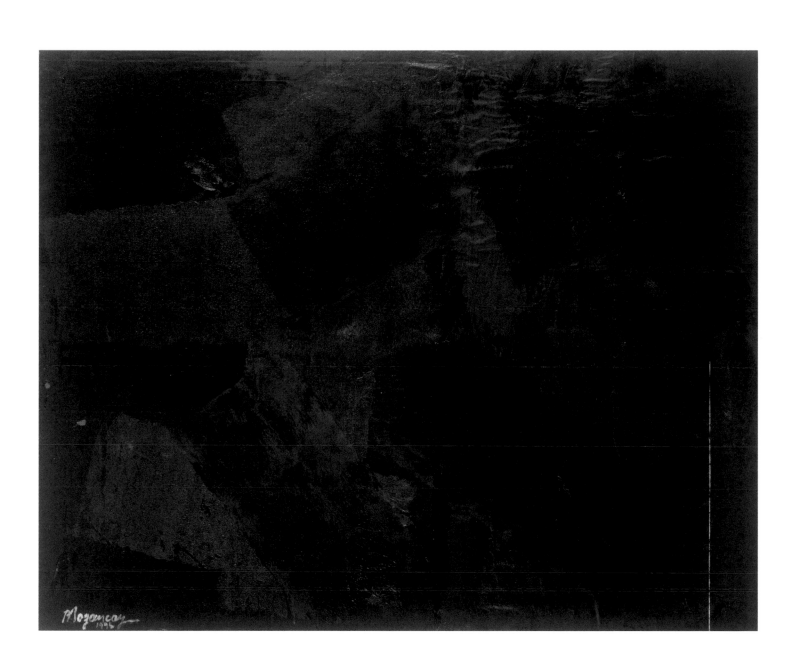

105
COW IS BEEF. 1997
Acrylic and mixed media on canvas
152 x 152 cm (59.8 x 59.8 in.)
Collection of the artist

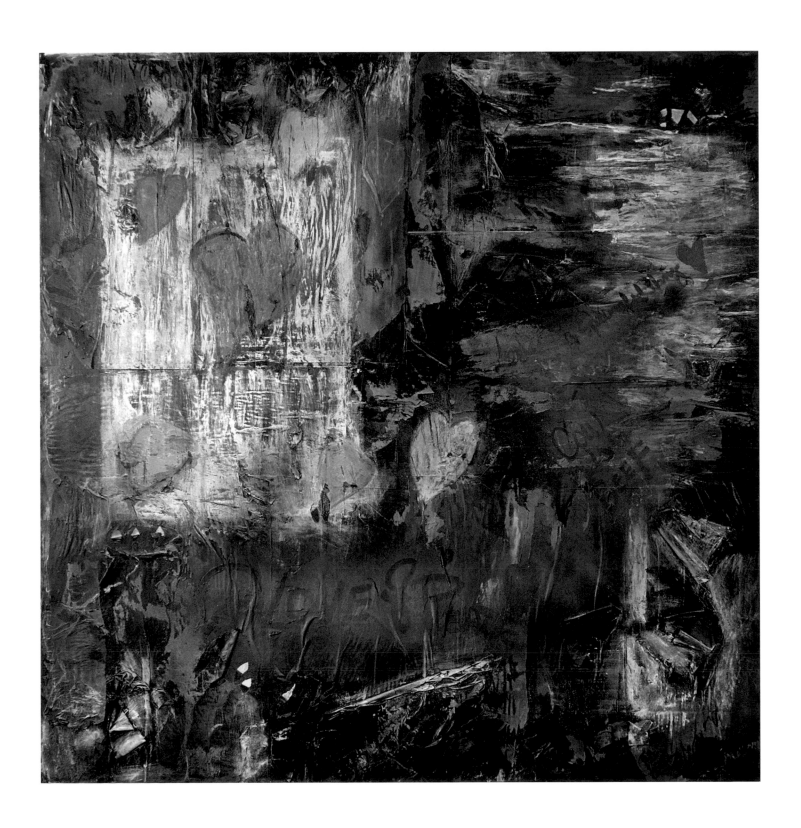

106
BLUE FLOWER GARDEN. 1997
Acrylic on paper collaged onto canvas
152 x 152 cm (59.8 x 59.8 in.)
Collection of the artist

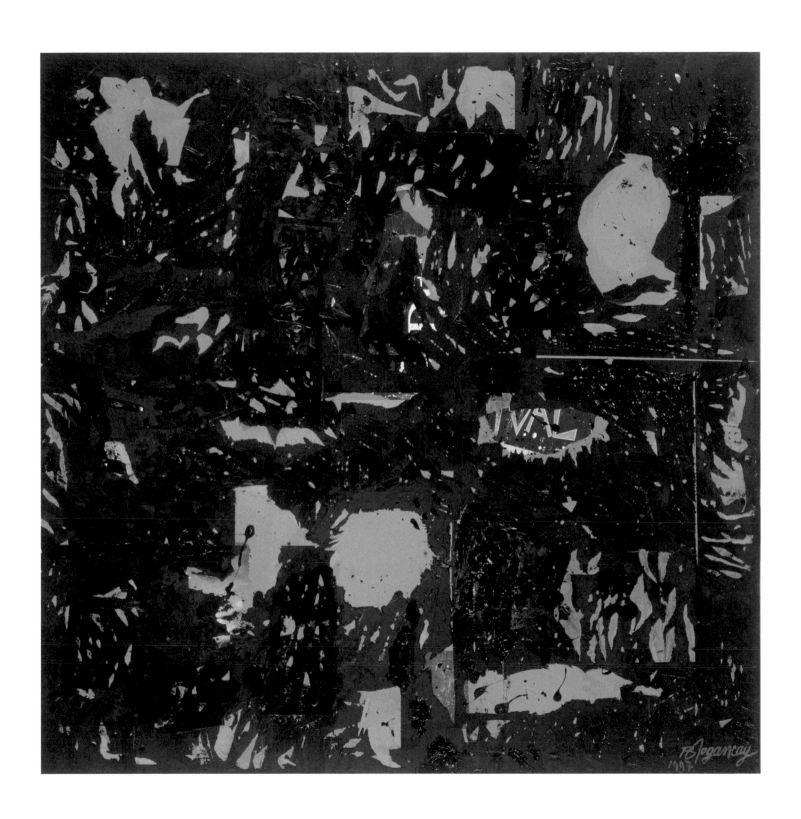

107
WHAT GLUE CAN DO. 1997
Acrylic on paper collaged onto canvas
152.4 x 203.2 cm (60 x 80 in.)
Collection of the artist

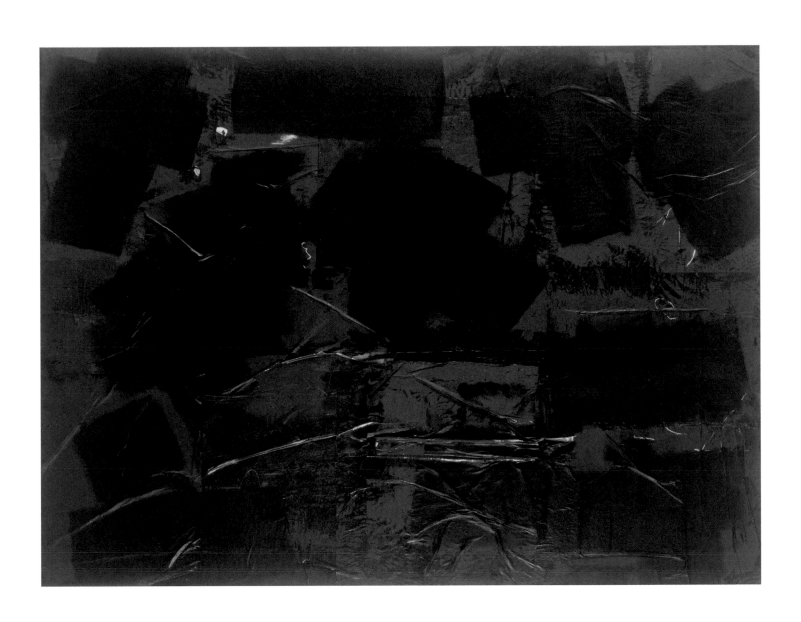

108
PROTRUDING BRICKS. 1997
Acrylic on paper collaged onto canvas
150 x 203 cm (59.1 x 79.9 in.)
Collection of the artist

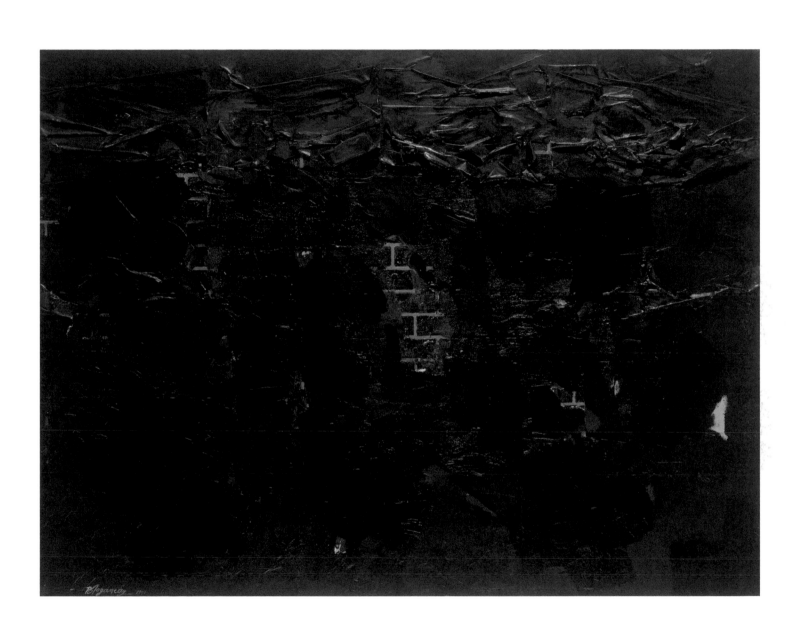

109
GARDEN OF EDEN. 1997
Acrylic on paper collaged onto canvas
101.6 x 127 cm (40 x 50 in.)
Bayerische Staatsgemäldesammlungen-
Pinakothek der Moderne München
Donation to the American Patrons of the Pinakothek

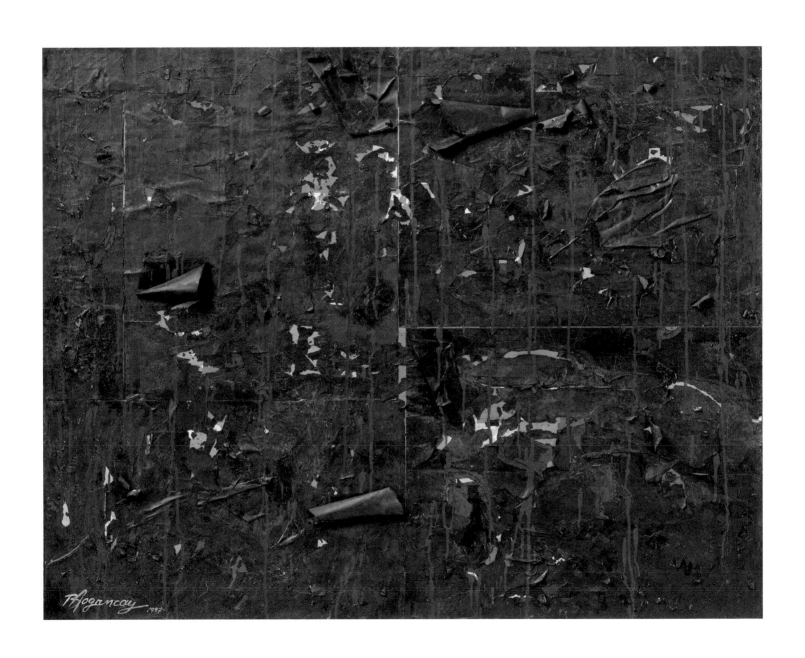

110
SCORCHED FACES. 1999
Collage, acrylic, fumage and mixed media on canvas
127 x 152.4 cm (50 x 60 in.)
Private collection

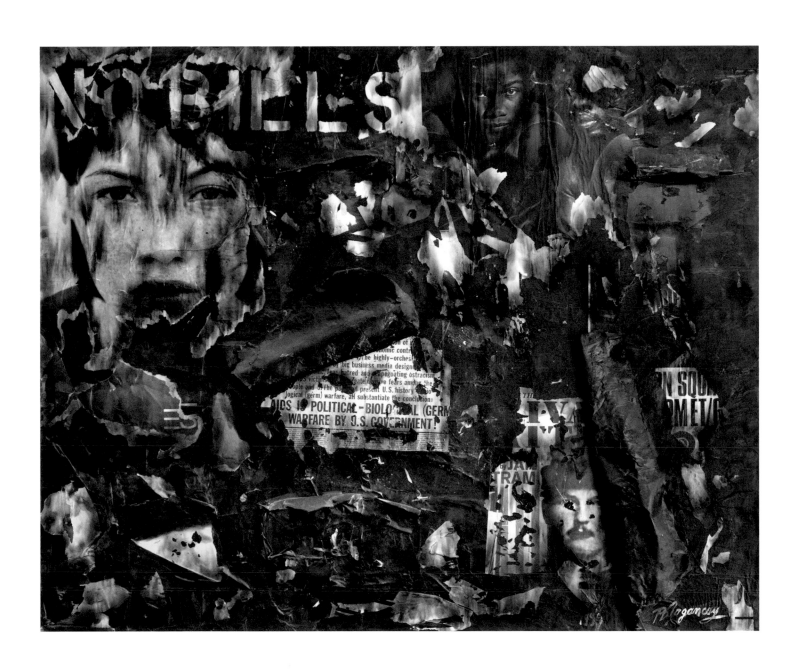

111
PEELING ALEXANDER. 1999
Acrylic on paper collaged onto canvas
130 x 110 cm (51.2 x 43.3 in.)
Collection of the artist

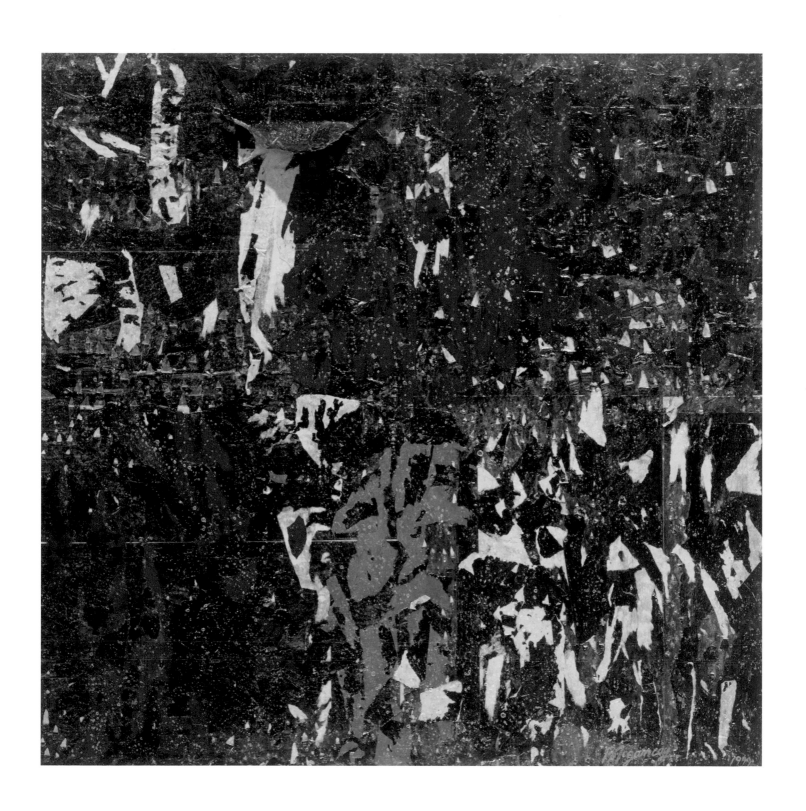

112
SADDAM & OTHER POLITICIANS. 1999
Collage, acrylic and fumage on canvas
128 x 152.5 cm (50.4 x 60 in.)
Collection of the artist

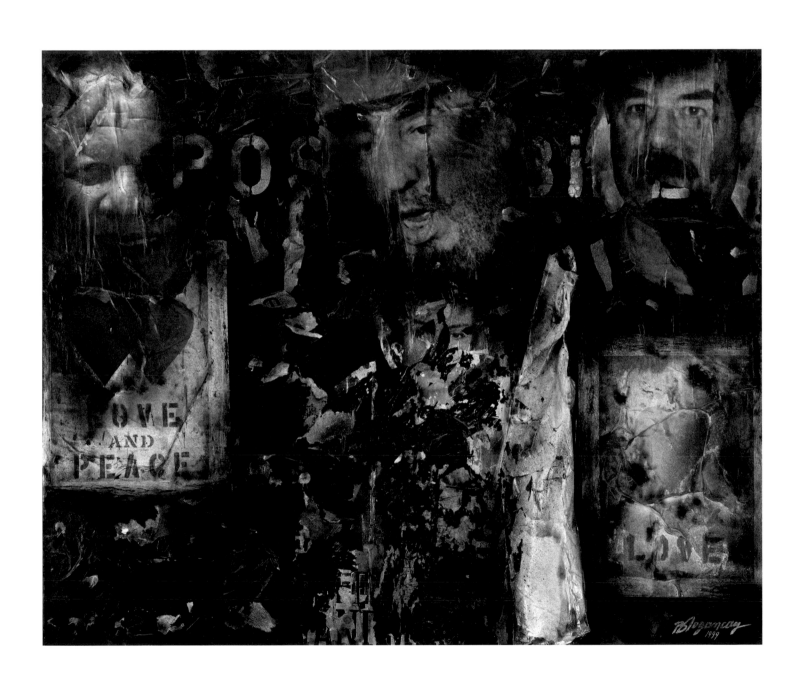

Blue Walls of New York

1998–2004

While the *Blue Walls of New York Series* may be considered as a continuation of the earlier *New York Subway Walls Series,* it reflects another time and is visually distinct. Initial inspiration was provided by the blue-painted construction fences erected on some subway platforms when New York's Metropolitan Transit Authority undertook a major remodeling of subway stations, and later by similar fences or screens that appeared on city streets. The authorities sometimes affixed temporary signs to the blue screens, as permanent ones had been covered up. They also tried imposing a 'Post No Bills' rule, but to no avail, as these inviting blue surfaces proved a magnet to all manner of graffiti and stickers.

113
BEN. 2002
Collage, acrylic and mixed media on canvas
114 x 195 cm (44.9 x 76.8 in.)
Dr. Nejat F. Eczacıbaşı Foundation Collection

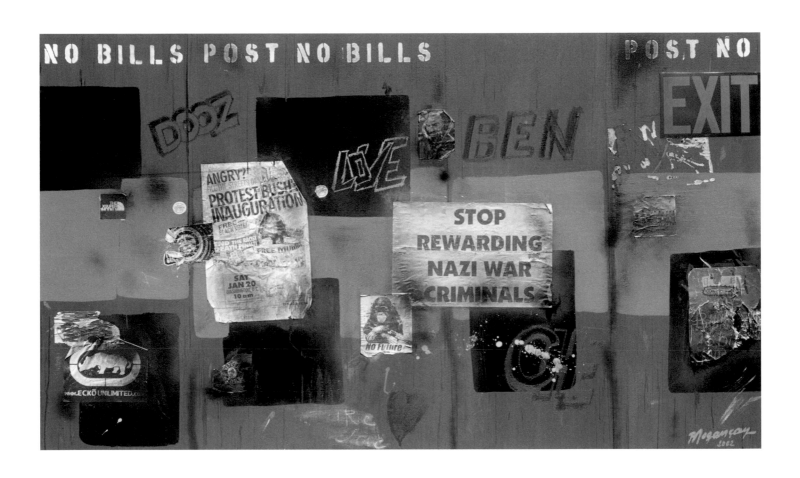

114
AIDS STREET. 2002
Collage, acrylic and mixed media on canvas
97 x 130 cm (38.2 x 51.2 in.)
Collection of the artist

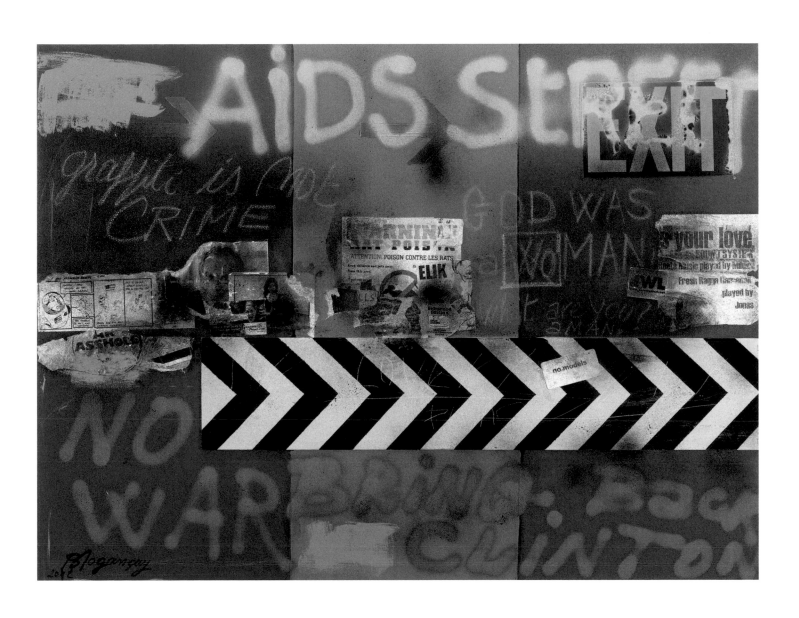

FIFTY YEARS OF URBAN WALLS **267**

115
TURTLE. 2002
Collage, acrylic and mixed media on canvas
89 x 130 cm (35 x 51.2 in.)
Collection of the artist

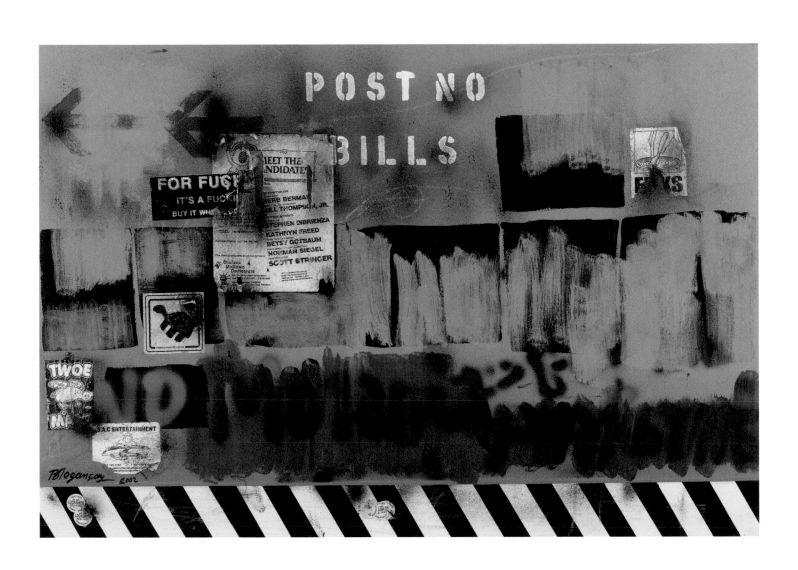

116
SLICK RICK. 2004
Collage, acrylic and wood on canvas
89 x 130 cm (35 x 51.2 in.)
Collection of the artist

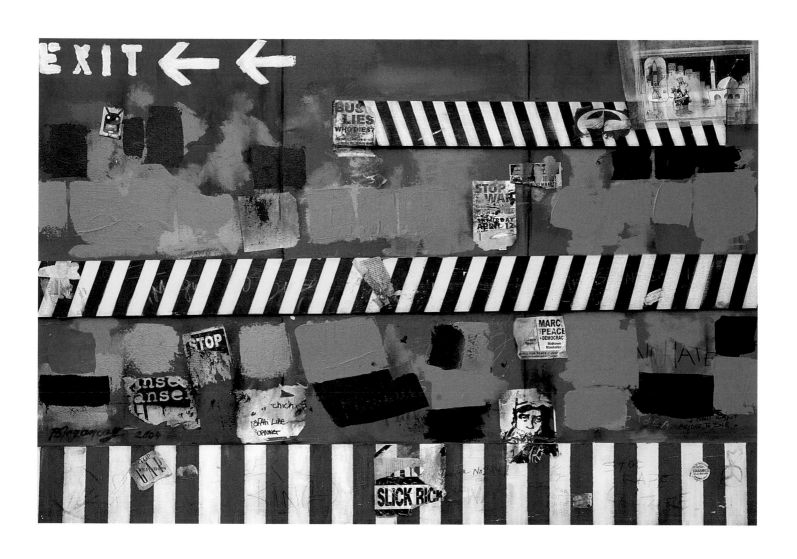

117
READ MY APOCALIPS. 2004
Collage, acrylic and wood on canvas
89 x 130 cm (35 x 51.2 in.)
Private collection

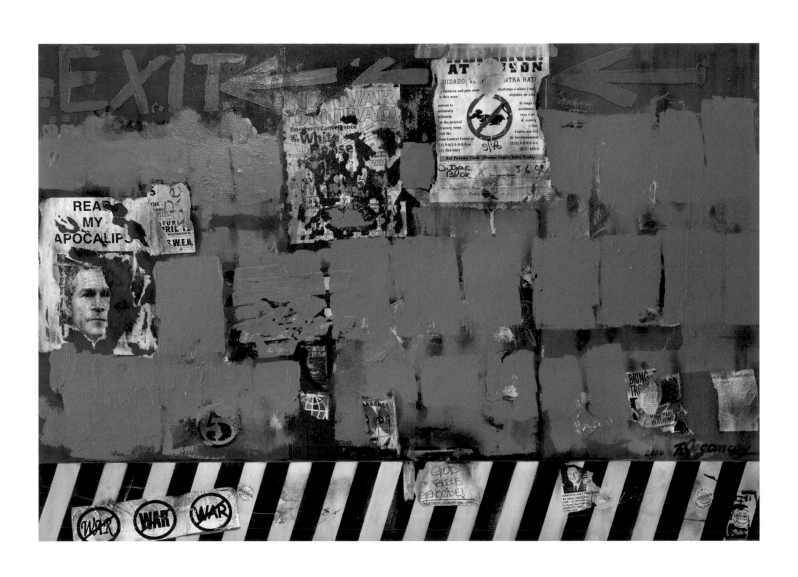

Framed Walls

2008–ongoing

These mature collages, which fill the areas of their canvas tightly from edge to edge, are from Dogançay's most recent series. Their distinct feature is the inclusion of wooden frames set around portraits of famous contemporary or historic personalities, as well as ordinary people, that contrast with the chaotic profusion of comments and images surrounding them.

118
JAMES DEAN. 2008
Collage, acrylic, fumage, stapled wood frame
and coffee stains on canvas
146 x 146 cm (57.5 x 57.5 in.)
Collection of the artist

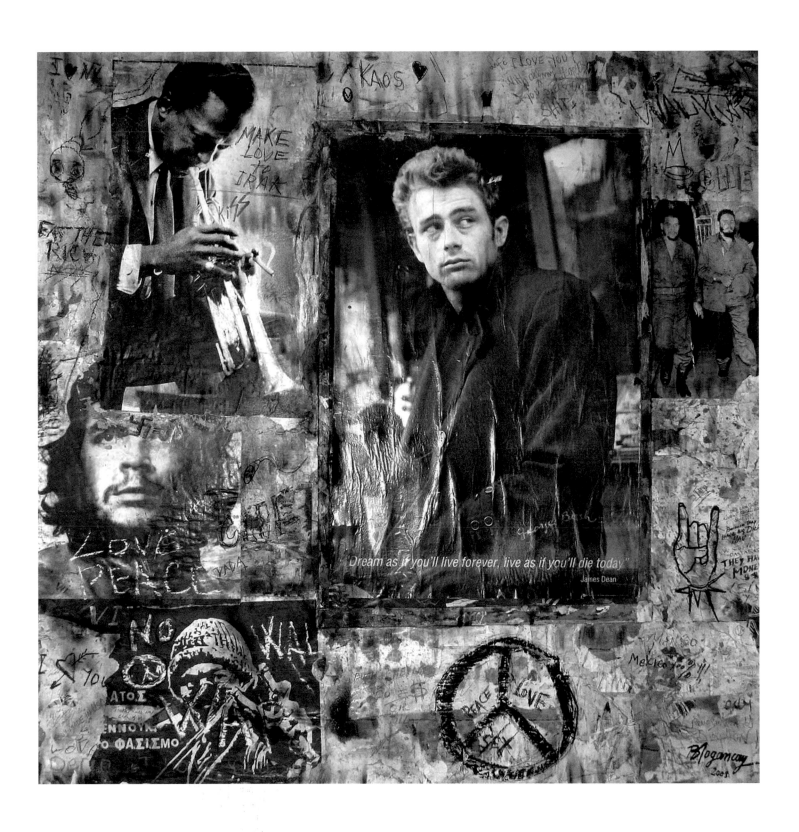

119
JLO. 2008
Collage, acrylic, fumage, coffee stains,
wood strips, oil and felt pen on canvas
146 x 146 cm (57.5 x 57.5 in.)
Collection of the artist

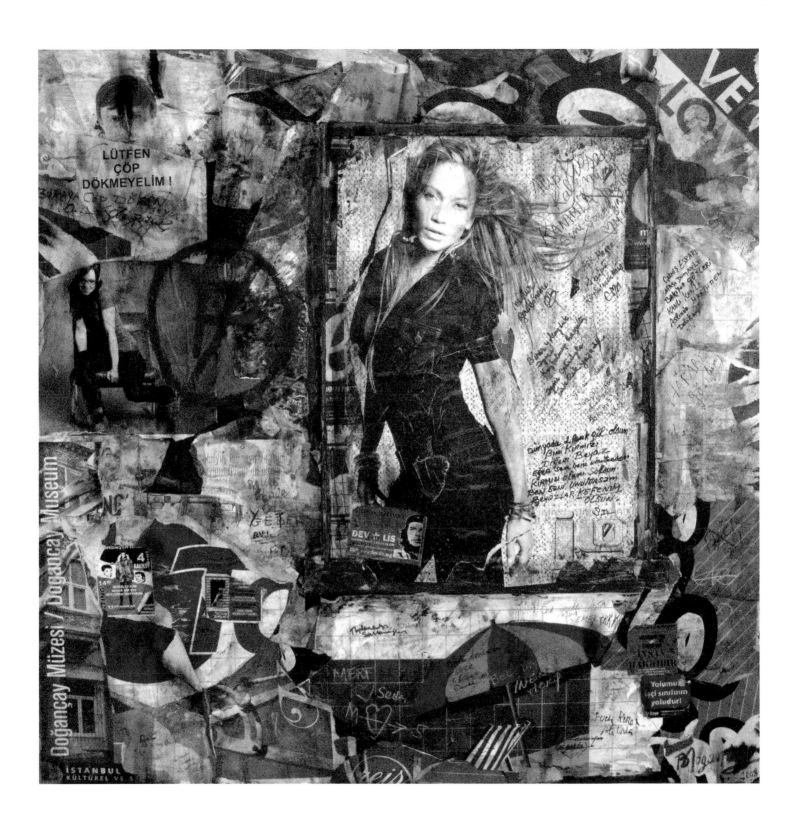

120
EYE OPENER. 2009
Collage, acrylic, sand, cement, fumage, coffee stains
and picture frame on colored, digitally printed canvas
104 x 157 cm (41 x 62 in.)
Collection of the artist

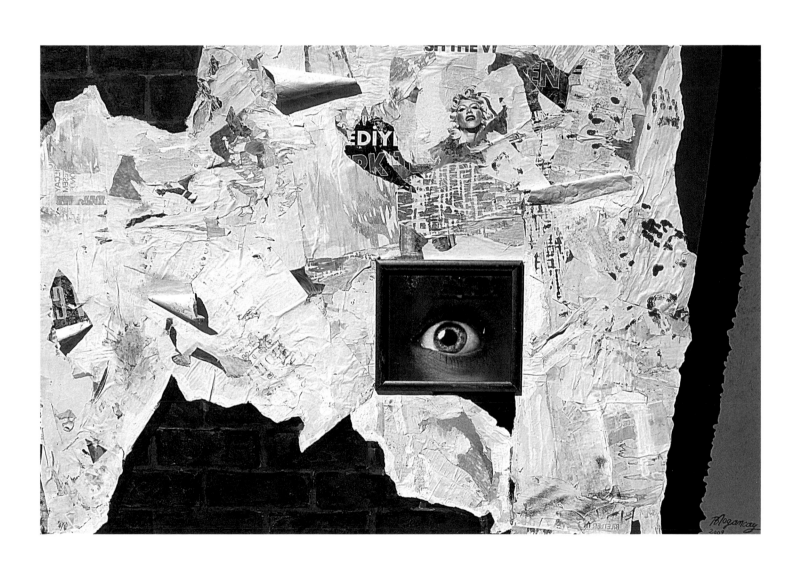

121
THE DRAWN CURTAIN. 2009
Collage, acrylic, sand, cement, coffee stains and
picture frame on colored digitally printed canvas
154.5 x 104 cm (60.8 x 40.9 in.)
Collection of the artist

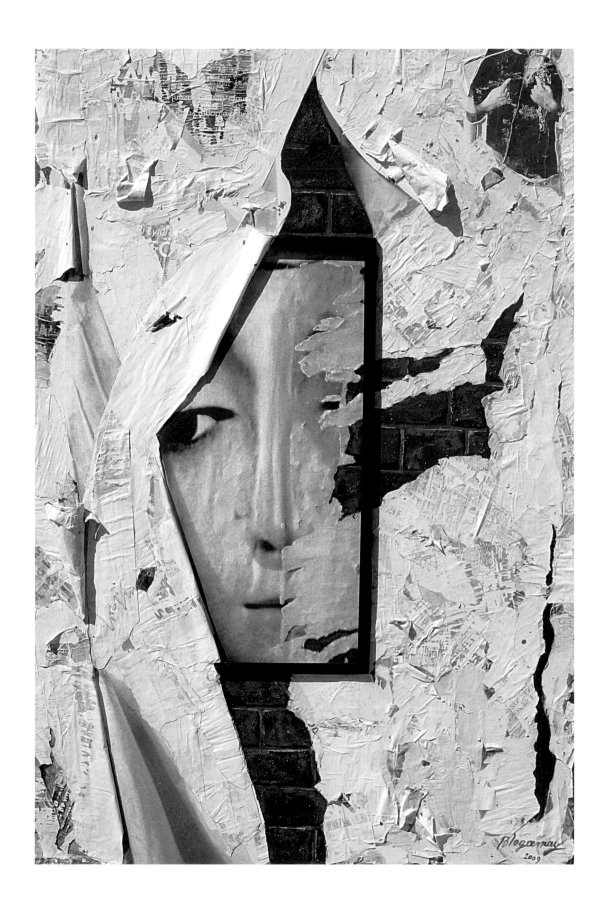

122
RISING STAR. 2009
Collage, acrylic, picture frame, oil and
fumage on wooden strips mounted on
colored digitally printed canvas
155 x 104 cm (61 x 40.9 in.)
Collection of the artist

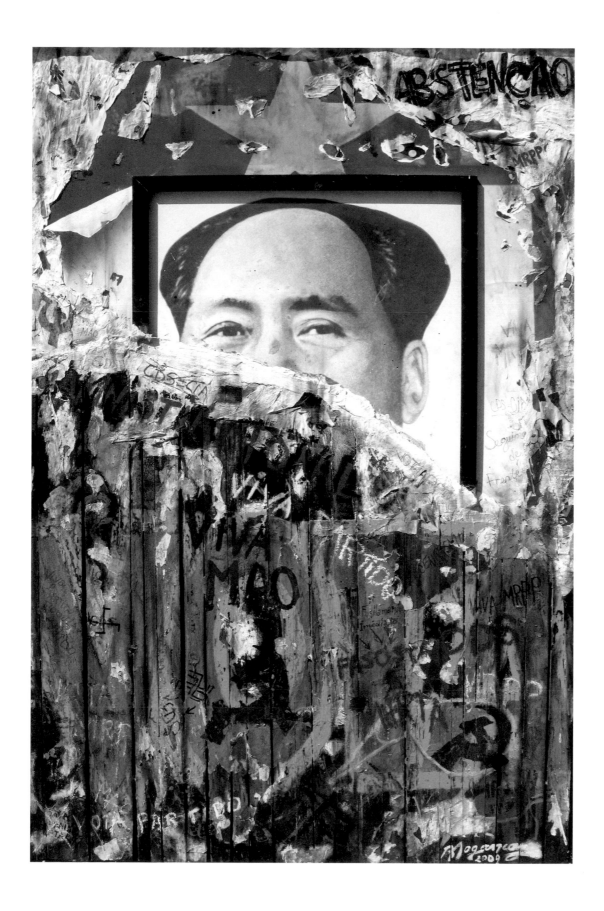

123
BERLUSCONI. 2010
Collage, acrylic, fumage, wooden frames
and sand on canvas
204 x 204 cm (80.3 x 80.3 in.)
Collection of the artist

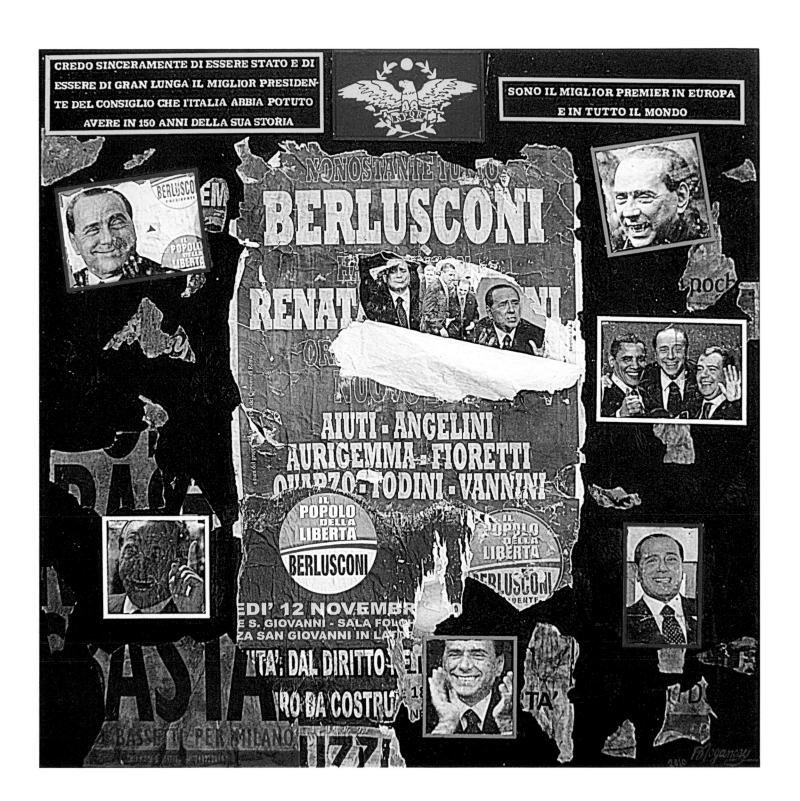

124
ÇÖP ATMA. 2010
Collage, acrylic, fumage, wooden frames,
metal doorknob and lock, pastel, sand and
coffee stains on canvas
150 x 220 cm (59.1 x 86.6 in.)
Collection of the artist

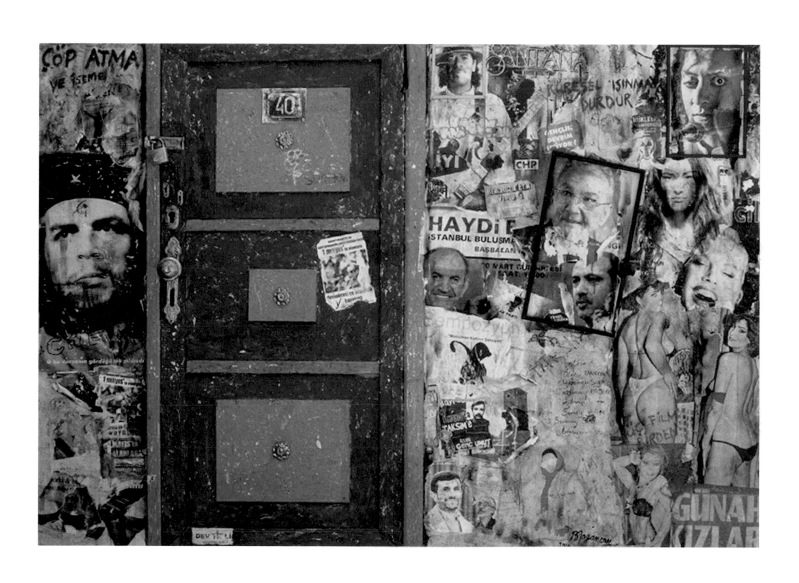

125

IN OIL WE TRUST. 2010
Collage, acrylic, wooden frames, sand,
spray and coffee stains on canvas
204 x 408 cm (80.3 x 160.6 in.)
Şahinöz Collection

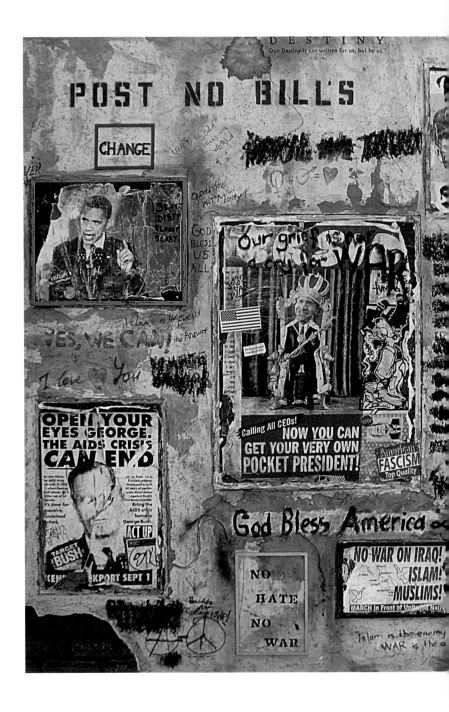

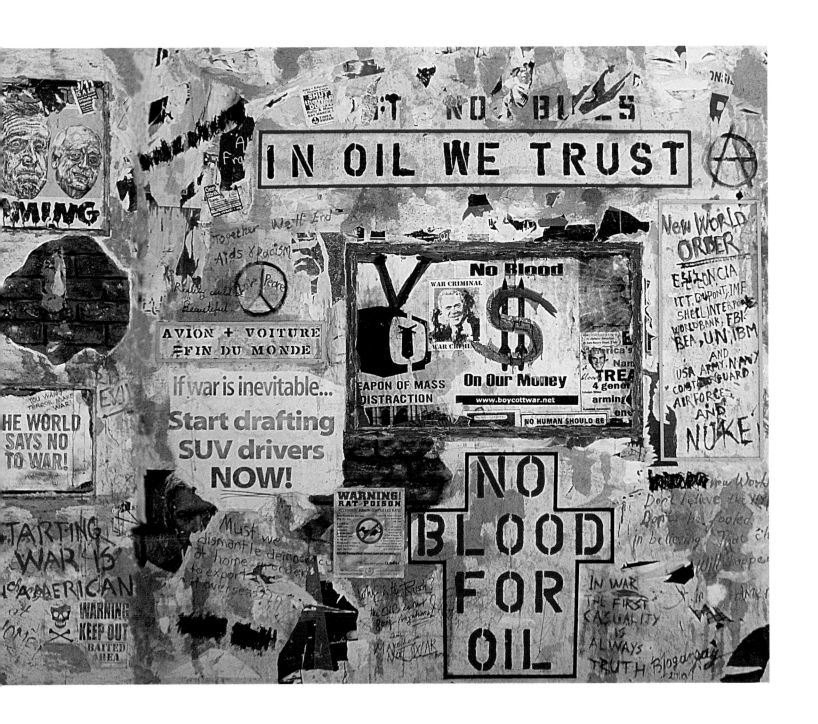

126
QUEENS OF HEARTS. 2010
Collage, acrylic, wooden frames,
coffee stains and spray on canvas
150 x 220 cm (59.1 x 86.6 in.)
Collection of the artist

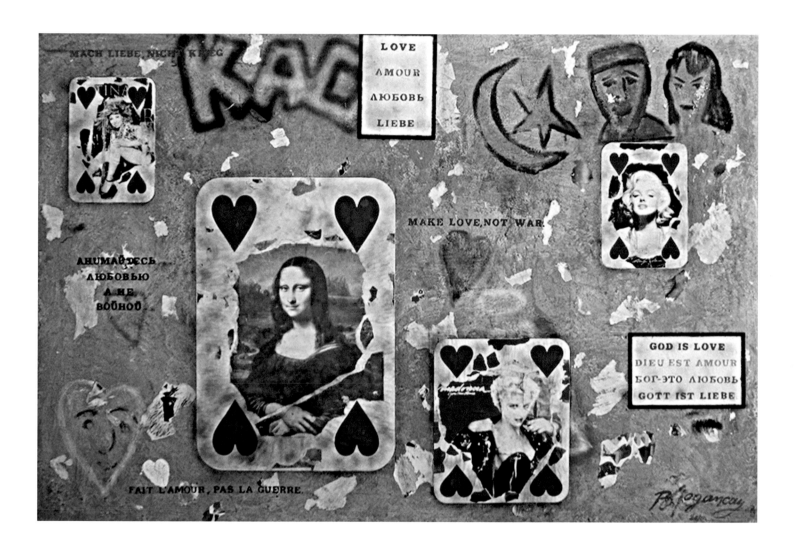

Compiled by
Angela Dogançay and
Clive Giboire

Chronology

1929

Istanbul, Turkey: Burhan Dogançay is the first of three children born to Adil Dogançay, a well-known painter and topography officer in the Turkish army, and his wife, Hediye.

1933–1950

Dogançay starts drawing at the age of four. His father encourages his son's talent and often takes him with him on tours of duty in the countryside so they can draw together.

During his high school years in Ankara, he takes courses with Arif Kaptan, a well-known painter, whose emphasis, like his father's, is on drawing.

Plays soccer for the Ankara team Gençlerbirliği.

After finishing high school, he enrolls at the University of Ankara, from which he graduates with a law degree.

1950

Goes to Paris to continue his studies. To learn French, he stays for several months in Honfleur, the coastal town once popular with the Impressionists. There he plays soccer with the local team, paints, and shows his watercolors at Madame Boutiron's fishmonger's shop.

1951

Fluent in French, he returns to Paris to study economics at the Université de Paris and attend art courses at L'Académie de la Grande Chaumière.

1952

In order to supplement his meager allowance, he acts as a stand-in for Ronald Shiner during the filming of the British movie *Innocents in Paris*, and performs various other odd jobs, including acting as a night guard at the American student's residence at the university, tending bar, and sweeping the floor of an American church.

Participates in group shows at the American House, Cité Universitaire, Paris.

Travels to Denmark, where he does research for his doctoral thesis: "Le Rôle de la Coopération et les Progrès de l'Agriculture Danoise" (The Role of Cooperatives and the Progress of Danish Agriculture).

Travels to Sweden, Germany, Switzerland, and Italy.

1953

Receives a doctorate in economics from the Université de Paris.

1954

Has a calcification surgically removed from his right lung and spends about six months convalescing in a sanatorium near Paris, where he paints watercolors of the surroundings, a surviving work on paper being *Spring in Paris II*.

After his recovery he travels around France before returning to Istanbul from Marseille on the *Ankara*, the same ship that initially took him to France.

1955

Returns to Ankara to work for the Ministry of Commerce.

First joint exhibition with his father at the Art Lovers Club, Ankara.

1957

Second joint exhibition with his father at the Art Lovers Club, Ankara.

1958

As Director of the Turkish Pavilion at the World's Fair in Brussels, Dogançay meets Princess Grace of Monaco, King Baudouin of the Belgians, Prince Bernhard of the Netherlands, Princess Beatrix of the Netherlands, and many other dignitaries and celebrities.

1959

Third joint exhibition with his father at the Art Lovers Club, Ankara.

Is appointed Director of the Turkish Tourism Department. Represents Turkey and the Middle East at the XIV General Assembly of the World Tourist Conference in Manila.

Travels around the world and visits the United States for the first time.

1961

Five of his paintings are selected for the *Twenty-Second Annual State Exhibition of Painting and Sculpture* in Ankara.

1962

Posted to New York as Director of the Turkish Information Office.

In spite of long work-filled days on the 58th floor of 500 Fifth Avenue, Dogançay still finds time for his art, even returning late at night to paint the

Dogançay with his father, Ankara, 1952

Manhattan skyline from his office windows. His cityscape watercolors are well received.

1963

Represents Turkey in the *World Show* exhibition at Washington Square Galleries, New York, which includes works by other up-and-coming artists such as Jasper Johns, Andy Warhol, and Willem de Kooning.

Chooses urban walls as his leitmotif and starts recreating on paper a few of the public walls that he has observed in the streets of Manhattan. This marks the start of his ongoing *General Urban Walls Series*. From this point on, Dogançay strives to bring the expression 'wall art' into the art world's lexicon.

1964

Resigns his government post to realize a childhood dream of being a painter full-time. Starts searching the streets of New York for inspiration and raw materials for his collage and assemblages.

Has his first American exhibition at Ward Eggleston Galleries, New York City. Although the exhibition is a critical success, no works are sold.

Receives a Certificate of Appreciation from the City of New York in recognition of his interpretation of New York City in a collection of 80 paintings.

Meets and is befriended by Thomas M. Messer, Director of The Solomon R. Guggenheim Museum. Messer significantly influences Dogançay's career, urging him to stay in New York and face the City's challenges.

1965

Works based on doors are added to his chosen subject matter. Works in the *Doors Series* are created entirely from scratch, though some include transformed *objets trouvés*, rescued from demolition sites.

His watercolors of New York are featured on the cover of the *Journal American* issues of January 3 and August 8.

Billboard (1964) is acquired by the Solomon R. Guggenheim Museum, New York, and becomes Dogançay's first work in a permanent museum collection.

1966

One of his New York watercolors is again featured on the cover of the *Journal American* (February 27 issue).

Creates three windows as part of the *Doors Series*. One of them is later acquired by the Bayerische Staatsgemäldesammlungen,

Pinakothek der Moderne, Munich, and another one by the Walker Art Center, Minneapolis.

Begins the *Detour Series* that comprise a subgroup of the *General Urban Walls Series*. Differentiated mostly by wood panels mounted on canvas each of these works features the word "detour" and arrows pointing the way.

1967

Starts his *New York Subway Walls Series* at this point, when most of the city's subway stations were blitzed by graffiti, and continues it for over 30 years until most of them have undergone major restoration.

1969

Henry Geldzahler, head of the Twentieth-Century Art Department at New York's Metropolitan Museum of Art, sponsors Dogançay for a fellowship at the Tamarind Lithography Workshop, Los Angeles, where he produces 16 lithographs, including *Walls V*, a portfolio of 10 lithographs in a limited edition of 20.

1970

Produces *Wall 70*, 15 lithographs in an edition of 120, at the Bank Street Atelier, New York.

1972

Produces the first work in his *Breakthrough Series*, which will continue through the late 1970s. The distinctive feature of the *Breakthrough* works are two layers of paper, with the bottom one apparently "breaking through" the top layer, which in turn curls away from the bottom layer, casting shadows that provide a striking three-dimensionality. This series heralds the *Ribbons* and *Cones Series* that follow shortly after.

The *Ribbons Series* that marks an important transition from Dogançay's hitherto realistic rendering of weather-beaten, grimy urban walls to a more refined, abstract approach that incorporates elegant experiments in shadow and light. Torn ribbon-like shreds of paper seemingly burst out of the wall, casting shadows that form extended calligraphic shapes.

Dogançay's Aubusson tapestries and Alucobond metal sculptures will be based on imagery from this series.

Cone shapes are frequently formed as posters curl up from walls under the influence of the elements and human touch. They provide the inspiration for his third important and distinctive series. Most works from the *Cones Series* incorporate collage, *fumage*—a blackening effect achieved with smoke from a lit candle— and *tromp l'oeil* effects.

Dogançay with Mayor Wagner at City Hall, New York, 1964

Billboard on exhibit (*Some Recent Gifts*) at The Solomon R. Guggenheim Museum, New York, 1965

Starts producing a playful series, *Ships*, using layers of paper in the shape of ship sails.

Meets his future wife, Angela Hausmann, at the Hungarian Ball at the Hotel Pierre, New York.

1974

UNICEF selects Dogançay's *Emergence* as the design for a greeting card.

1975

A trip to Israel marks the beginning of Dogançay's *Walls of the World* photographic documentary, a unique archive of our times, which has since grown to some 30,000 photographs of walls from well over 100 countries.

1976

One of Turkey's leading art dealers, Yahşi Baraz, hosts Dogançay's first exhibition in 15 years in Istanbul. This exhibition revolutionizes the Turkish art market, partly because the works are offered at international gallery prices. The show, however, is a huge success and almost completely sells out. Photographer and later the long time head of the Istanbul Foundation for Culture and Arts from 1993 till 2010, Şakir Eczacıbaşı predicts that this exhibition will become a historic milestone, marking the maturity of the Turkish art scene.

Lives in Switzerland until 1977 and travels extensively for his *Walls of the World* project.

1977

Produces 4 lithographs, *Walls 77*, in an edition of 75 at J.E. Wolfensberger Graphische Anstalt, Zurich.

1978

Returns to New York City where he marries Angela Hausmann.

Major works from the *Ribbons Series* are shown for the first time in a solo exhibition at the Gimpel & Weitzenhoffer Gallery, New York.

1979

With the permission of the Turkish government, Dogançay assumes dual citizenship (Turkish-American).

1982

One-man show of the *Walls of the World* project, entitled *Les murs murmurent, ils crient, ils chantent…,* opens at the Centre Georges Pompidou, Paris.

At Walkemühle, Germany, he experiments with his father-in-law, engineer and inventor Gerhard Hausmann, to produce shadow sculptures from aluminum.

For a program entitled *Art and the Environment*, Tunisian State TV produces a documentary about graffiti and city walls in two separate segments, one featuring Burhan Dogançay and the other Keith Haring.

Begins the *Housepainter Series*, inspired by walls Dogançay has seen in Turkey and Poland on which housepainters paint test swatches of paint with the cost per square meter alongside.

1983

Introduces Alucobond Shadow Sculptures, produced by the Research and Development Center of Swiss Aluminium Ltd., Neuhausen am Rheinfall, Switzerland.

In Paris, Dogançay is introduced to Maître Raymond Picaud and his son Jean-François of L'Atelier Raymond Picaud, Aubusson, France. Fascinated by Dogançay's *Ribbons Series* as ideal tapestry subjects, they instantly invite Dogançay to submit several tapestry cartoons. In the words of Jean-François Picaud, "the art of tapestry has found its leader for the 21st century in Burhan Dogançay."

Receives the Golden Palette Big Honor Award from *Ev&Ofis* magazine, Istanbul.

1984

The first three Dogançay tapestries woven at L'Atelier Raymond Picaud are an immediate critical success. Over the next several years a total of 14 tapestries are produced at L'Atelier Raymond Picaud.

Wins the Enka Arts and Science Award, Istanbul.

Travels to North and West Africa for the *Walls of the World* project.

1984–1986

Photographically documents skyscraper construction in New York. Secures special permission to ascend Manhattan skyscrapers and photograph ironworkers at work. His friendship with the ironworkers eventually leads him to the top of the Brooklyn Bridge during its major 1986 restoration, giving him the exclusive opportunity to take photographs of the bridge draped in safety nets. Paul Anbinder, publisher of Hudson Hills Press, wrote that these images are "one of the most sustained and serious artistic responses to the Brooklyn Bridge in our time."

1985

The construction weekly, *Engineering News-Record*, features a Dogançay photograph of Philip Johnson's Lipstick Building on the cover of its September 5 and September 19 issues.

Dogançay with his wife, Angela, 1999

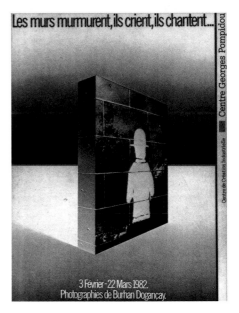

Les murs murmurent, ils crient, ils chantent… exhibition poster, Centre Georges Pompidou, Paris, 1982

Dogançay on top of the Brooklyn Bridge, 1986

Mimar Sinan and *Magnificent Era* on view during the First International Istanbul Biennial, 1987

Dogançay at the Great Wall of China, 1988

Dogançay working with light and shadow on *15.000 TL @ Pair*, Istanbul, 1991

Walls and Doors 1990–91 exhibition at the Artists' Union, Moscow, February 26–March 28, 1992

1986

Hudson Hills Press, New York, publishes the monograph, *Dogançay*, edited by Roy Moyer, with an introduction by Thomas M. Messer, to accompany the exhibition *Two Decades of Walls* at Hamideh Bayley Gallery, Greene Street, New York, the following year.

Participates in the First International Asian-European Art Biennial, Ankara.

1987

Participates in the First International Istanbul Biennial by showing three major works on canvas from the *Cones Series*: *Mimar Sinan*, *Magnificent Era*, and *Symphony in Blue*.

1988

In New York's SoHo, Dogançay comes across a multicolored brick wall with the tag of graffiti artist 'GREGO' written across it. Wondering why bricks are not cheerfully multicolored in reality, Dogançay inaugurates his *GREGO Series*, which will continue until 2012, that uses painted bricks as its support system. GREGO becomes an alter ego for Dogançay, enabling him to demonstrate through artwork how walls speak of issues that address passersby.

Travels to Australia, Southeast Asia, the Far East, China, and Eastern Europe for the *Walls of the World* project.

The French magazine *Décoration Internationale* features one of Dogançay's Aubusson tapestries on its October cover.

Travels to Central and South America for the *Walls of the World* project.

1989

Participates in the IX Bienal Internacional de Arte, Valparaiso, Chile.

1990

The 1990s is one of the most prolific decades in Dogancay's artistic trajectory. During the first half of this period he creates two notable series: *Double Realism*, in which he plays with light and shadow from incorporated found objects in such a way that it is not immediately apparent whether the shadows are real or painted; and *Formula 1*, inspired by the walls of Monaco when they are partly covered with black plastic during the Formula 1 Grand Prix to avoid distracting the drivers.

Dogancay's father, Adil, dies.

Travels to Central America and Cuba for the *Walls of the World* project.

Following the acquisition of a Dogançay collage on canvas by Kunsten Museum of Modern Art Aalborg, the Danish daily *Morgenavisen Jyllands-Posten* heralds Dogançay

a "Collagens Mester"—a Master of Collage.

1991

Travels to Togo, Benin, South Africa, Namibia, Zimbabwe, and Russia for the *Walls of the World* project. While taking photographs of walls in downtown Johannesburg, he is attacked at knife point and robbed of his cameras, which thanks to the help of plainclothes policemen are retrieved; luckily, Dogançay walks away with only a few scratches.

Produces *Walls–1980*, ten silkscreens in an edition of 100, at Artess Çamlıca Art Studio, Istanbul, under the supervision of Suleyman Saim Tekcan.

1992

As guest of Russia's Ministry of Culture, which honors him with its Medal of Appreciation, he is the first Western artist to have a solo exhibition (*Walls and Doors 1990-91*) at The State Russian Museum, St. Petersburg. The exhibition subsequently travels to the Artists' Union, Moscow.

Dessine-Moi l'Amour featuring a selection of Dogançay's *Walls of the World* photographs, with texts by Gilbert Lascault and Denys Riout, is published by Editions Syros Alternatives, Paris.

1993

The City of Aubusson, France, acquires a tapestry designed by Dogançay and executed by Atelier Raymond Picaud for the mayor's office.

After having worked 30 prolific years out the confined space of his two-bedroom midtown Manhattan apartment, he can finally afford a lofty penthouse studio in the landmark SoHo Singer Building, New York.

1994

Exhibits an extensive collection of door and wall paintings at the Nicholas Alexander Gallery in SoHo, New York. The exhibition is accompanied by *Doors & Walls*, a catalogue with an essay by Eleanor Flomenhaft.

UNICEF chooses one of Dogançay's paintings as the design for a placemat.

The French publisher, Gallimard, chooses one of Dogançay's paintings as the cover image for Julian Barnes' novel *Love, etc.*

1995

Starts work on the *Alexander's Walls Series* of large-scale canvases of great presence that evokes the boarded-up exterior of the defunct Manhattan department store, which at one point, though covered by black paper and paint, soon showed signs of wear and tear with colors

showing through rips and holes in the black ground.

Receives the National Medal of the Arts for Lifetime Achievement and Cultural Contribution from the President of Turkey, the highest honor that country bestows on an artist.

Travels to Vietnam, Burma, Nepal, Bangladesh, Sri Lanka, Bahrain, Qatar, Oman, United Arab Emirates, Yemen, Lebanon, and Syria for the *Walls of the World* project.

The Paris Review chooses a Dogançay image, *Detour V* (1994), for the cover of Issue 134.

1996

Contributes two photographs from his *Walls of the World* collection for two UNICEF greeting cards.

Moves to a new studio on the 8th floor of the Singer Building, New York.

1997

Travels to Azerbaijan, Ukraine, and Macedonia for the *Walls of the World* project.

1998

Receives an award for Turkish Cultural Heritage and Art in the field of visual arts from *Antik&Dekor*, Istanbul.

Blue Walls of New York Series is essentially a continuation of the *New York Subway Walls Series*. Initially inspiration was provided by the blue fences erected during station remodeling and later by similar ones seen on the city streets.

JFK International Airport celebrates New York City's Centennial by inaugurating an exhibition of 19 of Dogançay's large-scale photographs entitled *Brooklyn Bridge As Never Seen Before*, which will remain on show for two years in its international-arrivals building. These photographs will also be featured in the book *Bridge of Dreams* published by Hudson Hills Press the following year.

1999

Official launch of *Bridge of Dreams* by Philip Lopate, a book of Dogançay's Brooklyn Bridge platinum prints, at the Brooklyn Public Library, followed by additional book signing events at the Brooklyn Historical Society, the Museum of the City of New York, and Barnes & Noble bookstores.

Buys an old, dilapidated five-story building in the Beyoğlu district of Istanbul and with the help of his friends Oktay Duran and Cem Bahadir starts its three-year restoration. It is intended to house a representative cross section of works by Burhan and Adil Dogançay.

Inclusion of a Dogançay Brooklyn Bridge photograph in the Museum of the City of New York's 20th-century exhibition, *The New York Century: World Capital, Home Town, 1900–2000.*

2000

Produces *Dogançay–2000*, ten silkscreens in an edition of 100, at Sinan Demirtaş Workshop in collaboration with Artess Çamlıca Art Studio, both of Istanbul.

Travels to Kazakhstan, Kyrgyzstan, Turkmenistan, and Uzbekistan for the *Walls of the World* project.

2001

Holds his first retrospective exhibition at Dolmabahçe Cultural Center, Istanbul, under the sponsorship of the Dr. Nejat F. Eczacıbaşı Foundation.

2002

Since the beginning of the decade, the demand for Dogançay's work from museums has considerably increased and new acquisitions over the following years include: Kunstmuseum Basel; Museum Moderner Kunst, Vienna; Moderna Museet, Stockholm; Staatsgalerie Stuttgart; the Solomon R. Guggenheim Museum, New York; the Whitney Museum of American Art, New York; and the British Museum, London.

Undergoes open-heart surgery.

2003

Fully recovered from surgery and charged with new energy, Dogançay makes a major leap forward in his artistic career.

Moves to Istanbul in the spring to supervise the completion of work on the Dogançay Museum.

Receives *Alem Magazine*'s Lifetime Achievement Award and is also honored with a Medal of Appreciation by his former soccer team, *Gençlerbirliği.*

Under the auspices of the Turkish Government, Dogançay's *Homage to Calligraphy* (1981) is presented to the headquarters of the European Parliament, Brussels.

Travel to Batum, Georgia, for the *Walls of the World* project brings the total number of countries visited to 113.

Siegerland Museum, Siegen, Germany, exhibits 80 large-scale photographs from his *Walls of the World* archive, and Kerber Verlag, Bielefeld, publishes a companion book to the exhibition.

Burhan Dogançay: Works on Paper: 1950–2000 by Richard Vine is published by Hudson Hills Press, New York.

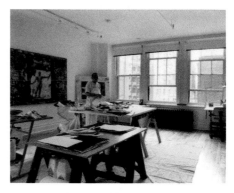

Dogançay in his New York studio, 1997

Dogançay studying and sketching a wall at the Spring St. subway station, New York, 1998

Iş Bankası, Istanbul, organizes a charity exhibition with 18 canvases and 15 works on paper of Dogançay's *Blue Walls of New York Series* at Kibele Art Gallery to benefit the Turkish Educational Volunteers Foundation, an organization providing education to underprivileged children.

2004

With the accession of *Walls V*, a portfolio of 10 lithographs created at the Tamarind Workshop, Dogançay becomes the first contemporary Turkish painter to be represented in the New York Metropolitan Museum of Art's permanent collection.

In March, travels again to Athens, Greece, to document the walls before the elections and subsequently to Cyprus, bringing the number of countries visited to 114.

On October 6, the Dogançay Museum, Istanbul, is officially inaugurated.

In March, receives *Best Painter of 2002-2003 Award* from Sanat Kurumu, Ankara, and in December receives an honorary doctorate from Hacettepe University, Ankara.

2005

In cooperation with the Municipality of Greater Istanbul, the Dogançay Museum organizes its first juried art competition for school children between the ages of 6 and 14. The subject is the Beyoğlu district of Istanbul and various corporate sponsors provide prizes.

In November, the Institut Français d'Istanbul hosts an exhibition of nine of Dogançay's Aubusson tapestries. To coincide with the exhibition, Thomas M. Messer is invited under the joint auspices of the Dogançay Museum and Bilgi University, Istanbul, to lecture at the university on the subject of the role and responsibility of modern art museums.

On November 19, becomes the first recipient of the Art Honor Award to be given annually by the Art Forum Ankara Plastic Arts Fair for important contributors to the promotion of the arts in and outside of Turkey.

2006

A second juried art competition for school children is organized by the Dogançay Museum in cooperation with the Municipality of Greater Istanbul. This time the subject is Istanbul and the first prize a one-week trip to Paris. The art competition becomes an annual event with an average of 7,000 students from 1,500 public and private schools participating.

On December 7 receives an award for his contribution to the arts from the art fair Contemporary Istanbul.

2007

Opens a studio (*Villa Angela*) in Turgutreis, near Bodrum, southern Turkey.

2008

Participates with Jacques Villeglé in *Collage-Décollage: Dogançay-Villeglé*, a two-person exhibition at the Pera Museum, Istanbul. In 2009 this exhibition travels to CentrePasquArt, Biel, Switzerland.

Introduces an on-going series of paintings on canvas, *Framed Walls*, that features wooden frames around collaged posters.

Urban Walls: A Generation of Collage in Europe and America by Brandon Taylor, with an introduction by Thomas Messer, is published by Hudson Hills Press, New York. This in-depth look at the history of modern collage has Dogançay's work as its focus.

2009

A major Dogançay work *Symphony in Blue* (1987) sells at auction for the highest amount ever paid for the work of a living Turkish artist.

Receives *Best Painter of 2008-2009 Award* from Sanat Kurumu, Ankara.

2010

The Burhan-Angela Dogançay Foundation for Art, Culture & Education is established as owner and operator of the Dogançay Museum.

The Ohio University Siegfried Hall Art Gallery holds an exhibition of Dogançay works on loan from the Kennedy Museum of Art, Ohio University, USA.

2011

Named Honorary Ambassador by the Metropolitan Municipality of Istanbul.

Is among the 18 recipients of this year's U.S.-based Golden Turk Awards.

Twenty-five large-scale black-and-white photographs from *Brooklyn Bridge As Never Seen Before* are exhibited at Aria Art Gallery, Florence.

2012

The Metropolitan Museum of Art, New York, acquires *Ribbon Mania* (1982), the first work of Turkish contemporary art to enter its permanent collection.

Contributes a star with a design based on the *Framed Walls Series* to the Stars of Istanbul, an event to benefit UNICEF, which is celebrating its 60th anniversary in Turkey.

Continues to experiment with new wall concepts in his work. Some of the previously distinct series have begun to overlap and fuse.

Divides his time between Istanbul, southern Turkey, and New York.

Left to right: Dogançay, Thomas M. Messer and Yahşi Baraz at Gallery Baraz, Istanbul, 2005

Dogançay with a group of school children visiting the Dogançay Museum, Istanbul, 2006

Villa Angela, Turgutreis, southern Turkey

Compiled by
Angela Dogançay

Bibliography

BOOKS

Blanchebarbe, Ursula. *Walls of the World*. Bielefeld, Germany: Kerber Verlag, 2003.

Lascault, Gilbert and Denys Riout. *Dessine-Moi l'Amour*. Paris: Syros Alternatives, 1992.

Lopate, Phillip. *Bridge of Dreams*. New York: Hudson Hills Press, 1999.

Moyer, Roy (ed.), Jacques Rigaud, Thomas M. Messer, Stephen DiLauro, Marcel van Jole, Roy Moyer, Gilbert Lascault, and Clive Giboire. *Dogançay*. New York: Hudson Hills Press, 1986.

Reisner, Robert. *Graffiti*. New York: Cowles, 1971.

Taylor, Brandon. *Urban Walls: A Generation of Collage in Europe and America*. New York: Hudson Hills Press, 2008.

Vine, Richard. *Burhan Dogançay: Works on Paper, 1950–2000*. New York: Hudson Hills Press, 2003.

EXHIBITION BROCHURES AND CATALOGUES

Aliçavuşoğlu, Esra. *Dönemler*. Exh. brochure, Istanbul: Mine Art Gallery, 2001.

Antmen, Ahu. *Blue Walls of New York*. Exh. cat., Istanbul: İş Bankası, 2003.

Borovsky, Alexander D., Oleg Loginov, and William Zimmer. *Dogançay: Walls and Doors, 1990–91*. Exh. cat., St. Petersburg: State Russian Museum, 1992.

Çalıkoğlu, Levent. *Burhan Dogançay: Shadow Sculptures*. Exh. brochure, Istanbul: Artpro, 2008.

— *Dogançay: Son Çalışmalar. Çerçeveli Duvarlar*. Exh. brochure, Istanbul: Dogançay Museum, 2010.

Cannaday, T. William, and Burhan Dogançay. *New York–New Heights*. Exh. brochure, Houston, Texas: Hooks-Epstein Galleries, 1996.

Castle, Frederick Ted, and Necmi Sönmez. *Dogançay–Walls 1990–93*. Exh. cat., Istanbul: Atatürk Cultural Center, 1993.

Ergüven, Mehmet. *Burhan Dogançay*. Exh. brochure, Istanbul: Görüntü Art Gallery, 2001.

Flomenhaft, Eleanor, and Clive Giboire. *Dogançay: Doors and Walls*. Exh. cat., New York: Nicholas Alexander Gallery, 1994 (2nd rev. ed. 1995).

Giboire, Clive. *Brooklyn Bridge As Never Seen Before*. Exh. cat., Aria Art Gallery, Florence. Poggibonsi: Carlo Cambi Editore, 2011.

Gören, Ahmet Kamil. *Kapılar*. Exh. brochure, Istanbul: Gallery Binyil, 2001.

Gürel, Haşim Nur. *Kalpler*. Exh. brochure, Istanbul: Gallery G, 2001.

Jacobs, J., and Thomas M. Messer. *Burhan Dogançay*. Exh. brochure, Zurich: Kunstsalon Wolfsberg, 1977.

Lascault, Gilbert. *Dogançay*. Exh. cat., Paris: Galerie du Génie, 1990.

Littardi, Arnaud, and Jean-François Picaud. *Dogançay: Tapisseries d'Aubusson*. Exh. cat., Istanbul: Institut Français d'Istanbul, 2005.

Messer, Thomas M. *Burhan Dogançay*. Exh. brochure, Zurich: Kunstsalon Wolfsberg, 1981.

Moyer, Roy. *Burhan Dogançay*. Exh. brochure, Vienna: Oesterreichische Postsparkasse, 1985.

Mullender, Jacques, et al. *Les murs murmurent, ils crient, ils chantent…* Exh. cat., Paris: Centre Georges Pompidou, 1982.

Ogura, Tadao. *Burhan Dogançay*. Exh. cat., Tokyo: Yurakucho Art Forum, 1989.

Piguet, Philippe. *Collage-Décollage: Dogançay-Villeglé*. Exh. cat., Istanbul: Pera Museum, 2008.

Piguet, Philippe and Dolores Denaro. *Collage-Décollage: Dogançay-Villeglé*. Exh. cat., Biel/Bienne: CentrePasquArt, 2009.

Rona, Zeynep, et al. *Burhan Dogançay: A Retrospective*. Exh. cat., Istanbul: Duran Editions, 2001.

Şahinoğlu, Elvan. *Alexander's Walls and Hearts*. Exh. cat., Istanbul: Gallery G, 1998.

ARTICLES

Acar, Barış. "Duvarları kağıt gibi yırtan adam." *Artist*, Istanbul, no. 04/55, April 2005.

Acar, Özgen. "Kapılar ve Duvarlar." *Cumhuriyet*, Istanbul, December 11, 1994.

Akagündüz Özel, Ülku. "25 yıllık hayali olan müzeyi kurdu; ama halka açamıyor." *Zaman*, Istanbul, August 30, 2003.

Akay, Ali. "Duvarın Tuval Üzerinde Yansıması." *Cumhuriyet*, Istanbul, October 20, 1998.

Aksenkal. Pelin. "Müze değil. 'Mucize!'" *Alem*, Istanbul, no. 18, May 2004.

Akyarli Güven, Ayşegül. "Türk koleksiyoner halıdan çagdaş sanata kaydı, ressama New York vitrini göründü." *Hürriyet*, Istanbul, June 21, 2009.

Allyn, Rex. "A Chance for Leisurely Study of Art Works." *Sarasota Herald Tribune*, Sarasota, July 15, 1984.

— "Harmon Features Internationally Known Artist." *The Longboat Observer*, Sarasota, February 21, 1985.

Altuğ, Evrim. "Yedi koldan Dogançay." *Radikal*, Istanbul, April 7, 2001.

Amirsadeghi, Houssein. *Contemporary Art from Turkey–Unleashed*. London: Thames & Hudson, 2010.

Anonymous. "Acclaimed artist not your ordinary painter of walls." *The Athens News*, Athens, Ohio, May 17, 2001.

— "Açılış Tablosuz Yapıldı." *Hürriyet*, Istanbul, October 6, 1983.

— "Altın Palet Büyük Onur Ödülü." *Sanat Çevresi*, Istanbul, no. 60, October 1983.

— "Artist says walls mirror the surrounding world." *The Messenger*, Athens, June 14, 2001.

— "Boğaz Köprüsü de Dogançay'ı Bekliyor." *Cumhuriyet*, Istanbul, March 8, 1997.

— "Brooklyn Bridge as Never Seen Before." *The Turkish Times*, Houston, Texas, June 15, 1997.

— "Brooklyn Köprüsünü JFK Havaalanına Taşıdı." *VIP*, Istanbul, October 1998.

— "Burhan Dogançay." *The New York Herald Tribune*, New York, April 11, 1964.

— "Burhan Dogançay." *The New York Herald Tribune*, New York, April 3, 1965.

— "Burhan Dogançay." *Politika*, Istanbul, August 18, 1976.

— "Burhan Dogançay." *Die Tat*, Zurich, February 2, 1977.

— "Burhan Dogançay." *Nieuwe Gazet*, Antwerp, December 8, 1982.

— "Burhan Dogançay." *Ev & Ofis*, no. 87, Istanbul, November 1983.

— "Burhan Dogançay beim Kunstverein." *Oberhessische Presse*, Marburg, March 2, 1989.

— "Burhan Dogançay: Duvalar ve Resimler." *Boyut*, Ankara, November 1982.

— "Burhan Dogançay Monografisi." *Sanat Çevresi*, Istanbul, no. 61, November 1983.

— "Burhan Dogançay: Wände der Welt." *Litfass*, Berlin, no. 16, April 1980.

— "Burpee Receives Dogançay Painting." *Register Star*, Rockford, January 6, 1974.

— "Dogançay is Attracting Great Interest." *Turkish News*, Istanbul, May 25, 2001.

— "Dünya Duvarlari'nin." *Alem*, Istanbul, March 27, 2003.

— "Duvara bak ne göreceksin?" *Radikal*, Istanbul, December 5, 2003.

— "The Foster Harmon Galleries." *The Longboat Observer*, Sarasota, July 15, 1982.

— "Foster Harmon Gallery." *The Longboat Observer*, Sarasota, June 13, 1991.

— "Galeri G Burhan Dogançay'ın Sergisi ile Açılıyor." *Vizyon Dekorasyon*, Istanbul, October 1998.

— "Harmon Combines Burhan Dogançay, Robert Watson and Group Exhibit." *Sarasota Herald Tribune*, Sarasota, February 17, 1985.

— "Kültür olmadan kalkınma olmaz." *Erzurum Gazetesi*, Erzurum, June 27, 2005.

— "Kunst in Zürich." *Neue Zürcher Zeitung*, Zurich, October 9, 1981.

— "Les Murs Murmurent." *Le Républicain Lorrain*, Pont-à-Mousson, February 3, 1983.

— "Les Murs Murmurent, Ils Crient, Ils Chantent." *La Vie Nouvelle*, Chambéry, November 12, 1982.

— "Les Murs Murmurent: Les Photos Insolites." *L'Est Républicain*, Pont-à-Mousson, February 2, 1983.

— "New York-New Heights." *The Turkish Times*, Houston, March 15, 1996.

— "One-Man Exhibits to Open." *Sarasota Herald Tribune*, Sarasota, February 1, 1981.

— "Paintings by Dogançay in Pan AM Spotlight." *Brooklyn Bay News*, New York, September 17, 1966.

— "Peinture: Burhan Dogançay." *Le Matin du Sahara*, Rabat, March 5, 1985.

— "Photographie: Du Souvenir à l'Image." *Pourquoi Pas?*, Brussels, April 1, 1982.

— "Retrospectif ve 7 sergi." *Cumhuriyet*, Istanbul, April 7, 2001.

— "Sahaya On Kişi Eksik Cikmisiz." *Turkishtime*, Istanbul, October 15, 2003.

— "Sanat ve Türkiye Üzerine." *Yeni Konya*, Konya, April 19, 2001.

— "Turkish Delight." *Interior Design*, New York, February 1965.

— "Turkish Diplomat in New York is Artist of Note." *The Observer*, Nashville, May 28, 1964.

— "Turkish Painting Presented to National Museum." *The Bangladesh Times*, Dacca, November 7, 1995.

— "The Two Worlds of Burhan Dogançay." *The Travel Agent*, New York, July 25, 1964.

— "Wall Preserver." *Sunday News*, New York, October 9, 1966.

— "Walls 70: A Powerful Pastiche." *Interiors Magazine*, New York, December 1970.

— "Wandmalereien." *Zürichsee Zeitung*, Zurich, February 14, 1977.

— "World Travel Aids Turkish Painter." *The Arizona Republic*, Phoenix, January 17, 1965.

— "Yirmi Küsur Yıldan Beri Duvarları Çiziyorum." *Cumhuriyet*, Istanbul, November 2, 1984.

Antmen, Ahu. "Dokunmaya Çağıran Bir Resim." *Cumhuriyet*, Istanbul, April 14, 1998.

— "Dünyanın Fısıldayan Duvarları." *Cumhuriyet*, Istanbul, October 6, 1991.

— "Her 'Dünyadan' İnsan İmgesi." *Cumhuriyet*, Istanbul, November 24, 1993.

— "Yaratıcılığı gözünün seçtiğinde." *Cumhuriyet*, Istanbul, May 19, 2001.

Aras, Funda A. "Babadan Oğula Resim Serüveni." *Skala*, Istanbul, no. 2, May 2001.

Arpacık, Elvan. "Dünyaya Duvardan Bakmak." *D Paper*, Istanbul, no. 1, July/August 2002.

Asılyazıcı, Hayati. "Dogançay'ın Resmini Anlamlandırma, *Hürriyet*, Istanbul, no. 49, December 1984.

— "Şehirlerin Duvarları'ndan Multi-Medyaya." *Aydınlık*, Istanbul, November 22, 1993.

Asselin, Hedwige. "Les Murs du Monde." *Le Devoir*, Montreal, July 30, 1983.

Atal, Nevzat. "Baba oğlun hazine sandığı." *Sabah*, Istanbul, September 6, 2003.

Atıkoğlu, Ayça. "Dogançay'ın Türkiye Çıkarması." *Milliyet*, Istanbul, November 2, 1984.

Aydıntaşbaş, Aslı. "Ressamın Vizöründen." *Radikal*, Istanbul, April 20, 1998.

Badouin, Uwe. "Leidenschaftliche Kunst verbindet Orient mit Okzident." *Oberhessische Presse*, Marburg, April 14, 2001.

— "Türkischer Künstler will Marburg auf Europas Kunstkarte verankern." *Oberhessische Presse*, Marburg, September 6, 2001.

Baharoğlu, Sarkis. "Duvarların Sanatçısı." *Yeni Asır*, Izmir, March 12, 1997.

Bankoğlu, Hülya. "Burhan Dogançay: Don Kişot'luk Yapıyorum." *Posta*, Istanbul, June 1986.

— "Burhan Dogançay: *Vizyon*, Istanbul, no. 100, October 1998.

Barandır, Sevda. "Dogançay Modern Sanat Müzesi." *Art + Décor*, Istanbul, no. 135, June 2004.

Baraz, Yahşi. "Bir Dünya Sanatçısı: Burhan Dogançay" *Sanat Çevresi*, Istanbul, June 2001.

Bartlett, Maxine. "Devoted Turkish Diplomat Shows Artistic Talents." *The Arizona Republic*, Phoenix, January 23, 1965.

Başaran, Ezgi. "New York'taki stüdyomu kiraya verdim, sırf burasını yürütebileyim diye." *Hürriyet*, Istanbul, October 16, 2004.

Bavlı, Umut. "Duvarların dili." *Yaşa*, Istanbul, 2008.

Bay, Yasemin. "Ünlü halıda Türk imzası."*Milliyet*, Istanbul, November 14, 2005.

Bayhan, Mehmet. "Fotografın Hazırladığı Tuzaklar." *Cumhuriyet*, Istanbul, April 13, 1991.

Berkand, Necdet. "Yeni Dünya'da Bir Sanat Elçimiz." *Tercüman*, Istanbul, June 10, 1969.

Bigat, Sadık. "Dogançay Müzesi." *Türkiye Seyahat Acentaları Birliği Dergisi*, Istanbul, no. 261, December 2005.

Bilekli, Ibrahim. "Üniversite müzesi için 20 resim birden verdi." *Sabah-Günaydin*, Istanbul, October 14, 2003.

Bilgin, Çetin. "Duvarların Dili."*Ankara Siyasi Halk Gazetesi*, Istanbul, September 7, 1976.

Birand, M. Ali. "SEİA mı, Süleyman ve Dogançay Sergileri mi?" *Milliyet*, Istanbul, March 20, 1983.

Birkholz von, Rolf. "Vor den Wänden der Welt." *Neue Westfälische*, Bielefeld, June 9, 2005.

Böcking, Peter. "Wände-Spiegel der Gesellschaft." *Siegener Zeitung*, Siegen, September 19, 2003.

Börekçi, Gülenay. "Diktatörlükle yönetilen ülkelerin duvarları bomboş ve tertemizdir." *Haber Türk*, Istanbul, March 18, 2011.

Bowles, Jerry and Tony Russell. "Walls 70, Burhan Dogançay." *This Book is a Movie*, New York: Dell, 1971.

Bozan, Aysel. "Kültürlü bir nesil, bizim aydınlık geleceğimiz." *Milliyet*, Istanbul, May 31, 2010.

Budak, Emel. "Burhan Dogançay." *Antik & Dekor*, Istanbul, no. 42, 1997.

— "Görkemli Bir Retrospektif'in Ardından." *Antik & Dekor*, Istanbul, no. 65, July/August 2001.

Bugay, Başak. "Burhan Dogançay'ın Gerçekleşen Hayali Üzerine." *Sanat Çevresi*, Istanbul, no. 302, December 2003.

— "Dünya'nın Duvarları." *Aydınlık*, Istanbul, May 20, 2001.

— "Yaşayan Duvarlardaki imza: Burhan Dogançay." *Sanat Çevresi*, Istanbul, no. 315, January 2005.

Büber Ayman, Oya. "Bir Yeraltı Sanatı Avcısı." *Tempo*, Istanbul, no. 14, April 7, 1993.

— "Gökdelenler Üzerinden Fotoğraflar." *Güneş*, Istanbul, April 9, 1991.

Büyükünal, Feriha. "Burhan Dogançay." *Sanat Çevresi*, Istanbul, no. 108, October 1987.

Çakkal, Ömer. "New York'un Duvarları." *Yeni Şafak*, Istanbul, December 7, 2003.

Çetin, Berna. "Sanatçının tek gayesi sanatının bilinmesidir." *Kariyer*, Istanbul, no. 30, December 2005.

Castle, Frederick Ted. "Burhan Dogançay at the Russian Museum." *Art in America*, New York, December 1992.

— "Dogançay'ın Duvarları." *Türkiye'de Sanat*, Istanbul, no. 10, September/October 1993.

Cemal, Hasan. "Bir Pazar sabahı, Hayaller Köprüsü..." *Milliyet*, Istanbul, September 10, 2000.

C. G. "Burhan Dogançay." *Arts Magazine*, New York, December/January 1968.

Civaoğlu, Güneri. "Gemi ve kapı." *Milliyet*, Istanbul, April 8, 2001.

Çokyiğit, Çoşkun. "Türkiyede bir ilk: Dogançay Modern Sanat Müzesi." *Tercüman*, Istanbul, April 29, 2004.

Çobanlı, Işıl/Özelsancak, Hande. "Değirmenlere karşı bir Don Kişot: Burhan Dogançay." *Vizon*, Istanbul, no. 2, January 2005.

Corbino, Marcia. "On the Wall Paintings." *Sarasota Herald Tribune*, Sarasota, February 9, 1981.

Çuhadar, Bahar. "114 Ülkeyi dolaşıp duvarları fotoğrafladı." *Dünya*, Istanbul, November 27, 2004.

Damar, Necip. "Duvarların sesini tüm dünyaya duyuran sanatçımız Burhan Dogançay." *Bodrum Life*, Bodrum, no. 11, September–November 2007.

Darcy, C. "Ière Exposition Intercontinentale à Monaco." *La Revue Moderne*, Paris, August 1, 1965.

Dean, Kevin. "A Conversation with Burhan Dogançay." *The Longboat Observer*, Sarasota, February 5, 1981.

— "Art/Foster Harmon Gallery." *The Longboat Observer*, Sarasota, February 21, 1985.

DiLauro, Stephen. "Don't be Quick to Condemn Graffiti; They can be a Blessing." *The Morning Call*, Miami, August 18, 1994.

Doğanay, Erkan. Gülveren Mevlut. "Ali, Ayşe'yi duvarlarda seviyor." *Hayvan*, Istanbul, August 2005.

Döndaş, İnci. "Metroplitan'da ilk Türk ressam." *Sabah*, Istanbul, 2 October 2004.

Dormen, Haldun. "Uluslararası Bir Türk Ressamı." *Milliyet*, Istanbul, May 8, 1977.

Dunn, Helen. "Burhan Dogançay: Artist, Photographer." *People, Places and Parties*, New York, Summer 1982.

Dural, Ayşe. "Not a Museum, But a Miracle." *The Gate*, Istanbul, no. 48, April 2004.

Durgun, Özgür. "İlmek İlmek Yaşam." *Radikal*, Istanbul, April 17, 1998.

Duru, Başak. "Dışarıda Türklerden Ressam Çıkacağına Inanan Çok Az Kişi Var." *Sanat Çevresi*, Istanbul, June 2001.

Elibal, Gültekin. "Burhan Dogançay'ın Bir Sergisi Daha." *Sanat Çevresi*, Istanbul, no. 61, November 1983.

Elkatip, Demet. "Öncesi Sonrası Duvar." *Milliyet*, Istanbul, October 22, 1998.

Eraslan, Ece. "Burhan Dogançay ve Aubusson Duvar Halıları." *Antik & Dekor*, Istanbul, no. 84, September–October 2004.

Erdoğan, Arzu. "1 milyon dolarlık bahis." *Fortune*, Istanbul, October 2008.

Erez, İrem. "Burhan Dogançay 'ın Çağdaş Resim Sanatındaki Yeri." *Sanat Olayı*, Istanbul, no. 9, September 1981.

Erfevel. "Burhan Dogançay." *La Semaine d'Anvers*, Antwerp, December 17, 1982.

Eroğlu, Özkan. "Burhan Dogançay Retrospektifi." *Yapı*, Istanbul, May 1, 2001.

Ersoy, Pınar. "Sanatın Yarısı Halkla İlişkiler, biz onu hiç beceremememişiz." *Vatan*, Istanbul, November 12, 2006.

Ertaş, Ayşe. "Aydın Bir Portre Aydınlık Bir Mekan." *Farmaskop*, Istanbul, no. 9, October–December 2004.

Esatoğlu, Mehmet. "İnsanlığın Aynası Duvarlar." *Evrensel Kültür*, Istanbul, November 18, 1995.

Filoğlu, Lale. "Burhan Dogançay: Benim için duvarlar tutku halini aldı." *Vizyon*, Istanbul, no. 65, December 1995.

Financı, Yurdakul. "B. Dogançay'ın Resimleri İlgi ile Karşılandı." *Ulus*, Ankara, January 6, 1965.

G. B. "Dogancay." *Art Voices Magazine*, New York, vol. 3, no. 4, April/May 1964.

Gezgin, Ümit. "Burhan Dogançay: Bir Metropol Sanatçısı." *Sanat Çevresi*, Istanbul, no. 271, May 2001.

—"Burhan Dogançay Resimlerindeki Görsel Yeni Söylem." *Sanat Çevresi*, Istanbul, no. 302, December 2003.

Gillemon, Danièle. "La Photographie Existe." *Le Soir*, Brussels, April 2, 1982.

Girgin, Emin Çetin. "Türk Resmi İçin Bir Başlangıç." *Cumhuriyet*, Istanbul, August 1, 1987.

—"Yapıtlarım Duvar Resmi Olarak Düşünülmeli." *Cumhuriyet*, Istanbul, June 29, 1986.

Göçer, Esin. "Burhan Dogançay'la Bir Gezinti." *Sanat Çevresi*, Istanbul, no. 24, October 1998.

Gördü, Bihter. "Sanat Özgün Bireysellik Ülkeye Yakılan Işık." *Bizim Sanat*, Istanbul, no. 37, July 5, 2004.

Gören, Ahmet Kamil. "Burhan Dogançay'ın Kapıları Galeri Binyıl'da." *Sanat Çevresi*, Istanbul, no. 270, June 2001.

—"Duvarları Konuşturan Usta: Burhan Dogançay ve Metropollerin Ruhu." *Sanat Çevresi*, Istanbul, no. 315, January 2005.

Graber, Isabelle. "Deux Affichistes rencontrent le jeune art turc contemporain." *Le Journal du Jura*, Biel/Bienne, June 27, 2009.

Grasskamp, Walter. *Kunstforum International*, Cologne, vol. 50, April 1982.

Gültaşlı, Selçuk. "Türkiye'den önce AB'ye resmi girdi." *Zaman*, Istanbul, June 20, 2003.

Gün, Nergiz. Dünyanın tanıdığı Ressamımız Burhan Dogançay." *Portreler*, Istanbul, no. 7, October/November/December 2005

Günçıkan, Berat. "Çocuklar ressam gördü." *Cumhuriyet*, Istanbul, May 6, 2001.

Güngör, Aylin. " Burhan Dogançay'ın Istanbul'u." *Vizyon*, Istanbul, no. 157, December 2003.

Günyaz, Abdülkadir. "Burhan Dogançay Sergisi'nin Düşündürdükleri." *Sanat Çevresi*, Istanbul, no. 181, November 1993.

Gürel, Haşim Nur. "Burhan Dogançay." *Sanat Çevresi*, Istanbul, no. 155, September 1991.

Halman, Talat. "Amerika'da Modern Türk Sanatı." *Türk Evi*, New York, November 1977.

—"Burhan Dogançay." *Ankara Sanat Dergisi*, Ankara, March 1977.

—"Burhan Dogançay New York'ta Sergi Açtı." *Milliyet*, Istanbul, November 25, 1967.

—"Sanatımızı Bilen, Kültürlü Kişilerden Yararlanmalıyız." *Hürriyet*, Istanbul, November 3, 1982.

Heinzel, Nina. "Zweimal Kunstabriss." *Berner Kulturagenda*, Bern, July 9, 2009.

Hekimoğlu, Müşerref. "Çöplük'ü İzleyen Gençler." *Cumhuriyet*, Istanbul, November 12, 1995.

Henkes, Alice. "Kraeftiger Kunsthauch Bosporus." *Der Bund*, Bern, July 2, 2009.

Hızlan, Doğan. "Burhan Dogançay Güneydoğu'ya okul yaptıracak." *Hürriyet*, Istanbul, March 1, 2001.

—"Dogançaylar'ın müzesini gezebilirsiniz. *Hürriyet*, Istanbul, August 28, 2003.

—"Güzel şeyler de oluyor." *Hürriyet*, Istanbul, April 20, 2001.

H. N. "Burhan Dogançay." *Die Tat*, Zurich, February 28, 1977.

Holt, Dennis. "New Photo Book on Brooklyn Bridge Reconstruction Celebrated at Library." *Brooklyn Daily Eagle*, Brooklyn, November 8, 1999.

—"Striking Photos Distinguish Brooklyn Bridge Book." *Brooklyn Heights Press*, Brooklyn, November 11, 1999.

İzer, Ayşegül. "Dogançay, Sanatı Yaşamı, Yaşamı da Sanatı." *Sanat Çevresi*, Istanbul, no. 302, December 2003.

İşleyen, Ercüment. "Resimde Büyük Sahtekârlık." *Milliyet*, Istanbul, August 6, 1995.

Jacobs, Jay. "Personality: Back to the Walls." *The Art Gallery Magazine*, Ivoryton, vol. XIV, no. 1, October 1970.

J. D. H. "Dogançay's Watercolors at Galaxy." *The Arizona Republic*, Phoenix, January 31, 1965.

Jensen, H. R. " Dogançay–Collagens Mester." *Morgenavisen Jyllands-Posten*, Aalborg, June 20, 1990.

J. L. "Murmures des Murs." *La Presse*, Montreal, July 30, 1983.

Kalkan, Nazire. "Müzeler sanatın Merkez Bankası." *Tempo*, Istanbul, no. 49, December 2005.

Kalkan, Bahar. "Ya hep, ya hic." *Sky Life*, Istanbul, January 2004.

Kanbay Doğantepe, Hülya. "Kalpten Kalbe, Akıldan Akıla Kapılar Açıyor." *Antik & Dekor*, Istanbul, no. 33, 1996.

Karahan, Jüliden. "Burhan Dogançay'ın desenleri halılara işlendi." *Zaman*, Istanbul, November 12, 2005.

Karakaş, Berrin. "Bebelere Müze." *Tempo*, Istanbul, August 2003.

Kardüz, Ali Rıza. "New York'ta İki Türk." *Sabah*, Istanbul, June 7, 1997.

—"Ressam Babanın Ressam Oğlu." *Sabah*, Istanbul, October 18, 1997.

Kayabal, Aslı. "Acemi Sahtekâr Aranıyor!" *Yeni Yüzyıl*, Istanbul, August 9, 1995.

—"Toplumun Aynası Duvarlar." *Yeni Yüzyıl*, Istanbul, November 19, 1995.

Keskin, Hasan. "Orada kimse var mı?" *Zaman*, Istanbul, April 20, 2001.

Kiger, Rumeysa. "Burhan Dogancay's Works on Display in Ohio." *Today's Zaman*, Istanbul, October 25, 2010.

Kılıç, Seçil. "Burhan Dogançay." *OK Magazine*, Istanbul, August 25, 2010.

Kilimci, Sibel. "Ölumden Öte Bir Köy." *Cosmopolitan*, Istanbul, no. 6, June 2004.

Kınaytürk, Hamit. "Dessine-Moi l'Amour." *Sanat Çevresi*, Istanbul, no. 181, November 1993.

—"Ressam Burhan Dogançay 'ın Sahte Resimleri Ortaya Çıktı." *Sanat Çevresi*, Istanbul, August/September 1995.

—"Rusya Cumhuriyet Kültür Bakanlığı Ressam Burhan Dogançay'a Takdir Madalyası Verdi." *Sanat Çevresi*, Istanbul, no. 162, April 1992.

Koçal, Ece. "Geleceğin Ressamları." *Sabah*, Istanbul, May 21, 2005.

Köksal, Ahmet. "Burhan Dogançay'la Bir Konuşma." *Sanat Çevresi*, Istanbul, no. 93, July 1986.

—"Dogançay'ın Resimleri." *Milliyet Sanat Dergisi*, Istanbul, September 17, 1976.

Kolabaş, Hülya. "Bir Ustadan Öğütler-Burhan Dogançay." *Hillsider*, Istanbul, no. 29, December 2002.

Köprülü, Tuna. "Sanatımızı Dogançay ile Dünyaya Duyuruyoruz." *Hürriyet*, Istanbul, June 23, 1982.

Küçük, Suat Hayri. "Duvarlardaki Kalpler, Kalplerdeki Köprü Burhan Dogancay." *Rh+Sanat*, Istanbul, no. 25, January 2006.

Küçüksayraç, Elif. "Burhan Dogançay'ın Istanbul Çıkartması" *Geniş Açi*, Istanbul, May 15, 1982.

Külahlıoğlu, Can. "Dogançay Yeni Aysan Yetkin." *Yeni Gündem*, Istanbul, no. 18, July 1986.

Kürklü, Damla. "Stamping Colours on the Walls." *Divan Touch Magazine*, Istanbul, no. 3, November 2008.

Landau, Ian. "Bridge of Sighs." *Time Out*, New York, no. 215, November 1999.

Levick, L. E. "Burhan Dogançay." *New York Journal American*, New York, April 11, 1964.

Lieber, Joel. "Travel of Turkish Tourist Head Forms Inspiration for Painting." *Travel Weekly*, New York, June 9, 1964.

Lopate, Phillip. "Burhan Dogançay." *Bomb*, New York, no. 80, Summer 2002.

Madra, Beral. "Burhan Dogançay: Duvar tutkum peşimi bırakmaz." *Vizyon*, Istanbul, no. 14, May 1991.

Madra, Ömer. "Burhan Dogançay." *Arredamento Dekorasyon*, Istanbul, January 1994.

M. B. "Burhan Dogançay: Walls V." *Arts Magazine*, New York, March 1969.

Mesayyah, Mirey. "Duvarlar Ülkelerin Aynasıdır." *Barometre 7*, Istanbul, April 22, 1991.

Meyer, Walter. "Handwriting on the Wall Tells Artist Great Deal." *Sunday News*, New York, September 18, 1966.

Miller, Marlan. "Diplomat Offers Dashing Shows." *The Phoenix Gazette*, Phoenix, February 1, 1965.

M. M. C. "New York in the Eyes of the World." *The Villager*, New York, October 1, 1964.

Moll, Kerstin. "Auf der Suche nach Botschaften." *Oberhessische Presse*, Marburg, March 17, 1989.

Muûls, Violaine. "On Baillonne Même les Murs." *L'Evénement*, Brussels, no. 102, March 25, 1982.

Nirven, Nur. "Burhan Dogançay ile Söyleşi." *Vizyon Dekorasyon*, Istanbul, no. 10, January 1994.

—"Burhan Dogançay ve Duvarlar." *Sanat Çevresi*, Istanbul, no. 181, November 1993.

—"Rengarenk Bir Sergi." *Güneş*, Istanbul, September 27, 1989.

Niyazioğlu, İbrahim. "Burhan Dogançay ve Uluslararası Sanat İlişkilerimiz." *Hürriyet Gösteri*, September 1987.

Noel, Serge. "L'Image a des Ratés." *Pour Bruxelles*, Brussels, March 25, 1982.

Nur, Yeşim. "Duvarlarda Hayat Var." *Istanbul Life*, Istanbul, no. 246, January 2004.

Oktay, Nilüfer. "Kızı süsledik, çeyizi hazır, damat bekliyoruz." *Milliyet*, Istanbul, September 7, 2003.

Öktülmüş, Buket. "Duvarların Dili." *Radikal*, Istanbul, October 15, 1998.

Oral, Zeynep. "Duvarları Yaşayan, Duvarları Yaşatan Sanatçı." *Milliyet Sanat Dergisi*, Istanbul, no. 184, January 15, 1988.

—"Müze Gerçekleri..." *Cumhuriyet*, Istanbul, June 5, 2004.

Ordu, Şenay. "Burhan Dogançay Yarın Müzesinde sizi bekliyor." *Hürriyet*, Istanbul, December 19, 2003.

Özatay, Dalida. "Metropolitan'da ilk Türk." *Akşam*, Istanbul, October 9, 2004.

—"Ressam Burhan Dogançay 40 yil yaşadiği New York'tan dönüp Istanbul'da Modern Sanatlar Müzesi'ni kurdu." *Akşam*, Istanbul, June 26, 2004.

Özgentürk, Nebil. "Duvarın kalbi." *Sabah*, Istanbul, April 14, 2001.

Özcan, Beril. "1 milyon dolarlık tabloyu pahalı bulan adama yurt dışında gülerler." *Vatan*, Istanbul, June 7, 2009.

Pak, Orhan. "Amerika'da Bir Türk Ressamı: Burhan Dogançay." *Sanat Çevresi*, Istanbul, July 1982.

Perlman, Mişel. "Düşgücünün Sınırı Yoktur." *Cumhuriyet*, Istanbul, December 20, 1992.

P. Wd. "Januaris/ Dogançay /Zeller." *Neue Zürcher Zeitung*, Zurich, February 8, 1977.

Pieper, Doris. "Flüsternde Mauern, schreiende Symbole." *Die Glocke*, Oelde, June 9, 2005.

Pope, Nicole. "In Istanbul, a Haven for Modern Art." *International Herald Tribune*, London, December 13, 2004.

Rona, Zeynep. "Aubusson Duvar Halıları ve Burhan Dogançay." *Arredamento Mimarlık*, Istanbul, April 1998.

Saçar, Bekir. "Sanatseverler Dogançay'la buluştu." *Posta*, Istanbul, April 7, 2001.

Şahin, Fatih. "Dogançay'ın sergisine büyük ilgi." *Alem*, Istanbul, no. 16, April 18, 2001.

Şahinoğlu, Elvan. "Burhan Dogançay." *Akademist*, Istanbul, no. 8, July 2004.

Şanlıer, Zeynep. "Karmaşadan İki Dakika Uzaklıktaki Vaha." *Varan Yolboyunca*, Istanbul, June 2005.

Sancılı, Dilek. "Bir harabeden müze yarattı." *Sabah*, Istanbul, October 10, 2004.

Şenyener, Şebnem. "Duvara Aşk Katan Ressam." *Sabah*, Istanbul, August 11, 1993.

—"Şu Malum Köprü." *Vizyon*, Istanbul, May 5, 1997.

Şimşek, Binnur Ertuş. "Burhan Dogançay." *Onduline-Dünyası*, Istanbul, no. 29, August/September 2005.

Schutz, Louis B. "Burhan Dogançay: The Man and His Art." Unpublished thesis, Randolph-Macon Woman's College, Lynchburg, June 1971.

Schwab, Christine. "Ein Türkischer Künstler in New York." *Marburger Magazin Express*, Marburg, July 1989.

Senft, Bret. "New Angle on an Old Bridge." *Photo District News*, New York, December 1999.

Sardar, Marika. "Art and Nationalism in Twentieth-Century Turkey." In: Timeline of Art History. New York: The Metropolitan Museum of Art, 2000.

Shemanski, Frances. "Diplomatic Mission." *Pictorial Living-New York Journal American*, New York, January 3, 1965.

Simavi, Aliye. "Burhan Dogançay." *Vizon Gazete*, Istanbul, October 1980.

Sever, Şirin. "Pazar Söyleşisi." *Sabah*, Istanbul, August 1, 2010.

Sönmez, Ayşegül. "Beni rol model olarak alıyorlar." *Milliyet Pazar*, Istanbul, April 15, 2001.

—"Duvarlarda Hayat Var." *Millyet Sanat*, Istanbul, no. 538, January 2004.

—"Türkiye'de otorite ve cesaret yok." *Radikal*, Istanbul, May 9, 2008.

Sönmez, Necmi. "Brooklyn Köprüsü 'Suretleri'." *Arredamento Mimarlık*, Istanbul, December 1999.

—"Dünya Duvarlarına Kök Salan İmgeler." *Avrupa ve Türkiye'de Yazın*, Istanbul, no. 87, September 1999.

—"Eş Zamanlı Gerçek." *Türkiye'de Sanat*, Istanbul, no. 10, September/October 1993.

—"Gerçekle kurgu arasındaki karşıtlıklar." *Hürriyet Gösteri*, Istanbul, April 1, 2001.

—"Görüntü ile İmgenin Çatışması." *Cumhuriyet*, Istanbul, November 8, 1995.

—"Istanbul Duvarlarının Önünde Burhan Dogançay." *Marie-Claire*, Istanbul, August 1989.

Sümercan, Aydan. "Burhan Dogançay ile Duvarlar Üzerine Çeşitlemeler." *Sanat Olayı*, Istanbul, no. 50, July 1986.

Tanaltay, Erdoğan. "Burhan Dogançay ile Bir Gün." *Sanat Çevresi*, Istanbul, no. 241, November 1998.

Tansuğ, Sezer. "Burhan Dogançay'ın Endüstriyel Standartlaşmayı Eleştiren Yeni Çalışmaları Üzerine." *Sanat Çevresi*, Istanbul, no. 181, November 1993.

—"Burhan Dogançay'la Söyleşiden İzlenimler." *Sanat Çevresi*, Istanbul, no. 11, September 1979.

—"Büyük Bir Resim Ustası: Burhan Dogançay." *Sanat Çevresi*, Istanbul, no. 61, November 1983.

—"Büyük Bir Usta: Burhan Dogançay." *Ev & Ofis*, Istanbul, no. 87, November 1983.

—"Dogancay." *Artist Plastik Sanatlar Dergisi*, Istanbul, no. 2, April 1986.

—"Dogançay'da Formların Nesneleşme Süreci." *Sanat Çevresi*, Istanbul, no. 205, November 1995.

Tanınmış, Selcen. "Son trenin son vagonunun son kapısına yetiştim." *Vatan*, Istanbul, October 10, 2004.

Taşçı, Gökçe. "Dogançay Müzesi." *Rixos Magazine*, Istanbul, Winter 2005–2006.

Tek, Özgür. "Türkiye'nin İlk Kişisel Müzesi." *Istanbul*, Istanbul, no. 54, July 2005.

Thomson, Jonathan. "Towards A Fictional Reality." *Asian Art News*, Hong Kong, no. 19 January/February 2009.

Turay, Anna. "Manhattan'dan Kazlıçeşme'ye." *Cumhuriyet*, Istanbul, April 1991.

Türkat, Seda. "Duvarların izinde bir ömür." *Tempo*, Istanbul, April 26, 2001.

Uluç, Doğan. "Açık Oturum." *Hürriyet*, Istanbul, November 3, 1982.

—"Dogançay ile Bir Söyleşi." *Dünya*, Istanbul, July 17, 1979.

—"Dogançay'a İlgi Buyuk Oldu." *Hürriyet*, Istanbul, November 8, 1986.

—"Türk Objektifinden Brooklyn Köprüsü." *Hürriyet*, Istanbul, July 4, 1998.

—"Zirvedeki Dogançay." *Hürriyet*, Istanbul, December 6, 1999.

Uslubaş, Tolga. "Duvardan kalplere." *Türkiye*, Istanbul, April 7, 2001.

Van der Brempt, S. "La Photographie: Grand 'Art Nouveau'." *La Semaine d'Anvers*, Antwerp, no. 336, April 16, 1982.

Vering, Jan. "Der Zustand eines Landes." *Westfälische Rundschau*, Siegen, September 19, 2003.

—"Mauerzeichen und Slogans." *Siegener Rundschau*, Siegen, September 19, 2003.

Wanfors, Lars. "American Graffiti." *American Trend Magazine*, Stockholm, no. 3, 1983.

Welch, Anita. "Artist Captures Tempo of Manhattan." *The Arizonian*, Phoenix, January 28, 1965.

Wenk, Marina. "Botschaften auf Wänden." *Westfalenpost*, Siegen, September 19, 2003.

Yalman, Canan. "Çağdaş Türk Resim Sanatının Duayenlerinden Burhan Dogançay İle Kültür, Sanat ve Müze Konulu Söyleşi." *Cey Sanat Platik Sanatlar Dergisi*, Istanbul, no. 5, July/August 2005.

Yaltı, Yaprak. "Kim korkar modern sanattan?" *Elle Magazine*, Istanbul, no. 12, December 2004.

Yıldız, Şebnem. "Anlamlı Miras." *House Beautiful*, Istanbul, August 2004.

Yıldızoğlu, Ayşe. "Sokak sanatını yükseltti." *Beyoğlu*, Istanbul, no. 62, September 24, 2004.

Yılmaz, İhsan. "Burhan Dogançay Beyoğlu kendi müzesini açacak." *Hürriyet*, Istanbul, July 26, 2003.

—"1 milyon dolarlık eserin esin kaynağı Bergamalı lastikçi Kemal'in dükkanı." *Hürriyet*, Istanbul, September 21, 2008.

—"Ressam Amca." *Hürriyet Cumartesi*, Istanbul, May 12, 2001.

—"Ünlü ressam sergisini TIR'la gezdirecek." *Hürriyet*, Istanbul, April 5, 2001.

Yücel, Ekim. "Dogançay Müze açtı." *Radikal*, Istanbul, August 29, 2003.

—"Müze kurdum duyan yok." *Radikal*, Istanbul, August 31, 2003.

Zimmerman, Dave. "Artist: Walls Mirror Society." *Register-Star*, Rockford, January 6, 1974.

Zoller, Johannes. " Wände der Welt." *Westfalen Blatt*, Bielefeld, June 9, 2005.

Zwez, Annelise. "Das Leben im Spiegel seiner Plakate." *Bieler Tagblatt*, Biel/Bienne, June 27, 2009.

RADIO AND TV INTERVIEWS AND DOCUMENTARIES
In chronological order

Dogançay, Burhan. Interview by Cindy Adams. Evening News, ABC TV, New York, September 15, 1966.

Dogançay, Burhan. Interview by Jack O'Brian. WOR Radio, New York, October 12, 1966.

Art and the Environment. Produced by Ezzedine Harbaqui for Tunisian State TV, Tunis, 1982.

Burhan Dogançay. Produced by Martin Kessler for *Kulturkalender*, HR3, Frankfurt, March 23, 1989.

Atölye (Studio). Produced and directed by Güneş Buharalı, interview by Ahu Antmen for TRT 2, Istanbul, January 24, 1998.

Kritik. Produced and presented by Nilüfer Kuyaş for NTV, Istanbul, April 26, 1998.

The Walls of the World. Produced by Bircan Ünver for Cable TV Channels 34, 35, 56 & 57, New York, 1998–1999.

New York'ta yaşayan santçılar haberi çerçevesinde Burhan Dogançay portresi. Produced and presented by Pınar Demirkapı for NTV for *Gece-Gündüz*, Istanbul, December 31, 1999.

Bridge of Dreams. Produced by Fran Ham for Brooklyn Community Access TV, New York, 1999.

Bridge of Dreams. Produced by Bircan Ünver for Cable TV Channels 34 & 35, New York, 2000.

Sergileri ve en çarpıcı sergisi Retrospektif üzerine söyleşi. Interview by Gani Müjde. Produced by NTV for *Gündemdışı*, Istanbul, April 16, 2001.

Burhan Dogançay resim sergisinden görüntü ve detaylar. Produced by NTV, Istanbul, August 6, 2002.

Rüzgara Karşı Yürüyenler. Interview by Nebil Özgen Türk. Produced by the Turkish Ministry of Culture for ATV, Istanbul, September 4, 2002.

Burhan Dogançay açtığı ilk bireysel müzeyi anlatıyor. Interview by Özgül Apaçe. Produced by CNN for *Beş N Bir K*, Istanbul, September 3, 2003.

Interview by Seynan Levent. Produced by TRT2 for *Akşama Doğru*, Ankara, October 14, 2003.

Yeni açılan Dogançay Müzesi ile ilgili röportaj. Interview by Ayşe Tolga. Produced by NTV for *Gece-Gündüz*, Istanbul, October 15, 2004.

Burhan Dogançay'ın sanatı ekseninde Türk resmine bakış. Interview by E. Zafer Bilgin. Produced by Ulusal Kanal, Istanbul, August 21, 2005.

Ben Yaptım olmuş mu? Produced by Sibel Çağlayan for TRT, Istanbul, January 21, 2006.

Yaz Zamanı. Interview by Ceyda Düvenci. Produced by NTV, Istanbul, July 18, 2006.

Beş Dakika Özel. Interview by Şahika Özarslan. Produced by Kocakaya for Ekavart TV (internet), Istanbul, October 22, 2008.

Maestro & Elizabeth. Interview by Müge Baysal. Produced by Tolga Gürdil for Expo Channel TV, Istanbul, November 15, 2008.

Art Galerim. Interview by Özlem Alıcı. Produced by Özlem Alıcı for Show TV, Istanbul, November 22, 2008.

Aktüalite. Interview by Serfiraz Ergun. Produced by Haber Türk, Istanbul, September 6, 2009.

Compiled by
Angela Dogançay

Exhibition History

SOLO EXHIBITIONS

1964
New York: Ward Eggleston Galleries. *Watercolors.*
April 8–18.

New York: Berlitz School. *New York in the Eyes of the World.* September 22–October 22. Organized by Ward Eggleston Galleries, New York, in cooperation with the Department of Public Events of the City of New York.

New York: Overseas Press Club

1965
Phoenix: Galaxy Gallery. *Dogançay: Watercolors and Gouaches.* January 22–February 11.

New York: Ward Eggleston Galleries. *The World on the Walls of New York.* March 29–April 17.

1966
New York: American Greetings Gallery. *Walls of New York.* September 17–October 10.

1967
New York: Spectrum Gallery. *Wall Paintings.* November 7–25.

1968
Cambridge, Mass.: Radcliffe Graduate Center. *Dogançay.* December 6, 1968–January 5, 1969.

1969
New York: Spectrum Gallery. *Walls V.* February 4–25.

1970
New York: Carus Gallery. *Walls 70.*

Washington, D.C.: Lunn Gallery.

1971
New York: J. Walter Thompson Company. *New York Scenes.*

1973
New York: Gimpel & Weitzenhoffer Gallery. *Recent Works.* January 30–February 28.

Rockford, Ill.: Sneed & Hillman Gallery. *Dream Ships and Hearts.* December 7, 1973–January 31, 1974.

1976
Istanbul: Gallery Baraz. *Burhan Dogançay.* September 1–25.

1977
Zurich: Kunstsalon Wolfsberg. *Acrylmalereien und Gouachen 1966–1976.* February 3–March 5.

Stockholm: Gallery Engström.

1978
Gothenburg: Gallery Olab.

New York: Gimpel & Weitzenhoffer Gallery. *Recent Paintings.* November 29–December 22.

New York: The Turkish Center.

1981
Sarasota, Fla.: Foster Harmon Galleries. *Paintings by Burhan Dogançay.* February 1–14.

Zurich: Kunstsalon Wolfsberg. *Gouachen 1977–1981.* October 1–24.

1982
Paris: Centre Georges Pompidou. *Les murs murmurent, ils crient, ils chantent...* February 3–March 22. Traveled to: Palais des Beaux-Art, Brussels. March 19–April 18, 1982; Musée d'Art Contemporain, Montreal. July 24–September 4, 1983; International Cultural Center, Antwerp. December 3–30; Provincial Museum, Hasselt.

Cologne: Baukunst-Galerie. *Burhan Dogançay.* November 23–January 15, 1983.

1983
Istanbul: Gallery Baraz. *Burhan Dogançay.* November 18–December 17.

1984
Düsseldorf: Galerie Swidbert. *Bilder und Skulpturen.* October 5–December 7.

Izmir: Izmir Painting and Sculpture Museum. *Burhan Dogançay.* November 1–15.

Izmir: Vakko Art Gallery. *Burhan Dogançay.* November 1–30.

Istanbul: Vakko Art Gallery. *Burhan Dogançay.* November 2–30.

Ankara: Vakko Art Gallery. *Burhan Dogançay.* November 3–30.

1985
Bordeaux: Centre d'Art et de Communication. Sarasota, Fla.: Foster Harmon Galleries. *Paintings by Burhan Dogançay.* February 17–March 1.

Rabat: Galerie L'Atelier. *Peintures, Gouaches.* March 7–April 6.

Vienna: Österreichische Postsparkasse. *Ribbons.*

1986
Ankara: GaleriArtist. April 12–29. Organized by Gallery Baraz, Istanbul.

Istanbul: Atatürk Cultural Center. *Burhan Dogançay.* June 20–July 5. Organized by Gallery Baraz.

1987
Sarasota, Fla.: Foster Harmon Galleries. *Paintings by Burhan Dogançay.* March 15–27.

New York: Hamideh Bayley Gallery, *Two Decades of Walls.* March 21–May 5.

Istanbul: Garanti Art Gallery. October 3–30.

Ankara: Gallery Nev. *Dogançay.* October 9–27.

1988
Sarasota, Fla.: Foster Harmon Galleries. *Paintings by Burhan Dogançay.* February 7–26.

1989
Marburg: Kunstverein Marburg e. V. *Ölbilder, Gouachen, Lithographien, Shadow Sculptures,* March 4–April 8.

Tokyo: The Seibu Museum of Art-Yurakucho Art Forum. *Dogançay.* May 26–June 13.

1990
Paris: Galerie du Génie. *Dogançay.* April 28–May 26.

Odense: Gallery Torso. *Recent Works.* May 26–June 23.

1991
Istanbul: Derimod Cultural Center. *Ironworkers (Photographs).* April 6–May 13.

Sarasota, Fla.: Foster Harmon Galleries. *Paintings by Burhan Dogançay.* May 27–June 28.

Istanbul: Arkeon Art Gallery. *Burhan Dogançay: Original Prints.* September 25–October 5.

London: A.D. Orsay Ltd. *Works by Dogançay 1988–1991.* October 17–December 17.

1992
St. Petersburg: The State Russian Museum. *Walls and Doors 1990–91.* January 16–February 8. Traveled to: Artists' Union, Moscow. February 26–March 28.

Antalya: Falez Art Gallery. *Original Prints.* October 15–November 10.

1993
Istanbul: Atatürk Cultural Center. *Walls 1990–93.* November 3–27.
Organized and sponsored by Renault-Mais, Istanbul.

1994
New York: Nicholas Alexander Gallery. *Doors & Walls.* October 15–November 26.

1995
Ankara: Gallery Nev. *1965–1995 Dönemi.* November 10–December 6.

Istanbul: Gallery Nev. November 17–December 13.

1996
Houston, Tx.: Hooks-Epstein Galleries. *New York–New Heights* (participating in *FotoFest '96*). February 24–March 23.

Ankara: GaleriArtist. April 12–29.

New York: Duggal Gallery. *The Brooklyn Bridge As Never Seen Before.* April 30–June 30.

Ankara: Artium Art Gallery. *Burhan Dogançay.* November 6–December 6.

1998
Adana, Turkey: Görüntü Art Gallery. *Burhan Dogançay.* May 16–June 13.

Istanbul: Gallery G. *Alexander's Walls and Hearts.* October 15–November 28.

1999
New York: Radio House Gallery. *The Rebirth of the Brooklyn Bridge.* November 6–December 4.

2000
New York: The Brooklyn Historical Society. *Bridge of Dreams.*

New York: St. Francis College. *Bridge of Dreams.* February 3–29.

2001
Istanbul: Dolmabahçe Cultural Center. *Dogançay: A Retrospective.* April 5–May 27. Organized and sponsored by Dr. Nejat F. Eczacıbaşı Foundation, Istanbul.

Istanbul: Gallery Baraz. *Gouaches&Photographs.* April 7–May 7.

Istanbul: Mine Art Gallery. *Series.* April 9–30.

Istanbul: Gallery Binyıl. *Doors.* April 10–May 12.

Istanbul: Gallery G. *Hearts.* April 12–May 31.

Adana, Turkey: Görüntü Art Gallery. *Burhan Dogançay.* April 13–May 12.

Athens, Ohio: Kennedy Museum of Art–Ohio University. *Dogançay–Wall Paintings from the Museum Collection.* May 15–August 26.

2002
New York: Radio House Gallery. *New York Subway Walls.* October 3–November 9.

2003
Siegen: Siegerlandmuseum. *Walls of the World.* September 20, 2003–January 11, 2004.

Istanbul: Kibele Art Gallery. *Blue Walls of New York.* December 10, 2003–January 30, 2004.

2004
Ankara: Gallery Nev. *Works on Paper.* October 10–November 5.

2005
Gütersloh: Kunstverein Kreis Gütersloh e.V. *Walls of the World.* June 9–July 10.

Istanbul: Institut Français d'Istanbul. *Tapisseries d'Aubusson.* November 8–25.

2009
Ankara: GaleriArtist. *70'li Yıllardan Günümüze Koleksiyonlardan Seçmeler.* January 8–February 5. Curated by Yahşi Baraz.

2010
Athens, Ohio: Ohio University Art Gallery. *Burhan Dogançay: Urban Walls.* September 14–November 20.

2011
Wynwood, Fla.: Myra Galleries. *Burhan Dogançay.* February 1–March 15.

Ankara: GaleriArtist. *Burhan Dogançay.* April 16–May 7. Organized by Yahşi Baraz.

Izmir: Çesme Altın Yunus Hotel. *Burhan Dogançay.* July 16–August 5. Organized by Yaşar Eğitim ve Kültür Vakfı.

Florence: Aria Art Gallery. *Brooklyn Bridge As Never Seen Before.* September 30–November 27.

GROUP EXHIBITIONS

1953
Paris: American House at the Cité Universitaire, *Exposition des Peintres Résidants de la Fondation des Etats-Unis.* April 30–May 7.

1955
Ankara: Art Lovers Club, *Father-Son Painting Exhibition.* December 4, 1955–January 15, 1956.

1957
Ankara: Art Lovers Club, *Second Father-Son Painting Exhibition.* February 2–28.

1959
Ankara: Art Lovers Club, *Third Father-Son Painting Exhibition.* March 15–April 15.

Ankara: Turkish-American Association, *Painters of Ankara.* October 20–November 18.

1961
Ankara: Turkish-American Association, *Exhibition of Modern Paintings.* April 8–20.

Ankara: University of Ankara, *Twenty-Second State Exhibition of Painting and Sculpture.* April 22–May 22.

1963
New York: Washington Square Galleries. *World Show.*

New York: National Arts Club. *First 65th Anniversary Exhibition.* September 26–October 18.

1964
New York: National Arts Club. *The 65th Anniversary Exhibition.* January 15–31.

New York: National Arts Club. *Members' Summer Exhibition.* June 28–September 7.

1965
New York: The Solomon R. Guggenheim Museum. *Some Recent Gifts.* June–July.

Monaco: Palais des Congrès. *Exposition Intercontinentale.* June 19–July 15. Organized by the International Art Exchange for the benefit of UNICEF. Traveled to: Union Carbide Galleries, New York. October 7–November 4.

New York: Gallery of Modern Art. *About New York: Night and Day.*

1970
New York: Union Carbide Galleries. *Contemporary Turkish Artists and Calligraphy from the Topkapı Palace Museum.* September 9–18.

Binghamton, N.Y.: University Art Gallery. *Contemporary Turkish Painting.* Traveled to: University of Chicago, 1971.

Minneapolis: Minneapolis College of Art and Design.

New York: Finch College Museum of Art. *Artists at Work.*

1972
New York: Pace Gallery. *Printmakers at Pace.* May 6–31.

1974
New York: Gallery 43. *Center City: An Exhibition of Midtown Artists.* Sponsored by the Durst Organization in cooperation with the New York City Department of Cultural Affairs. May 8–June 1.

1975
New York: The Solomon R. Guggenheim Museum. *Recent Acquisitions.* May 2–June 1.

1977
Istanbul: Gallery Baraz. January 8–February 8.

New York: Union Carbide Galleries. *Artists 77.* May 11–27. Organized by International Play Group, Inc. and The Crèche.

New York: The Solomon R. Guggenheim Museum. *From the American Collection.* September 30–December 5.

Istanbul: Gallery Baraz. *Group Show.* November 1–27.

1979
Chicago: Mary Bell Galleries. *Three Great Abstract Painters: Stratmanis-Dogançay-Spalatin.* May 4–25.

1980
Chicago: Mary Bell Galleries. *New Works by Gallery Artists.*

Rockford, Ill.: Sneed Gallery. *Small Works by Big Artists.*

1982
Cologne: Baukunst-Galerie.

Houston, Tx.: The Houston Museum of Natural Science. *The Heritage of Islam.* March 10–May 30. Traveled to: The California Academy of Sciences, San Francisco, July 2, 1982–January 2, 1983; The National Museum of Natural History Smithsonian Institution, Washington, D.C., June 1–September 5, 1983.

1983
Istanbul: Alarko Art Gallery. *Fifty Rare Turkish Paintings of This Century.* May 5–18. Organized by Gallery Baraz, Istanbul.

Zurich: Kunstsalon Wolfsberg.

1984
Istanbul: Alarko Art Gallery. *1950'den Günümüze Türk Resim Sanatından Bir Kesit.* April 10–30.

Rockford, Ill.: Sneed Gallery. *Who's New and What's New.* May 4–31.

Sarasota, Fla.: Foster Harmon Galleries. *Major American Artists.* August 13–September 4.

1985
La Tronche/Grenoble: Maison des Artistes-Fondation Herbert d'Uckermann. *Itinéraire d'une Galerie.*

Lormont: Centre de Formation et Création Artistique. *Tapisseries d'Aubusson.*

Montreux: Palais des Congrès. *Les Chefs d'œuvre d'Aubusson.* July 2–August 31.

Paris: Maison de L'Assurance. *Tapisseries Contemporaines d'Aubusson.*

Talence: E.N.S.A.M. *Tapisseries de l'Atelier Raymond Picaud.*

1986
Ankara: First International Asian-European Art Biennial. April 28–May 15.

Bordeaux: Galeries Lafayette. April 28–May 31.

1987
Istanbul: Atatürk Cultural Center. *Türk Resminde Modernleşme Süreci.* April 15–May 15. Organized by Yahşi Baraz.

Istanbul: 1st International Istanbul Biennial. September 25–November 15.

Istanbul: Garanti Art Gallery. October 2–30.

Sarasota, Fla.: Foster Harmon Galleries. *Paintings by Burhan Dogançay.*

1988
Paris: Foire Internationale d'Art Contemporain. October 26–30.

1989
Valparaiso: IX Bienal Internacional de Arte.

1990
Sarasota, Fla.: Foster Harmon Galleries.

Istanbul: Almelek Art Gallery. *Yurt Dışındakiler Almelek'te.* November 8–December 1.

Istanbul: Atatürk Cultural Center. *Etkinlikler sürecinde 15. Yıl.* November 9–20. Organized by Yahşi Baraz.

1991
Montluçon: Centre Athanor, *Panorama de la Tapisserie Contemporaine.*

New York: Lehman College Art Gallery. *Collage: New Applications.* March 21–May 4. Organized by William Zimmer.

1992
Istanbul: Atatürk Cultural Center. *New York-Istanbul.* November 6–28. Organized by Yahşi Baraz.

Aubusson: Espace Philips. *L'Hommage de 50 Peintres à Jean Lurçat.*

1993
Münster: City Hall. *Zeitgenössische türkische Kunst.* March 10–April 2.

1994
New York: Nicholas Alexander Gallery. *Group Show.* February 1–March 12.

1996
Rio de Janeiro: Arcos da Lapa. Organized by Laboratoire, Grenoble. November 1–November 30.

1997

Istanbul: Borusan Art Gallery. *Aynı'lık & Ayrı'lık.* October 13–November 22.

Istanbul: Pg Art Gallery. *Adil and Burhan Dogançay.* October 17–November 29.

1998

Ankara: Artium Art Gallery. *Original Prints.* October 24–November 25.

Istanbul: Atatürk Cultural Center. *Türk Resminde Soyut Eğilimler.* November 12–December 4. Organized by Yahşi Baraz.

Aubusson, France: Hotel Le France, *De Jean Lurçat à Nos Jours.*

1999

New York: The Museum of the City of New York, *The New York Century: World Capital, Home Town, 1900–2000.* November 17–December 31.

2000

Marburg: Marburger Universitätsmuseum. *Kunst der Gegenwart: 1975–2000.* January 23–March 12.

2001

Istanbul: EleganArt Sanat Galerisi. *Çağdaş Türk Resminden Bir Kesit.* June 9–September 30. Organized by Yahşi Baraz.

Purchase, NY: Neuberger Museum of Art. *Outside In.* June 10–December 2.

2002

Istanbul: EleganArt Sanat Galerisi. *Modern Cağdaşlar-I.* March 7–April 12. Organized by Yahşi Baraz.

Summit: New Jersey Center for Visual Arts. *Doors: Image and Metaphor in Contemporary Art.*

2003

Istanbul: Mine Art Gallery. *Çağdaş Sanat 16.* June 16–September 30.

Marburg: Marburger Universitätsmuseum. *Selten gezeigte Bilder aus dem Museumsbestand.* November 2–January 4, 2004.

2004

Savannah, Ga.: Telfair Museum of Art. *New on View: Recent Acquisitions to the Permanent Collection.* January 17–February 18.

Istanbul: Gallery Binyıl. *Sanata 5 Farklı Bakış.* October 5–October 28.

2005

Istanbul: Photography Center Istanbul. *2005 Collection Exhibition.*

Istanbul: Istanbul Museum of Graphic Arts. *Baskıresim Sergisi.* February 9–28.

Savannah, Ga.: Telfair Museum of Art. *Watercolors and Pastels from the Permanent Collection.* April 4–24.

Istanbul: Mine Art Gallery. *Çağdaş Sanat 18.* July 15–August 15.

New York: Andrea Rosen Gallery. *Looking at Words.* November 2, 2005–January 5, 2006.

Toledo, Ohio: Toledo Museum of Art. *Recent Acquisitions: Works on Paper.* December 9, 2005–March 5, 2006.

2006

Fredonia, N.Y.: Rockefeller Arts Center Art Gallery. *Connoisseurship.* October 13–November 12.

2007

Ankara: Contemporary Arts Center in Ankara, *Selected Paintings from the CBT'S Art Collection: Trace of 75 Years.* March 19–April 2.

Istanbul: Project 4L/Elgiz Museum of Contemporary Art. *Selection 2007.* May 1–December 1.

Istanbul: Mine Art Gallery. *Çağdaş Sanat 20.* June 11–August 25.

Toledo, Ohio: Toledo Museum of Art. *Above Water: Bridges from the Collection.* July 20–October 21.

Istanbul: SantralIstanbul. *Modern and Beyond.* September 9, 2007–June 15, 2008.

2008

Istanbul: Pera Museum: *Collage–Décollage: Dogançay–Villeglé.* May 2–July 31.

Istanbul: Mine Art Gallery. *Çağdaş Sanat 21.* May 21–July 30.

Newark: Newark Public Library. *Over 50 Years of Major Art History.* July 2–September 20.

2009

Salzburg: Museum der Moderne. *SPOTLIGHT. Neuzugänge seit 2006.* February 14–June 7.

Istanbul. Mine Art Gallery. *Çağdaş Sanat 22.* May 5–August 30.

Istanbul: Gallery Işık. *Soyut.* May 14–June 11.

Biel/Bienne: CentrePasquArt. *Collage–Décollage: Dogançay–Villeglé.* June 28–August 30.

Istanbul: Istanbul Museum of Modern Art. *New Works, New Horizons.* May 2009– April 2012.

Berlin: Martin-Gropius-Bau. *Istanbul Next Wave.* November 12, 2009–January 17, 2010.

2010

London: British Museum. *Modern Turkish Art at the British Museum.* July 28–December 12.

Minneapolis, MN: Walker Art Center, Perlman Gallery. *50/50: Audience and Experts Curate the Paper Collection.* December 16, 2010–July 17, 2011.

2011

Istanbul: SantralIstanbul. *20 Modern Turkish Artists of the XXth Century: 1940–2000.* March 10–June 19.

2012

Vienna: Belvedere, Orangerie. *Kokoschka sucht einen Rahmen.* February 1–February 26.

Istanbul: İstanbul Museum of Modern Art. *After Yesterday.* February 16–May 28.

Museum and Public Collections

Albertina, Vienna

Amon Carter Museum, Fort Worth, Texas

Anadolu University Museum of Contemporary Arts, Eskişehir

Art Gallery of Greater Victoria, BC, Canada

Bangladesh National Museum, Dacca

Bayerische Staatsgemäldesammlungen, Pinakothek der Moderne, Munich

Belvedere, Vienna

Benaki Museum, Athens, Greece

Bibliothèque Historique de la Ville de Paris

The British Museum, London

The Brooklyn Historical Society, Brooklyn, New York

The Brooklyn Museum, Brooklyn, New York

The Brooklyn Public Library, Brooklyn, New York

Carnegie Museum of Art, Pittsburgh, Pennsylvania

CentrePasquArt, Biel/Bienne

Clark Arts Center-Rockford College, Illinois

The Cleveland Museum of Art, Cleveland, Ohio

Cultural Foundation, Abu Dhabi

Dogançay Museum, Istanbul

Farnsworth Art Museum, Rockland, Maine

Fotomuseum Winterthur, Winterthur

Frac Collection Aquitaine, Bordeaux

Fred Jones Jr. Museum of Art–University of Oklahoma, Norman, Oklahoma

Frederick R. Weisman Art Museum–University of Minnesota, Minneapolis, Minnesota

Georgia Museum of Art–University of Georgia, Athens, Georgia

Grafische Sammlung ETH, Zurich

Grunwald Center for the Graphic Arts–Hammer Museum, Los Angeles, California

Heckscher Museum of Art, Huntington, New York

Hiroshima City Museum of Contemporary Art, Hiroshima

The Israel Museum, Jerusalem

Istanbul Museum of Modern Art, Istanbul

Istanbul Museum of Painting & Sculpture, Istanbul

John & Mable Ringling Museum, Sarasota, Florida

Jordan National Gallery of Fine Arts, Amman

JP Morgan Chase Art Collection, New York

Kennedy Museum of Art, Ohio University, Athens, Ohio

KUNSTEN Museum of Modern Art Aalborg

Kunsthalle Mannheim

Kunstmuseum Basel

Kunstmuseum Bern

The Library of Congress, Washington, D.C.

Los Angeles County Museum of Art, Los Angeles, California

Louisiana Museum of Modern Art, Humlebæk

Maier Museum of Art–Randolph College, Lynchburg, Virginia

Marburger Universitätsmuseum, Marburg

The Metropolitan Museum of Art, New York

Michael C. Rockefeller Arts Center Art Gallery–State University of New York Fredonia, New York: The Daniel A. Reed Library Art Collection, Fredonia, New York

Moderna Museet, Stockholm

Musée d'Art Contemporain, Strasbourg

Musée de Grenoble

Musée National d'Art Moderne, Centre Georges Pompidou, Paris

Museet for Fotokunst–Brandts Klaedefabrik, Odense

Museo Nacional de Bellas Artes, Santiago

Museu de Arte Moderna do Rio de Janeiro, Rio de Janeiro

Museum Bellerive, Zurich

Museum der Moderne, Salzburg

Museum für Kunst und Gewerbe Hamburg, Hamburg

Museum of Contemporary Art, Ghent

Museum of Contemporary Art, Skopje

Museum of Fine Arts Boston, Massachusetts

Museum of Fine Arts Houston, Texas

The Museum of Modern Art, New York

The Museum of the City of New York

Museum Moderner Kunst Stiftung Ludwig Wien, Vienna

National Gallery of Art, Washington, D.C.

Dr. Nejat F. Eczacıbaşı Foundation Collection

Neuberger Museum of Art, Purchase, New York

The Newark Museum, Newark, New Jersey

The New-York Historical Society, New York

Norton Simon Museum, Pasadena, California

Index of Works Exhibited

Photo Credits

FOUNDER AND SPONSORS

FOUNDER

COMMUNICATION AND TECHNOLOGY SPONSOR

EDUCATION SPONSOR

Başka bir arzunuz?

YOUR THURSDAY SPONSOR

ARCHITECTURAL DESIGN
TABANLIOĞLU

COMMUNICATION DESIGN
TBWA \ ISTANBUL

LIGHTING
TEPTA AYDINLATMA

SPECIAL PROJECTS
BASF-THE CHEMICAL COMPANY
ŞEKERBANK

ATÖLYE MODERN SPONSOR
FİNANSBANK PRIVATE BANKING

ACCOMMODATION
POINT HOTEL

CONTRIBUTORS
ACARLAR MAKİNE
ALLIANZ SİGORTA
ANADOLU SİGORTA
AXA SİGORTA
BİLETİX
BUZZYWORKS
COCA-COLA
GENERALI SİGORTA
INSPARK
IPSOS KMG
İDO
KİRAZZ TEKNOLOJİ
KREA DIRECT
MARSHALL
POST IT
SABİHA GÖKÇEN HAVALİMANI
SCOTCH
TAV HAVALİMANLARI HOLDİNG
WALL

CORPORATE MEMBERS-GOLD
DOĞUŞ OTOMOTİV-AUDI
LİMAK HOLDİNG
YAPI KREDİ PRIVATE BANKING

CORPORATE MEMBERS-SILVER
İSTANBUL TİCARET ODASI
SÜZER GRUBU
TEB FAKTORİNG
TEB ÖZEL BANKACILIK

MEDIA SPONSORS

NEWSPAPER	TAKVİM	NATIONAL GEOGRAPHIC	POWER FM	CNBC-E BUSINESS	MEETURKEY INCENTIVE MAGAZINE
AKŞAM	TÜRKİYE	NTV	POWER XL EXTRA LOUNGE	COSMOPOLITAN	
BİZİM GAZETE	VATAN	STAR TV		FOCUS ON TRAVEL NEWS	NATIONAL GEOGRAPHIC
CUMHURİYET	YENİ ŞAFAK	TGRT HABER	POWERTÜRK FM	FORBES	NATIONAL GEOGRAPHIC KIDS
HABERTÜRK	ZAMAN	TV8	RADYO D	FORTUNE	
HÜRRİYET	**TV**	WORLD TRAVEL CHANNEL	RADYO EKSEN	HOME ART	NEW FOCUS TRAVEL MAGAZINE
HÜRRİYET KEYİF	24	**RADIO**	RADYO FENOMEN	INSTYLE	
MİLLİYET	BLOOMBERG HT	AÇIK RADYO	VIRGIN RADIO	INSTYLE HOME	NTV TARİH
POSTA	CNBC-E	CNN TÜRK RADYO	**PERIODICAL**	İSTANBUL LIFE	PLATİN
RADİKAL	CNN TÜRK	DİNAMO	AND MAG	KÜLTÜR SANAT HARİTASI	THE GUIDE ISTANBUL
SABAH	HABERTÜRK	LOUNGE FM	ARTİST ACTUAL	MARIE CLAIRE	TOUCH İSTANBUL
STAR GAZETESİ	KANAL D	NUMBER ONE FM	ARTİST MODERN	MARIE CLAIRE MAISON	WHICHCONTENT

WE ARE THANKFUL FOR THE CONTRIBUTIONS OF

İSTANBUL
BÜYÜKŞEHİR
BELEDİYESİ

TÜRKİYE DENİZCİLİK
İŞLETMELERİ A.Ş.

İSTANBUL MODERN WOULD LIKE TO THANK
THE EXHIBITION SPONSOR YILDIZ HOLDING FOR
THE GENEROUS SUPPORT THEY HAVE GIVEN TO
FIFTY YEARS OF URBAN WALLS.

EXHIBITION SPONSOR

İSTANBUL MODERN WOULD LIKE TO THANK
ALL THE EXHIBITION SUPPORTERS FOR THE
SPONSORSHIP THEY HAVE GIVEN TO
FIFTY YEARS OF URBAN WALLS.

CONTRIBUTORS

İSTANBUL MODERN
RECEIVED
**THE PRESIDENT'S CULTURE AND
ART GRAND AWARD FOR
2010** AND
A **SPECIAL COMMENDATION FROM
THE EUROPEAN MUSEUM FORUM
IN 2009.**